HAYWARD GALLERY, LONDON

20 FEBRUARY—20 APRIL 1992

DOUBLETAKE

COLLECTIVE MEMORY & CURRENT ART

The South Bank Centre / Parkett 1992

Exhibition curated by Lynne Cooke, Bice Curiger, Greg Hilty

Exhibition organised by Greg Hilty, assisted by Lynne Richards

Exhibition Design: Studio di Architettura, New York, Aldo Rossi, Morris Adjmi, Jan Greben

Presented in association with Visiting Arts

Supported by the Cultural Department of the French Embassy in London; the Goethe Institut, London

Catalogue compiled and written by Lynne Cooke, Bice Curiger and Greg Hilty, assisted by Lynne Richards

Published by The South Bank Centre and Parkett Publishers

Editor: Marianne Ryan

Design: Trix Wetter

Typesetting & Printing: Steidl Druckerei, Göttingen

Text © 1992 The South Bank Centre and the authors

ISBN 185332-082-X

Distributed in the United Kingdom by The South Bank Centre. A list of all South Bank Centre and Arts Council exhibition publications may be obtained from the Publications Office, The South Bank Centre, Royal Festival Hall, London SE1 8 XX.

Distributed in the rest of the world by Parkett / Scalo Publishers

Quellenstraße 27, CH-8005 Zürich / 636 Broadway, New York, NY 10012

Stephan Balkenhol

Sophie Calle Saint Clair Cemin

Peter Fischli / David Weiss Katharina Fritsch

Jeff Koons Glenn Ligon Christian Marclay Julio Galán

Robert Gober Andreas Gursky Ann Hamilton Gary Hill

Jenny Holzer Narelle Jubelin Mike Kelley Jon Kessler

Juan Muñoz Simon Patterson Philip Taaffe

Boyd Webb Tim Rollins + K.O.S.

Rachel Whiteread

CONTENTS

FOREWORD

Substantial group exhibitions of contemporary art from around the world might be expected to form a natural part of our cultural life. In fact they happen here rarely and irregularly, for the understandable reasons that they are costly to organise, come fraught with curatorial perils, and guarantee neither a large nor a receptive audience. They are also demanding on the artists themselves for whom they can seem, at worst, irrelevant. Before embarking on this project we considered carefully whether there was truly a need for it at the present moment. We concluded that there was, both as a demonstration of the Hayward Gallery's commitment to contemporary art and more importantly to offer our public a focused and thoughtful view of a strand of current practice in the visual arts, at a moment of great vitality and intellectual ferment. We are confident that there is much in the content and presentation of this exhibition that will be of considerable interest to a wide public, as well as contributing to artistic debate.

It seems especially fitting, given the breadth of programming at the Hayward and indeed the whole South Bank Centre, that this exhibition should bring together artists of diverse backgrounds, inspired by a wide range of historical and cultural influences, and employing such a variety of media. We are most grateful to the artists for their generous commitment to this project. Thanks are also due to their agents, who have greatly assisted with organisational matters. We owe a considerable debt of gratitude to the private collectors listed overleaf, without whose generosity this exhibition could not have been realised.

We have greatly valued the involvement of our two guest curators, Lynne Cooke and Bice Curiger. At the time of our initial discussions Lynne Cooke, highly respected as a writer about art in Britain and abroad, had recently moved to the United States, where she has since co-curated the 1991 Carnegie International and become Curator of New York's Dia Center for the Arts. Bice Curiger has since 1984 been Editor-in-Chief of *Parkett,* a Swiss-based international art magazine second to none in its thoughtful approach to contemporary art, and known especially for its collaborations with artists. Both have brought to this undertaking their wide general know-

ledge and close familiarity with the art of their time. Their distinct but complementary sensibilities have informed the broad development and precise shaping of *Doubletake,* as both exhibition and publication.

This project has been characterised by three unusual but highly rewarding collaborations with respect to installation, publication, and outdoor projects. For keeping the exhibition's requirements foremost in mind, while responding creatively to them, our sincere thanks are due to: Aldo Rossi, Morris Adjmi and Jan Greben from the Studio di Architettura in New York; Walter Keller and Gabriele Hemmersbach from Parkett Publishers in Zürich, together with designer Trix Wetter and, in London, our editor, Marianne Ryan; and James Lingwood and Lisa Harty of The Artangel Trust, London.

We are most grateful to Visiting Arts for their significant contribution towards the costs of bringing the artists to London to install their work. Finally, sincere thanks are due to colleagues at the South Bank Centre for their generous contribution of creative and organisational advice and support for key aspects of this undertaking.

JOANNA DREW
Director of Hayward and Regional Exhibitions

GREG HILTY
Exhibition Organiser

ACKNOWLEDGEMENTS

Oscar Agüera

Theresa Beattie

Iwona Blazwyk

Gertrud Blum

Mary Boone

Captain A. J. Bull

Diana Bulman

Judith Calamandre

John Cheim

Paula Cooper

Michael Craig-Martin

Chantal Crousel

Tom Cugliani

Ursula Debiel

Maura Dooley

Robert Edelman

Barbara Farber

Rosamund Felsen

Richard Flood

Jessica Fredericks

Patty Aande Gallinger

Guy Gijpens

Barbara Gladstone

Malcolm Hardy

Cynthia Hedstrom

Sue Higginson

Jo Holder

Sean Kelly

Cara Kennedy

Melissa Lazarov

Fabienne Leclerc

Larry Levine

Valeria Liebermann

Gary McCraw

Robert Miller

Alexandra Morphett

Birgit Müller

Gaby Naher

Louise Neri

Lars Nittve

Annina Nosei

Marga Paz

Gaye Poulton

Max Protetch

Deac Rossel

Karsten Schubert

Graham Sheffield

Laurence Shopmaker

Natasha Sigmund

Thomas Sokolowsky

Molly Sullivan

Alexis Summer

Gilane Tawadros

Ron Warren

Tracey Williams

Wendy Williams

Helen Windsor

John Wyver

Donald Young

LENDERS

Thomas Ammann, Zürich

Mary Boone Gallery, New York

Janet de Botton, London

Paula Cooper Gallery, New York

Galerie Crousel-Robelin / BAMA, Paris

Rosamund Felsen Gallery, Los Angeles

Gagosian Gallery, New York

Family H. de Groot, Groningen

Jablonka Galerie, Cologne

Galerie Johnen & Schöttle, Cologne

Joan Kerr, Sydney

Emily Fisher Landau, New York

Maureen Laing, Brisbane

Louver Art Gallery, New York

Luhring Augustine Gallery, New York

Metro Pictures, New York

Robert Miller Gallery, New York

Musée d'Art Contemporain, Nîmes

Francesco Pellizzi

Max Protetch Gallery, New York

Collection of Fredrik Roos

Galerie Thaddaeus Ropac, Paris

Karsten Schubert Ltd., London

Vivienne Sharpe, Darling Point

Geoff Wilson, Adelaide

Joe Wissert, Woollahra

Donald Young Gallery, Seattle

The artists and other collectors who wish
to remain anonymous

INTRODUCTION

'Collective Memory' is a phrase that can mean all or nothing to different people. We focused on it in our preliminary discussions about shaping this exhibition, as a useful key to some of the most compelling and resonant art of today. Rather than adopting biographical or stylistic criteria for our selection and hoping that meaning would follow, or on the other hand looking for work that illustrated an already delimited theme, we have sought to let the current concerns of artists both expand and define our subject.

In the interest of carrying this dynamic through to the actual presentation of the show, we early on made two fundamental decisions: first, strictly to limit the numbers of artists shown, primarily to give each a chance for a full statement; and second, to extend the exhibition where appropriate beyond the walls of the gallery into broad channels of communication or sites already charged with public meaning. We thank all those artists who have so generously contributed to this project: those who have developed new work or presented earlier pieces in thoughtful new ways; those who have taken on the additional challenge and responsibility of operating outside the protected confines of the gallery; and also those whose work we have carefully considered but finally not included here.

A later but equally determining decision was to seek an installation design that would reinforce the exhibition's theme while respecting each artist's individual requirements. Central to Aldo Rossi's architecture and aesthetic, the notion of collective memory also informs his writings. It seems highly appropriate that his involvement in drawing up plans for the South Bronx Academy of Art with the Art & Knowledge Workshop should have led to his contribution here.

Along with images and sounds, words of various kinds and origins appear throughout this exhibition and publication. In the latter, we have chosen to write essays that elaborate certain strands which can be identified in the work in question, without trying to fix it or its context. The artists' notes provide background information and sometimes elucidate particular works shown. The anthology of texts is for us an

important parallel document, bringing together fragments of writings and images that have guided or accompanied our thoughts about this project, and in a number of instances been brought to our attention by artists in the exhibition.

At a time when ideologies are collapsing, technology continues to develop exponentially, and biological research brings into question just what it means today to be human, the tension between our public and private selves has become acute. The artists in this exhibition share an equal distrust of the purely personal and the securely social. They suggest how the infinite raw material that contributes to forming our experience of the world – including most notably the cultural products from diverse realms and ages – remains inert until brought into play in the present. The 'doubletake' we allude to therefore implies neither a style nor content but rather an approach, on the part of both artist and viewer, entailing recognition and reinvestment of significance where it might otherwise be overlooked or taken for granted.

LYNNE COOKE
BICE CURIGER
GREG HILTY

GREG HILTY

Thrown Voices

'THE VENTRILOQUIST' A recent work by the Canadian artist Jeff Wall is remarkable both in relation to the artist's own wide range of subject matter, and for the focus it brings to concerns shared by many of his contemporaries. The first mark of its singularity is its mysteriously specific title: 'The Ventriloquist at a Birthday Party in October 1947.' Since we are given no clue to the meaning, either personal or historical, of this occasion or its date, what poses as precise information turns into a precise fiction, establishing a mood that is doubly resonant. In the centre sits the ventriloquist herself, a woman of somewhat indeterminate age, reminiscent of the growing number of Hollywood actresses now called upon to play, within the course of the same film, characters both younger and older than themselves. She holds a hand-carved dummy, a hideous toy with a child-sized body and an adult head, whose features successfully bridge the gap between the sentimental and the monstrous. The ventriloquist seems unaware that her prop is so aberrant, and gazes towards it with a proprietorial, professional assurance. The dummy gazes into another world altogether and the children at the party gaze at it; they are symmetrically arrayed across the front of the picture plane, staring rapt towards the centre, their expressions caught at the moment when delight and horror merge. The atmosphere is enhanced by the artificially low ceiling, by the large balloons seen pushing up against it, by the dingy domestic lighting which contrasts tellingly with the unearthly artifical glow of the lightbox format Wall habitually uses, and by the sight of the dummy's travelling case set against the rear wall, like a compact bondage unit. Although *sui generis,* this work also contrives to offer a convincing paradigm of attitudes that underlie many of the most compelling examples of recent art. It may be useful to consider in turn each of these characteristics – which can be narrowed down and summarised as *memory, projection, rapture,* and its concomitant, *unease* – in relation to a number of the artists and works within this exhibition.

MEMORY Memory is fundamental to meaning. Even the meaning conveyed by logic is dependent upon an agreed structure of shared beliefs, albeit in principle

14

without reference beyond its own strict terms. Most of what we see as significant to our lives is much more intimately tied to a fine network of associations, the consequence of countless acts brought directly or indirectly into the scope of our experience and built up into a value system. Or rather, many hundreds of such systems, since we each have our own and all adhere to others, with greater or lesser conviction. The coherent overlapping of these systems can be called a culture. What seems especially interesting about the present moment is that we live within a culture of incoherence, whose single unifying characteristic is its diffusion. This is not to say that there are no ideologies, no strong and general systems of belief, just that none is dominant, many prevail, and all are therefore thrown into doubt. Residues of previously discarded or neglected thought-patterns are brought back to the fore, competing with those that would seek to define the world anew.

As art is a central and self-conscious cultural activity, artists must find their way through this maze of possible paths and contradictions. A number of those in DOUBLETAKE directly employ historically charged material, broadly recognisable carriers of collective significance. They do so in ways that undermine any linear, one-track reading of their subject matter. Simon Patterson places side by side, or in borrowed schematic arrangements, names that have a common currency within his culture. Such attempts at regrouping almost always show up the hollowness or limitations of standard classifications when we are as likely as not, within this culture, to see or hear together names extracted from quite alien strata. What single framework, for instance, could possibly encompass Chief Cochise and Ronald Coleman? Yet there they are, adjacent. We are forced to draw our own conclusions, unlikely as they are to be conclusive. Philip Taaffe's sources are also wide, although more focused by a logic of historical accident: most of this abstract imagery derives from traces left behind by cultures that have through the centuries converged on Naples, where he lives. A real, historical melting pot is both the metaphorical excuse and the actual inspiration for Taaffe's fluid combinations of diverse decorative devices. The artist becomes the nexus, or receiver, for messages which have their own impulse. The historical intervention that permits him to add to this Mediterranean repertoire the familiar curves and harder edges of postwar Western abstraction is precisely his own, personal, presence and the culture he has brought with him. Narelle Jubelin portrays quite specific markers of institutional remembrance – a group of colonial monuments in Australia – using a language that effectively dispels

15

their self-defining context and negates their message of dominance. It is paradoxically through the very accuracy, the obsessive faithfulness of Jubelin's re-interpretation of such emblems through the medium of petit-point, that their overweening power is withdrawn. These artists, in tearing from their roots signs whose derivations can be directly traced, do not deny their original connotations or even their present, revised, implications. With vastly different intentions and means they are, instead, proposing as the domain of their art a free zone between the historical text and the individual action consequent upon its interpretation. We all behave according to our compulsions and it is not the place of art strictly to delimit that behaviour: art can, however, open up our options and give visual form to their potential significance. Such a motive lies behind the collaborative endeavour of Tim Rollins + K.O.S. Taking acknowledged landmarks of 'high' or 'popular' literature as their points of departure – classics ranging from the Bible through Flaubert's 'Temptation of St. Antony' to 'Pinocchio' – they aim neither to interpret nor to explain. Rather they seek to re-signify for themselves, at this moment, what they discern as the central message of these books, viewed not as inviolable monuments but as voices from another age, continually reaffirming for new generations their status as enduring works of art.

PROJECTION Many critics of contemporary art allege among its faults, and the failings of the general sensibility it reflects, coldness, coyness, and a lack of real emotion. In this at least they are fundamentally mistaken, and to interpret displacement as dispassion is wilfully naïve. To draw an obvious example from the wider culture: much of the recent popular success of David Lynch's television series 'Twin Peaks' clearly lies in the compelling disjunction it creates in using the over-familiar, second-hand format of soap opera to convey the rawest most archetypal of emotions. The intention is only partly one of parody (not that its comic, ironic overtones are in themselves pointless or unworthy): it is rather to work through existing genres and channels of communication, acknowledging their power as vehicles of both collective and individual significance. There is a scene, some way into its early episodes, which provides an overwhelming though utterly mediated moment of revelation: a minah bird named Waldo, belonging to the chief murder suspect Jacques Renault, has been seized by the police and brought in for 'questioning'. Waldo remains silent, however, and is left alone in the interview room with Agent Cooper's dictaphone set to 'record', in case the bird should talk. It does, briefly and

eerily, just as a mysterious presence is perceived outside the window. The presence has a shotgun which he uses to blast Waldo away in a faintly comic flurry of black feathers. The police rush in, as the feathers touch the floor: they play back the tape to see if Waldo has given anything away before passing on. What they hear is the chilling, disembodied voice of a young girl being tortured and witnessing her friend Laura Palmer's death throes. The fact that this extreme expression is twice transmitted, first through a bird and then through a machine, does not diminish but on the contrary heightens its emotive impact. Part of what heightens it is, of course, the fact that it is heard, by a group of people who stand in silent shock and are able to gauge its significance. Before that moment the sound was no more than an awful private cry in a cabin in the wilderness.

As if simultaneously recognising the limitations and acknowledging the strengths of some of the key art movements of the past twenty years, many of today's artists employ less programmatic, less single-minded approaches. Face to face with the formalising dead-end of Minimalism, the closed-circuit introversion of Concept art, the dreamy mythologising of the New Expressionism and the market-led conceptualism of late eighties Commodity art (all uncharitable caricaturisations of labels appended to vigorous and complex artistic approaches), artists might be forgiven for resorting to either garrulousness or silence. There is indeed a kind of reticence, an artistic loss of self, that has offered fruitful ground for much recent work. Juan Muñoz has explicitly used the image of the ventriloquist's dummy, the prompter or the story teller, as well as the empty stage or arena, to evoke potential holders or transmitters of meaning. In his proposals for public works for DOUBLE-TAKE, he carries these implications of transference one stage further, by 'disguising' his works in one instance as a series of short radio broadcasts, and in another as a monument commemorating nothing but the act of public remembrance. Rachel Whiteread's sculptures are more evidently private monuments, in the form of plaster or rubber casts of impressions made, as if on the memory, by familiar objects that themselves have seen the presence or passage of people. Small scale cenotaphs (literally, 'a tomb without a body'), their silences testify to the accumulated, ineffable dignity of the everyday.

Jenny Holzer has explicitly employed the image of the sarcophagus; her works, too, possess a double edge as carriers of meaning. Their outward forms are usually those of public information systems, from posters to television. The words that they

transmit are, however, more than merely messages: caught somewhere between the found phrase and prophetic utterance, they have an unassuming resonance less easily conveyed through first-order speech. Fleeting, transient, they nevertheless reverberate with their own and other echoes. Transferrence of radically different but complementary kinds is to be found in the works of Glenn Ligon and Julio Galán. Galán treats his own self-image as a kind of dummy, putting it through repeated acts of role playing. This is not in itself unique in recent art: both Cindy Sherman and Yasumasa Morimura have assumed, through photographic techniques, multiple cultural identities. Galán is different, first because he works deliberately with an indigenous tradition of painting, which happens to be Mexican, but also because he quite clearly portrays aspects of his own complex inner personalities, *as if* they were assumed characters. Glenn Ligon's voices are those of anonymous soothsayers (personified under names such as 'Professor de Hits') who through their published lexicons of dream interpretations offer a kind of logic and purpose to a whole community's collective dreaming. For neither artist can the intimately personal and the communal be simply or wholly separated. As multiple constructs of biology, history, culture and personal experience, we speak to the world and the world speaks back. Seen another way, the artifacts of our cultural heritage are like the consonants of a language, bare bones of meaning which depend literally upon the inspiration of our voices to receive their full expression and their sense.

RAPTURE AND UNEASE An equation can be proposed between the invigoration of the social order and a full engagement with a work of art. Both breathe life – our own, fugitive lives – into intrinsically inert though potentially significant material, which in turn articulates and directs ourselves. Such a process can only be described in terms of revelation, as a breaching of the subjective/objective divide, a completely physical awareness of our momentary place within a broader order. This sensation can take one of two complementary forms, both extreme but not so very far apart. The first is the fusion of the participant and the scene, which can be achieved through an absorbing theatricality or through more modest but persuasive fictions; the second is the bathos of disillusion, from which the spectator recoils in mental discomfort. Although unlikely to be experienced simultaneously, these responses certainly can be felt by different people or at different times, in relation to the same art object. Many of the artists in DOUBLETAKE keep us moving between the two,

emphasising that they are equal agents in the same process of signification. Mike Kelley disposes on the gallery floor, in acute disorder, the ragged, rejected toys of a society that has institutionalised sentimentality. Words, no more than private whispers, that have been written on these former vehicles for love are blown up and reproduced on the surrounding walls as a cursive meta-language, a suddenly standardised recital of garbled and half-formed thoughts. Ann Hamilton infuses the elaborate completeness of her installations with the germ of their own decay, usually in the form of living animals or animal matter, their very warmth the evidence of their corruptibility. The works of Katharina Fritsch, by contrast, are forever frozen, their sublime stasis holding the potential for infinite change by disallowing even the most infinitesimal alteration. The video installations of Gary Hill embrace this dichotomy wholeheartedly in the very fabric of their technology, building up an image of the world through its ceaseless electronic deconstruction and reconstitution. Hill proposes that only in the perpetual breaking down of meaning can new and transient meanings be seen to emerge; that the moment of revelation is also inevitably the moment of catastrophe.

These artists simultaneously challenge our notions of transcendence and our foothold on this earth. There is cold comfort, but no need for despair and much delight on the way, in the realisation that as we seek to define our lives and build for our salvation, we prepare for our own unravelling. We are all already turning in our graves.

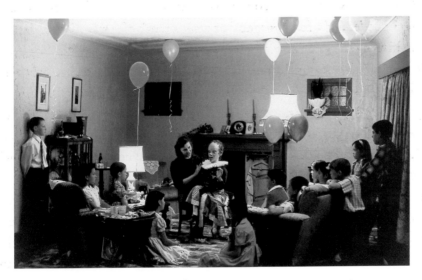

Jeff Wall, *The Ventriloquist at a Birthday Party in October 1947,* 1990, courtesy the artist.

BICE CURIGER

Epater le bourgeois – revisited

'Middle, *milieu* has nothing to do with means, average, is neither centrism nor moderation nor mediocrity. On the contrary, it has to do with absolute speed. Only something that grows in the midst of things is capable of such velocity.'

GILLES DELEUZE/CLAIRE PARNET, *Dialogues,* Paris, 1977

In the winter of 1989, two different artistic events challenged the New York art public in a manner that was neither particularly spectacular nor specifically novel, but in the present context, they merit closer examination. They shared the fact that, on stopping in front of the work in question, beholders automatically threw their heads back in order to look up. This picture of moving individuals frozen for a brief moment as part of a group as if rehearsing a concentrated, distant gaze made a remarkable impression. In the Jenny Holzer exhibition at the Guggenheim Museum, viewers entered the central rotunda, there to join other visitors already craning their necks to see the work. The artist had mounted her pulsating illuminated signs along the spiral-shaped ramp. With one's face reflecting the coloured light, one felt immediately drawn into this circle of voices deciphering Jenny Holzer's messages, neither personal nor entirely impersonal, a continuum of sentences and opinions.

The other event involved the billboard that Jeff Koons put up on the intersection of Broadway and Houston Street. It showed the artist and Ilona Staller, whom he has since taken as his wedded wife, lying almost nude in close embrace on an ocean cliff under the slogan, 'Made in Heaven' – as if campaigning for Paradise on Earth. Pedestrians peering up at the billboard became a species of art viewer utterly distinct from the traditional art lover engrossed in edifying, serene and singular contemplation. Koons converted utmost intimacy into utmost publicness; he pulled the most remote thing imaginable – a product of Heaven, as it were – down into the lowlands of the street in order to unite the two poles or cause friction between them. And in so doing, he turned his fellow human beings into a laboratory in which their reality content could be tested.

DOUBLETAKE is an exhibition in which certain works appear in public spaces outside the Hayward Gallery. The extension of the exhibition site into the city of London and into London's air waves (through Juan Muñoz' radio presentation) must not be misinterpreted as self-assured, expansive action or as a kind of aggressively educational incursion of art into everyday spaces. Instead, a certain self-evidence of approach erases the line between inside and outside, in keeping with the exhibition theme of 'collective memory'.

The spectacle, if it is one, derives from the same material as the context in which it takes place. In 1985 and 1987, Reinhard Mucha made an enormous, elaborate installation using desks, chairs, neon tubes, ladders, dollies, mirrors, cables, and tape. It took the form of a ferris wheel at the Kunstverein in Stuttgart, and became a carousel at the Kunsthalle in Basel. The artist metaphorically exploited a recycled accumulation of institutional paraphernalia. The extreme investment of labour testifies to a mind that wants to escape the logic of commodification in order to celebrate a purposelessness in which miracle and void collide.

The power of recognition merges with a concept of material that takes up the philosophy of the readymade and the *objet trouvé,* but is more inclusive and – more importantly – explores sociopsychological underpinnings. Thus the song that issues from Jon Kessler's oversized music box on one of the Hayward Gallery's sculpture courts is material, as are the countless variations on language in the works of such artists as Glenn Ligon, Mike Kelley, Tim Rollins + K.O.S. and Simon Patterson. Kessler's kinetic object is of an almost proud shabbiness as it blares its tyrannical and familiar melody at the city's neighbouring buildings.

The works in DOUBLETAKE rely on immediate effects that could be circumscribed by words like puzzling, bewildering, disturbing, gently startling, unbalancing, spellbinding. Everything looks so very familiar, yet its meaning eludes us or crosses over into regions that are charged with the paradox of familiar uncharted territory. It is like recognising a piece of our own clothing worn by someone else.

We are reminded of the old battle cry *Epater le bourgeois* but ironically its thrust has been inverted. It would seem that the shock-effect, once aimed at the 'middle class' from an ex-centric stance, is now being fired from within and gradually spreading out in concentric circles. While *épater* in isolation can be translated as 'to astonish someone', the standing expression coined in the mid-19th century in connection with the *bourgeois* has always had an aggressive connotation (see *Le Grand Robert de*

la langue française, 1985, Le Robert, Paris: *Epater le(s) bourgeois = choquer, scandaliser; faire impression*).

The expression stood and still stands for playful provocation, targeting a collective that has congealed into a rigid mass. It is a spontaneous critique of culture *par excellence.* Not bound *a priori* to art, *Epater le bourgeois* has been ennobled and enhanced in literature and the arts. No matter how purposeless the shock-effect, one objective has always inspired it: to shake up, to shatter a mob frozen in false and falsifying positivity by means of a negative integrity developed elsewhere.

Now that there is talk of a crisis of generality, of the disintegration of a binding view, of an all-consuming neutralisation, artists – working from within – find it essential to track down and draw out the contradictions intrinsic to the microtexture of society. If sociologists today conclude that dwindling public spirit might be followed by a more ecologically-based morality, artistic impulses likewise signal a collective self-examination and self-diagnosis, as in the works of Robert Gober, Mike Kelley, or Ann Hamilton. There is also a cautious opposition exemplified by Stephan Balkenhol, Tim Rollins + K.O.S. and Katharina Fritsch, to the notion or even the fact that 'human beings are certainly not human beings but rather a shrivelled form of strategic survival' (Dieter Kamper).

The desire to invent an alphabet of viable primal images is evident. In some works, the past, domesticity, and childhood are placed in that diffuse, grey zone that borders both on the non-institutionalised data and facts of personal biography, and sociological research. These works evoke a sense of body in the context of a cultural mentality. Like a kind of acupuncture, they zero in on the profound deformations inflicted by culture, whether these are manifested in habits of personal hygiene or the discipline of ersatz love (Robert Gober, Mike Kelley).

Tradition, heritage, and culture are sources of conservative edification. In DOUBLETAKE, however, we see an active commitment to exposing what might be called subterranean universals, in disillusioned but not defeatist reassessment of the 1968 slogan, *Sous le pavé il y a la plage* – under the pavement lies the beach.

(Translation: Catherine Schelbert)

LYNNE COOKE

The Site of Memory

'... elephants know where to go to die, led there by the memory of something that hadn't happened to them ... We're not elephants, or salmon that swim upstream to cold water, and memory isn't an instinct, but after a while, once the thing has happened, the event, gesture, the word spoken or withheld, it becomes a fact in your body that may not be physical but is returned to as if it were an instinct...'

LYNNE TILLMAN, *Fixing Memory, 1987*

I

Rachel Rosen is saved at the end of *Blade Runner* by Deckard acquiescing to her passionate conviction that the family photographs she possesses are indeed the source of authentic memories. And since in Ridley Scott's version of the tale it is by the presence of memories, and their attendant emotions, that humans are distinguished from replicants, or simulated humans, she crosses over and is accepted as human. For all their affectivity these are, nonetheless, false memories since the figures pictured in the photographs are not Rachel's relatives, nor could she herself have been actually present. And yet, Deckard reasons, given the depth of her belief in these images, and the intensity with which she has invested in them, they have become for her as potent as genuine memories. If this opens up the worrying prospect (for him) that there is little to distinguish fabricated memories and experiential memories, today this notion no longer belongs to the realm of futuristic fiction: historical memory is currently constructed mostly from, and grows increasingly dependent on, material provided by reproductive technologies – photography, film, video and audio recordings; and private memory has largely been subsumed in public spectacle.

Significantly, it is photography which provides Rachel with access to not merely a past that is not her own but to emotional recollections. This points to the extent to which the shards and shreds of all our memories, even those from childhood, are increasingly supplemented, shaped, structured and recomposed – albeit often unwittingly – by reproductive imagery. Just as it is doubtful whether pristine memo-

23

ries are possible (that is, memories preserved intact from their moment of origin and resistant to subsequent shading and amplification) so seldom can clear distinctions be maintained between those memories based on direct experience and those which are mechanically mediated.

The distinction between the human and the android, the organic and the artificially simulated, lies at the heart of Deckard's dilemma. In the novel written by Philip K. Dick in 1968, *Do Androids Dream of Electric Sheep?*, on which Ridley Scott's film was later loosely based, animals and their substitutes, electronic simulations, play a crucial role in distinguishing between humans and their fabricated doubles. By contrast, in William Gibson's 1980s cyberpunk fiction not only is this distinction no longer tenable – cyborgs (who have replaced humans) coexist alongside beings with diverse types and degrees of artificial intelligence – but, perhaps more importantly, such distinctions carry no moral weight. More numerous outside than within the confines of science fiction, the apologists for Gibson's work, which has now gained cult status, contend that he provides compelling poetic models for comprehending and dealing with the interface between man and the machine, and with the proliferation of technologies in contemporary life: in short, that his work is best read as an eloquent metaphor for contemporary reality rather than as futurist prophecy.[1] In contrast to the (dystopian) vision of many other sci-fi writers such as J. G. Ballard, Gibson's and Dick's tales are parables for the present, the principal difference lying in their attitudes to technoculture. Acknowledging and yet at the same time wary of the irreversible relationship humankind has now established with technology, the feminist historian of science, Donna Haraway, argues that technoculture be explored closely since it offers the risky but valuable opportunity to construct multiple, contradictory selves, and to find 'a way out of the maze of dualisms in which we have explained our bodies and our tools to ourselves'.[2]

Negative projections of a collective mind (and its ancillary, a collective memory) have contended with positive ones throughout the twentieth century. They range across the spectrum from Sigmund Freud's, outlined in *Totem and Taboo,* to those postulated by sociologists in the wake of Durkheim, not least by Maurice Halbwachs whose book devoted to the subject was written in the 1930s.[3] Others include Wilhelm Reich writing on fascism, and Aldous Huxley and Herbert Marcuse, also focusing on totalitarian structures. In the post-war period the continuing presence of such regimes together with recent developments in late capitalism have caused

those on both the left and right to continue to treat it as the locus of ever-growing state or corporate control and expression, and hence as emblematic of the loss of individual autonomy.

The proliferation of computer technology and of technoculture, as well as vast strides in the development of artificial intelligence over the past thirty years, also contribute to contemporary preoccupations with this theme.[4] Each era posits a different image of the mind: the Enlightenment likened it to a watch, the later nineteenth century to a telephone switchboard. The twentieth century favours the notion of a computer, an information storage system. The effectiveness of this analogy is evidenced in the extensive borrowing of terminology from the one discourse for the other. But far more significant than mere comparisons between the organic and the burgeoning technological mind – the greater complexity of the former, the increased speed and power of the latter etc. – is the way this parallel matches current scientific speculation that humans might eventually overcome mortality by downloading their minds into computers, into memory banks. Research in this area has in turn been connected to experiments in cryonics, which freezes the brain as soon as possible after what is currently defined as death until such time as developments will permit either the revival of the molecular framework of the brain alongside a reconstructed body, or, alternatively, the transference of the mind to another storage unit. Irrespective of the form these developments take, in addition to resurrecting the brain it will be necessary to restore memory if the individual is to be fully reconstructed, for the essence of personality lies in memory.[5]

The possibility of storing the mind in computer form has fostered speculation about cloning, erasing, combining and multiplying memory, and hence the self, since with these developments they would have become one and the same. Multiple selves could be created via back-up copies, copies which could be then synthesised, permitting, say, the eradication of certain areas of memory and the borrowing of others from elsewhere as occurs in the conflating and transferring of files on different discs. The shiver of Orwellian horror that once accompanied notions of programming the mind, and of remapping memory, may be somewhat mitigated if, in place of memory lapse, multiple memory is on offer.

Just as bioengineering attempts to alter genetic memory, effecting radical changes of an unprecedented order to the structure not only of the body but also of the mind so, analogously, forms of social engineering might be carried out through

the agency of their societal analogues, memes. Richard Dawkins describes memes as ideas which flow through the culture with great ubiquity, which proliferate and, sometimes, develop seemingly without specific ownership or particularity: jokes, tunes, rumours, certain idiomatic expressions or phrases all belong in this category.[6] As they form part of the collective consciousness of a society or culture so they become available as part of the substance of memories. Utilised by Richard Prince in diverse ways from his rephotographed Marlboro advertisements to his joke paintings, this kind of material also forms the substance of most of Jenny Holzer's texts. But whereas Prince plays it back, deadpan as it were, Holzer orchestrates it so that, like a Greek chorus, it rails, cajoles, bewails, laments, infiltrates....

The deluge of mass cultural material lately pouring into the pool of shared cultural legacy already brimming with mythic, vernacular and folkloric residues, threatens to turn what was once a lake into an ocean; in the process it has reversed the relations between the collective and the private reaches of memory, swamping the latter. Indeed Howard Singerman argues persuasively that the collective memory of any recent generation has now become the individual memory of each of its members, for 'the things that carry the memory are marked not by the privacy, the specificity and insignificance, of Proust's *madeleine,* but precisely by their publicness and their claims to significance'.[7] This abstracting, totalising force submerges private into public images. For example, for the babyboomer generation the assassination of President Kennedy is typically remembered in dual terms, due to media saturation: as if one had actually been there, and simultaneously, where one was on first hearing the news, often via the very same media which soon colonised all memory of it. Overlaid, the two become a composite entity which, in turn, becomes a benchmark in the individual's personal experience. For this same generation Oliver Stone's latest film, *J. F. K,* serves as a further means of remapping memories, in that its substitution of an idealised, heroic DA for the far more flawed figure of the actual District Attorney, Jim Garrison, facilitates the kinds of nostalgic reminiscences that currently do duty for historical knowledge.

Jon Kessler's work wryly plays on this kind of manufactured nostalgia particularly as it informs memories attached to music, and not least to hit parade favourites. In *The Millenium Machine* the rapidity with which the blanket of sentiment smothers recollection is parodied through the re-creation of the tune *Those were the Days* by an archaic instrument of mock-heroic proportions. Like so much else that is fabricated

fantasy, the bright patina on this song, played endlessly since its debut barely twenty-five years ago, may prove far from durable when subject to the indifferent forces of nature.

What he considers the falsity, repression and hypocrisy underpinning aspects of this communal cultural legacy fuels Mike Kelley's art. Those cherished toys that populate recollections of childhood never resemble the stuffed animals that had to be discarded because they were dirty, dishevelled and old; those that survive the bruisings of affectionate use are much too uncomfortable to be mementoes, Kelley contends. 'Because dolls represent such an idealized notion of the child, when you see a dirty one you think of a fouled child. And so you think of a dysfunctional family. In actuality', he continues, 'that's a misreading, because the doll itself is a dysfunctional picture of a child. It's ... an impossible ideal produced by a corporate notion of the family.'[8] The Freudian tenet that culture is built on repression is dear to Kelley, whose focus on toys serves to underline the hypocrisy in the notion of the innocence of childhood, and the sublimation of sexual passion. In confronting the adult's halcyon collective notion of childhood, and his or her reconditioned memories of the infant's first manifestations of affection and regard, with the soiled and worn residual evidence Kelley stirs actual memories, many of which are buried almost beyond recall, and therefore acknowledgement. The sullied toy becomes metaphorically the site of a conflict between the wish for mint condition dreams and the stained memories of actuality.

Stephan Balkenhol, Robert Gober and Katharina Fritsch seek to step beyond the hallmarks of their particular grouping and the confines of their precise socio-cultural moment without, however, denying either the rootedness of their apperceptions of the world or the identifiability of the locale internalised in their imaginations.

Katharina Fritsch's images are usually sparked by a haunting personal memory but she so reduces and pares them that finally they approximate the tropes of what Jean-Paul Sartre, in his discussion of the work of Nathalie Sarraute, refers to as the 'commonplace'.[9] They retain a high specificity for Fritsch herself while taking on the generality of the folkloric emblem, the mythic symbol, or the childish fantasy. Many of Robert Gober's images, too, by his own account stem from dreams, but are then stripped and condensed into simple handmade forms: a bed, crib, chair, or a sink. Were they not handmade, were they the thing itself – either the actual pre-

27

existing object, or a comparable readymade on which the memory was based – it is unlikely they would be as resonant, as imbued with loss and longing as the replica. An image at one remove, Gober's version substitutes the reassuring recognisability that pertains to the model or standardised form for the unsettling accidents attendant on specificity.

Stephan Balkenhol strives toward a generic image: in the prototype of, for example, a standing man, a bust of a woman, or a relief of a head, he hopes to find a common language that necessarily carries with it recollections of its past embodiments. Fischli and Weiss move between these two extremes of attitude, at moments parodying the stereotypes and clichés that are the hallmarks equally of the exotic and of the celebrated landmark, of the momentous icon and of the trivial tourist snapshot. On other occasions their regard for this pathetic paraphernalia of mundane experience is positively affectionate. Overall, it becomes unimportant whether the objects they employ are actual or imitated, real or illusory, they will always have the tenor of a *déjà-vu,* of the already-known, the recognised if not quite recollected.

II

Scarlett, the much vaunted sequel to Margaret Mitchell's runaway hit of 1936, quickly climbed to the top of the best seller list in Britain and the United States, and possibly in others of the thirty countries where *Gone With the Wind* is currently available. With sales of some 28 million copies to date, Mitchell's novel ranks second only to the Bible in numbers of purchases: the movie by David Selznick based on the novel has been seen by many millions more. Notwithstanding a huge and skilfully engineered publicity campaign, *Scarlett's* success must nevertheless largely be attributed to the cult value of its predecessor. That that book is typically recalled as a romantic tale of love in the Confederate South rather than as a polemical right-wing racist vision presumably would lead few to suspect that Alexandra Ripley, working closely with Mitchell's estate in the production of the sequel, would be asked to sign a contract which stipulated that there be no instances of miscegenation in her follow-up tale: in response to questions about this her agent explained that no sexual perversion was to enter the book.[10] For many white readers *Gone With the Wind* forms the very basis of their understanding of the South, of the Civil War and Confederate culture. Ripley's opportunistic spin-off does little to enhance or question that knowledge.

Fiction is not history. Bound not by the same ties to fact and verifiability, fiction can, nevertheless, also aspire to reveal the truth. For those who have little or no access to their own history, or whose history has been written by others, memory often provides the best access and hence is often the best means of reconstructing the past. Slave narratives – autobiographies, recollections and memoirs – provide much of the key material for resurrecting the history of the first generations of African Americans in the United States. This same body of testimonials forms the literary heritage of writers such as Toni Morrison who seek to retrieve the inner lives of their forebears. In Morrison's own writing the memory of past experience is crucial to the recreating of a world as not only lived but experienced and felt by black people. For her the very act of imagination is intrinsically bound up with memory: 'You know, they straightened up the Mississippi River in places, to make room for houses and liveable acreage. Occasionally the river floods these places. "Floods" is the word they use but in fact it is not flooding, it is remembering. Remembering where it used to be. All water has a perfect memory and is trying to get back to where it was. Writers are like that; remembering where we were, what valley we ran through, what the banks were like, the light that was there and the route back to our original place. It is emotional memory – what the nerves and the skin remember as well as how it appeared. And a rush of imagination is our "Flooding".'[11]

Mitchell emphasised the massive amount of fact checking that she thought verified her account of the past but it is arguably what she omitted that proves most falsifying: and in the novel there is nothing equivalent to the emotional memory on which Morrison rests her case for presenting the truth. Narelle Jubelin also engages with the ways in which another, an alternative, history may be served through memory. Amongst her subjects are civic monuments, memorials to the heroes of the past, as well as awe-inspiring scenic vistas which pay homage to the sublime in nature. Jubelin renders these renowned images in petit-point, transferring them not only from the realm of high culture – fine art – to the more lowly one of anonymous craft, but from the public arena to the domestic. Placing them in old frames aids in rendering them as keepsakes and, consequently, drastically changes the perspective. Filtered through a refined screen of tiny stitches their rhetoric is unwoven; the memorial becomes a memento.

Glenn Ligon drew on dreambooks for a sequence of small works in which a three-digit number is added to a monochrome ground. If the origins of abstract

painting lay in a search for a transcendental metaphysical content the dreambooks also were the means to future well-being. Dream images would be looked up in the lexicon which provided a corresponding number for each motive, a number on which to bet in the lottery. Morrison's fond recollections of her grandmother's temporary successes when gambling on her granddaughter's dreams, like Ligon's own memories, belong to a shared history whose texture, as in Jubelin's work, is at once unassuming, richly patterned and sustaining.[12]

In her series known as *Ghosts* Sophie Calle utilises personal memory with all its lapses and misrepresentations to build a composite portrait for absent masterpieces. Whether this lifesize substitution represents a great impoverishment, whether the usual recourse to a small photograph beside the official notice that documents the museum's removal of the picture is preferable, whether the viewer's own memories are more desirable, are all questions the spectator is left to ponder. To propose that notwithstanding the inaccuracies inherent in these visual and verbal recollections they may still be preferred over factual documentation is, however, to uphold the emotional truths of memory.

Aldo Rossi similarly seems to weigh memory against history, and to find the latter wanting. His recurring forms and images based on elemental stereometries have an almost archaic simplicity of form: for Rossi such signature motifs as the unadorned column function symbolically as both relic and as a fundamental element of architecture. Using them repeatedly attests to his wish to preserve and revitalise primal memories over his concerns for historical reconstruction. He treats civic architecture as a kind of stage for life and its monuments as persistent and consistent symbolic artefacts. Via these motifs his works become imbued with a familiarity that cannot quite be pinpointed: since their origins cannot be located in any one particular place at any given moment, since they are at once known and yet not identifiable, displaced and yet free-floating, they get attributed to the site of memory.

III

Boyd Webb's photographs speak often to a malfunctioning in genetic memory as much as to ecologically and environmentally generated disasters, whereas for Ann Hamilton the rootedness of bodily memory in biological memory is a source of valuable if almost forgotten, or lost, knowledge. By incorporating living systems

into her work she attempts to re-establish these bonds, in contradiction to Webb, whose mordant vision has a dystopian air more akin to that of Ballard.

The integrity of memory that is rooted in the body, that seems to stretch back beyond, or before, language in different ways fascinates Gary Hill as it does Hamilton. If all experience is inscribed in language some is inscribed retrospectively. Not only are some of the infant's earliest experiences named and identified when, and if, recalled much later on, but perhaps the earliest experiences – both psychic and corporeal – have left prelinguistic imprints which can still be traced. When focusing on the formative role of language in shaping experience, Hill has been led to split language as structure and sound off from language as sense or meaning: *Inasmuch As it is Always Already Taking Place* (1990) makes present, proximate and continuous what is available to sight only as distant, partial, and abstracted images. The filtering effect of the screen is countered by the comforting sound of the voice even when it is reduced to a nonspecific language, reduced, that is, below the threshold of comprehensibility. In the piece he proposes to make for DOUBLETAKE, the camera will establish a general impression of probing the body in close up, as if rubbing its way along it, burrowing into the body, excavating images in some quasi-elemental way that Hill likens to tilling the soil, an approach as paradoxical in effect as if the subject were x-rayed in an attempt to get a bigger, fuller picture. Far from serving to reveal what is otherwise unavailable (which is what details normally do) being drawn in in this case will not result in exposure but in a form of embeddedness. Offsetting this effect of immersion, a very rapid flickering and switching of the focus will be interspersed across the monitors as if the mechanism were not mindful, and hence not respectful, of what it was that was under examination. Ensuring that the viewer is alerted to the medium that is serving to make the idea concrete, Hill seeks to provide neither new images about the body nor a new way to see old images but, instead, a kind of seeing from within, one that might meld knowing about the body with knowing within the body.

In Ann Hamilton's *Malediction* (1991) the maze of wine-stained cloths which the viewer had to negotiate in order to enter into the principal exhibition space slowed his or her pace to one commensurate with the unhurried rhythms of the quasi-ritualistic gestures of the artist, seated at a refectory table in the inner room. More agent than performer, Hamilton shaped handfuls of raw dough day after day with the imprint of her mouth. Subsequently baked, these small rounded loaves became

31

emblems conflating the staff of life with language as formed in the body. In giving shape to what is otherwise incoherent and inchoate experience the mind fills the space left empty by the body. Positioned at some distance across the gallery was the lid to a wicker casket (of a type traditionally used to remove the dead from their homes to the morgue prior to burial) that itself lay on the central table and served as a receptacle for the pellets of dough. Issuing from the wall just above the casket lid was a voice, reading in a steady unbroken stream, redolent of the monotonous waves made by a habituated initiate intoning the liturgy almost by rote. The gist of what was being conveyed as distinct from what was actually said was picked up through the senses rather than as information given in direct speech. Engaging with *Malediction* depends on digesting the initial sensory responses prior to analysing its content.

The recurrent longing for a return to something more deeply rooted, to something seemingly earlier and hence primal, has led, as the anthropologist Mircea Eliade has pointed out, to a host of different but related responses over the twentieth century.[13] In psychoanalytical terms it becomes a concern with the primitive in the case of civilisation and with the child in respect to the individual psyche. Other theories have recourse instead to accounts of originary myths, to legendary first births, to creation stories. A similar account couched in evolutionary terms might speculate on biologically based relationships connecting mankind with nature and with other species; that is, it might delve into bodily based, sensorily determined experiences. Yet all these primal or originary or prelinguistic needs imply some kind of mnemonic basis. Just as certain impulses, instincts and functions of the mind are thought by neurologists to belong to older parts of the brain so certain types of memory experience might be located in the other zones of the body.

Some theorists, including Elaine Scarry, define bodily memory as certain skills that cannot be easily eradicated such as riding a bicycle or playing the violin, as well as certain types of stance or social behaviour that are culturally signified.[14] Research into the ways in which bodily memories are differently affected when the mind suffers short or long-term neural amnesia has recently aroused considerable interest via the writings of A. R. Luria, Oliver Sacks and others. Through such studies ways of knowing about the body can be contrasted from ways of knowing with the body. If the former is defined as intellectual or spiritual knowledge, the latter, a dynamic physical and material relationship with the body, is experiential, though

both of course are socially constructed: we learn to feel our bodies in particular ways, we don't feel 'naturally'. Like Gary Hill's work, Ann Hamilton's often involves an attempt to focus on this knowing through the body.

By contrast, in recent works by Robert Gober and by Jeff Koons, the stress falls on what the body means rather than what it is. In Gober's art this takes the form of life casts in wax. Sometimes the body fragment is then clothed, at other times it is overlaid with another form – a musical score, an outgrowth of candles – or riddled with drainholes. The hyper-reality of these truncated bodyparts takes on an unnerving presence when they are set either in a pristine white gallery space, or alternatively in the theatrical *mise-en-scène* of an oppressively patterned wall-papered room. They seem to flaunt a level of reality that is normally consigned to the diorama, or the wax-works museum, and flagrantly ignore the mediated realism that traditionally pertains in the art museum. As in a confusion of nakedness with nudity, this provides an opening metaphor for considering what is usually expurgated, and consequently for what gets consigned elsewhere as inappropriate or unsuitable.

Jeff Koons touches on taboos in a somewhat different way. His recent images of himself and his wife Ilona Staller straddle the usually clear segregation of the erotic from the pornographic. The term eroticism is conventionally used as a euphemism for upmarket pornography because it is less specific and less suggestive of actual sexual activity. That which is expressed in a literary language or expensive photography and consumed by the upper middle class becomes erotica; the cheap stuff, which cannot pretend to any purpose other than arousing the viewer, is simply porn.[15] Koons' images are inserted into the current debate in which pornography is being attacked from both the left and right. His tactic is to up the ante by coperforming with his wife whose career is based on her former roles as a porn star. In part, this makes any notions of exploitation problematic since these are not the anonymous performers typical of this genre but individuals who astutely position themselves within it. The contradictions faced by the liberal in a censorious regressive period, the divisions widening between various sectors of feminism on this subject, the uncomfortable aligning of sectors of the left and right over just this issue are all brought to the surface in these works. A defence of pornography as a genre (which is not the same as defending most of what pornography currently consists of) might be grounded in the idea that an art of bodily affect can give a knowledge of the body that other art cannot. Koons seems to strive to keep all at the

level of discussion rather than of affectivity, however. The chilly sterility in the stagey presentation, like the formulaic acting out of a routine procedure, ensures that the results are far from libertarian. They do not warrant defence in the way that say the writings of Sade do as major artistic achievements, but rather as gestures which demonstrate how circumscribed much bodily based experience has become in recent times.

<div align="center">IV</div>

The apprehension of a work of art takes place against a background of/within a complex scheme of references mostly drawn from our memories of previous experiences, generating an interaction between the two. As we accommodate a new stimulus, 'the signs that constitute it and on which we have repeatedly focused our attention ... reach a sort of saturation point', Umberto Eco writes, 'after which they begin to lose their edge, to look dull, whereas in fact it is our sensibility that has become temporarily dulled. Similarly, the memories which we have integrated into our new perception, instead of remaining the spontaneous products of a stimulated mind, are eventually turned by habit into ready-made schemes, endlessly rehashed summaries. The process of aesthetic pleasure is thus blocked and the contemplated form is reduced to a conventional formula on which our overexercised sensibility can now rest.' After years of looking at a certain acclaimed work of art, there comes a moment, Eco argues, 'when the work is beautiful to us only because we have long considered it such: and the enjoyment we now draw out of it is merely the memory of the pleasure we once felt while contemplating it. In fact, it no longer stirs any emotion and is thus unable to entice our imagination or our intelligence into new perceptual adventures.'[16] Its form being temporarily exhausted, it needs to be put into quarantine for a time, he suggests, before it can reawaken fresh and authentic reponses.

Yet it is just this kind of overly familiar acquiescence, this predictability that borders on the stale, that Philip Taaffe toys with. In *Le Quattro Stagioni,* he manoeuvres an almost lethargic semi-automatic response through several registers without at the same time pretending to radical revitalisation. This etiolated savouring of one's memories of one's former responses requires a kind of distance that Taaffe's paintings deliberately refuse to sustain. As the viewer draws close as if seeking to be fully enveloped in the experience, the mood is spiked; what seemed at a

34

distance seamless is revealed at close quarters as a fractured and layered collage; what appeared hitherto an easy relaxed sensuality is revealed as the product of intricate and sustained labour. The seductions of the decorative and the decadent, for that is what Eco in effect passes over as inadmissable, are accorded their due without being succumbed to.

Neither attempting to squeeze some last squeak of novelty by the unexpectedness of his conjunctions of borrowed form, nor harvesting that moment of reverie when, as Eco says, pleasure resides in a memory of a previous experience rather than in an active experience itself, Julio Galán melds diverse cultural images together so that in reweaving images of the past he may forge an identity for himself. From the amalgam of eclectic cultural quotation a chameleon emerges, a mercurial, multiple persona. Tim Rollins + K.O.S. work in the opposite direction, salvaging works from Eco's quarantine to regalvanise them in the present and to reaffirm their continuing centrality. They discover through their collaborative examination an unexpected relevance to their own often marginalised positions that others, for who these texts are an assumed part of their cultural legacy, never manage to unearth for themselves. That they work, however, equally within mainstream literature and with other, selected, classics from the realms of children's literature – *Black Beauty*, for example – and from popular culture – as in the *X-Men* comics series – indicates how necessary is a constant revision of the canon, how much its viability depends on its being dusted and tested and struggled over.

In their performances the Wooster Group also typically splinters hallowed texts to the point of rewriting them, and even remaking them, against the grain of their guiding premises, assumptions and presuppositions. As with the work of Rollins + K.O.S., memory of the 'original' is crucial to a fuller understanding: it is presupposed in the reappraisal – 'reproduction' is the term that the director Elizabeth LeCompte prefers – that the text undergoes. The authority of the original is undermined, yet the original is respected to the extent that its manipulation is openly announced by such strategies as having one of the actors, all of whom read their lines rather than memorise them, indicate that they now 'turn to page 45'. Amalgamated and collaged with material drawn from a diversity of other extraneous sources, these deliberately piecemeal and precarious constructions are bracketed together to form a tenuous narrative as idiosyncratic as that forged, in Kathy Halbreich's vivid metaphor, by a frantic channel changer sampling from dozens of

different programmes.[17] Recognition of the genres, the clichés and stereotypes from which this imported material is culled is crucial to the viewer's ability to patch for him- or herself, to give provisional shape to the maelstrom of matter pitched into that insubstantial communal space linking players and audience.

Something analogous occurs in the sampling that Christian Marclay incorporates into his performances which often involve improvised interactions between live musicians and prerecorded material. Borrowing techniques and strategies from rappers, Marclay dexterously overlays snatches and fragments of records played simultaneously on several turntables as he both responds to and counterpoints with the musicians, treating the turntables themselves as instruments. Playing on the borderline of the familiar and the recognisable, he teases recollection whilst simultaneously precluding any full-bodied relapse into unimpeded identification. As the performance pulls the viewer relentlessly forward in real time the echoes of elusive past moments can be caught only by a kind of attention that deliberately splits off part of what is heard from its novel context: even so emotional engagement is always sacrificed for no track is sufficiently prolonged to allow clear entry before it is severed by a countersound, a competing claim. Where the Wooster Group actively draws on and invites recollection in order to remap and reappraise, it is involuntary memory that Marclay engages with, teasing responses that cannot be held, cannot be sustained and yet cannot, it seems, be altogether shortcircuited.

Like those strategies devised to activate conscious memory, or to extend the range of what partakes in the collective memory of a culture, systems devoted to the act of memory, to memorising, also have a long tradition in visual representation. Echoes of such mnemonic processes reverberate through the more complex and intricate of Simon Patterson's work. The vast heterogeneous array of names artfully mapped onto a Delta flight plan, for example, is reminiscent of such schematic mnemotechnics as Giulio Camillo's famed *Theatre of Memory,* and as seductive and, ultimately, as arbitrary and idiosyncratic in its methodology.[18] Bracketing the tautological simplicity of most lists while pointing to their monochromatic obviousness – the way, that is, that by so baldly stringing together naked words they, to adapt Proust's description, 'present to us a little picture of things, clear and familiar, like the pictures hung on the walls of schoolrooms … things chosen as typical of everything else of the same sort' – Patterson's chains convey something of the elusive ambiguity of those placenames savoured by the novelist for the manner they

'present to us ... a confused picture, which draws out from the brightness or darkness of their tone, the color in which it is uniformly painted'.[19]

Memory struggles against amnesia in Saint Clair Cemin's works as echoes of the art of the past struggle to reach the surface of the mind, blocked by the wilfully aberrant strangeness that is a hallmark of the artist's sensibility. By eluding straightforward categorisation as sculpture, furniture or *objet d'art,* identity becomes withheld, suspended. In many respects Cemin's approach seems the antithesis of that employed by Andreas Gursky, whose unequivocal, finely detailed documentation of quite familiar, unremarkable scenes, suffused in a tranquil light, seems to conceal no mysteries. With their large formats, seductive tones and lustrous surfaces these works are nonetheless highly arresting. It is a truism that photography records a trace, that it captures an unrepeatable instant; the instants selected in these cases seem markedly devoid of ostensible significance, of symbolic value, of psychological charge, of historical or archival import. Given their detail these photographs are far from easily memorised, though the scenes themselves are readily recognised when reencountered. In inexplicable ways peculiar to certain memorable photographs they stave off that satiation which Eco attributes to over familiarity, in order to renew those subtle pleasures residing in recognition.

V

Rachel Whiteread temporarily fills up the spaces once occupied by ordinary things, things which leave traces of their presence on the substance now preserving their absent form. That she favours wax and plaster which are traditionally the intermediaries chosen for giving a more permanent existence in bronze, or for the models from which once stone carvings would have been carried out by the master's highly skilled assistants, is no accident. On occasion, her casts assume a tomblike character, akin to sarcophagi or mortuary tombs. The evocation of the past life of a thing, which being a thing can manifest its memories only in physical form, in its body, preoccupies Whiteread. Relating in certain ways to the types of objects chosen by Gober, and, in the fact that they are personally meaningful and therefore very carefully chosen, by Fritsch, Whiteread's sculptures differ in that she shuns the assertive sense of presence that characteristically informs the works of the two older artists. By her choice of scale and/or colour Fritsch charges her objects in ways that separate them from ordinary everyday artefacts however much they superfi-

cially resemble them. Whiteread's, by contrast, are elusive; bled of colour and divested of a certain tangible sensuality, they become 'ghosts' in effect. Yet since they invite attention to whatever minute traces of their now absent host remain, identity is restored to them: otherwise they would be merely surrogates, replicants. When memory and imagination invest in them, restoring to them sufficient of their former life, they are able like Rachel Rosen to cross over from the realm of the inanimate to that of the living.

Something similar is proposed in much of Juan Muñoz's work, which seems to combine familiar motifs like the dwarf, the ventriloquist's dummy and the prompter into situations that require the viewer to complete the scenario, to enter and become a participant. His ballerinas and the male puppet-like figures are similarly uprooted, and dispossessed of meaningful contexts. Familiar and yet displaced, Muñoz's images are recognised easily, and even recollected with assurance, but only hesitantly do they reach the threshold of memory for uncertainty marks their entrance into its halls and once inside they are doomed to wander restlessly from chamber to chamber.

Photographs of Freud's study in Vienna, and later in London, show that he arranged his collection of some two thousand small artworks in serried ranks, across his desk, over shelves and in vitrines, in such a way, that is, that his primary object could not have been to see them to their best advantage. Speculating on what motivated his collecting, Louise Bourgeois argues that his reasons were personal rather than professional. Unlike Jung, who constructed a reality from the material culture of the past, Freud found no practical purpose in it; instead, it reassured him of the meaningfulness of his life: 'All the cultures that Freud put together in his collection gave him the hope that history is whole. All civilizations have the right to exist. He could make sense out of history, and that assured him he had a place in it.'[20] Bourgeois contends that Freud might have offered something to artists in their suffering, but he chose not to: he valued art more.

Le Défi (1991) might almost be read as Bourgeois' response to Freud. A large cabinet containing many empty glass bottles, it is composed entirely from found objects. Enveloped in the memories of his patients, Freud was able via his collection to turn his thoughts to history. Bourgeois's own history provides much of the initial impetus for her art to the point where her works are too frequently examined as if they were but the raw material for a case study of her psyche. Yet her collection of

bottles, like her work in general, invites and solicits the memories of others. In *Notes of a Native Son,* in which he records his father's life, as well as his own relationship to his father, James Baldwin writes: 'All of my father's Biblical texts and songs, which I had decided were meaningless, were ranged before me at his death like empty bottles, waiting to hold the meaning which life would give them for me.'[21] His text then fills those bottles. In this novel, as in the work of many contemporary artists, collected memories are offered in the hope of forging a richer, broader, collective biography.

1 For a fuller discussion see Peter Fitting, 'The Lessons of Cyberpunk', in Constance Penley & Andrew Ross, *Technoculture,* Minneapolis, University of Minnesota Press, 1991, pp. 295–315.

2 Donna J. Haraway, 'A Cyborg Manifesto: Science, Technology, and Social-Feminism in the Late Twentieth Century', in *Simians, Cyborgs, and Women: The Reinvention of Nature,* New York, Routledge, 1991, p. 181.

3 Maurice Halbwachs, *The Collective Memory,* New York, Harper and Row, 1980 (1950). Note also Jung's concept of the collective unconscious.

4 See *The Enchanted Loom: Chapters in the History of Neuroscience,* ed. Pietro Corsi, New York, Oxford University Press, 1991.

5 As one scientist put it, 'If I can remember who I am I will continue to exist'. See Ed Regis, *Great Mambo Chicken & the Transhuman Condition,* Reading, Massachusetts, Addison Wesley, 1990. See also Wim Wenders' film, *Until the End of the World* (1991).

6 Dawkins defines memes as 'a unit of cultural inheritance, hypothesized as analogous to the particulate gene and as naturally selected by virtue of its "phenotypic" consequences on its own survival and replication in the cultural environment'. See Rupert Sheldrake. *The Presence of the Past: Morphic Resonance and the Habits of Nature,* New York, Vintage, 1988, p. 370.

7 Howard Singerman, 'Trivia Questions and Lists', in *Remembrance of Things Past,* Long Beach Museum of Art, Long Beach, California, 1986, pp. 11–12.

8 Ralph Rugoff, 'Dirty Toys: Mike Kelley Interviewed', *XX!st century,* vol. 1, no. 1, Winter 1991/92, p. 4.

9 Jean-Paul Sartre, 'Preface', in Nathalie Sarraute, *Portrait of a Man Unknown,* New York, George Braziller, 1958, pp. ix–xiv. See also the extract reprinted on pp. 80–83 in this volume.

10 See Patricia Storace, 'Look Away, Dixie Land', *The New York Review of Books,* 19 Dec. 1991, pp. 24–37.

11 Toni Morrison, 'The Site of Memory', in *Out There: Marginalization and Contemporary Cultures,* eds. Russell Ferguson, Martha Gover, Trinh T. Minh-ha, Cornel West, The New Museum of Contemporary Art, New York/The MIT Press, Cambridge, Massachusetts, 1990, p. 305. The title of this essay has been borrowed from Morrison's article.

12 See 'Toni Morrison', in Charles Ruas, *Conversations with American Writers,* New York, Knopf, 1984, pp. 222–3. I am grateful to Glenn Ligon for bringing this interview to my attention.

13 Mircea Eliade, *Myths, Rites and Symbols,* New York, Harper & Row, 1975. I am grateful to Mike Kelley for bringing this and Singerman's text to my attention.

14 Elaine Scarry, *The Body in Pain,* New York/Oxford, The Oxford University Press, 1985.

15 For a fuller discussion of the issue of pornography see Richard Dyer, 'Coming to Terms', in *Out There,* op. cit., pp. 289–98.

16 Umberto Eco, 'Analysis of Poetic Language', in *The Open Work,* Cambridge, Massachusetts, Harvard University Press, 1989, pp. 37–8.

17 Kathy Halbreich, 'Real Abstract Theater: The Wooster Group', *Parkett,* 17, 1988, p. 98.

18 For a fuller discussion see Francis A. Yates, *The Art of Memory,* Chicago, The University of Chicago Press, 1988 (1966).

19 Quoted in Singerman, op. cit., p. 6.

20 Louise Bourgeois, 'Freud's Toys', *Artforum,* January 1990, p. 113.

21 Quoted in Morrison, 'The Site of Memory', op. cit., p. 303.

An Analogical Anthology

Louise Bourgeois, *Le Défi,* 1991

JACQUES ATTALI

from *Noise: The Political Economy of Music*

'This remarkable absence of texts on music' is tied to the impossibility of a general definition, to a fundamental ambiguity, 'The science of the rational use of sounds, that is, those sounds organized as a scale' – that is how the *Littré,* at the end of the nineteenth century, defined music in order to reduce it to its harmonic dimension, to confuse it with a pure syntax, Michel Serres, on the contrary, points to the 'extreme simplicity of the signals,' 'the message at its extreme, a ciphered mode of communicating universals' as a way of reminding us that beyond syntax there is meaning. But which meaning? Music is a 'dialectical confrontation with the course of time.'

Science, message, and time – music is all of that simultaneously. It is, by its very presence, a mode of communication between man and his environment, a mode of social expression, and duration itself. It is therapeutic, purifying, enveloping, liberating; it is rooted in a comprehensive conception of knowledge about the body, in a pursuit of exorcism through noise and dance. But it is also past time to be produced, heard, and exchanged.

Thus it exhibits the three dimensions of all human works: joy for the creator, use-value for the listener, and exchange-value for the seller. In this seesaw between the various possible forms of human activity, music was, and still is, ubiquitous: 'Art is everywhere, for artifice is at the heart of reality.'

MIRROR

But even more than that, it is 'the Dionysian mirror of the world' (Nietzsche). 'Person-to-person described in the language of things' (Pierre Schaeffer).

It is a mirror, because as a mode of immaterial production it relates to the structuring of theoretical paradigms, far ahead of concrete production. It is thus an immaterial recording surface for human works, the mark of something missing, a shred of utopia to decipher, information in negative, a collective *memory* allowing those who hear it to record their own personalized, specified, modeled meanings, affirmed in time with the beat – a collective memory of order and genealogies, the repository of the word and the social score.

But it reflects a fluid reality. The only thing that primitive polyphony, classical counterpoint, tonal harmony, twelve-tone serial music, and electronic music have in common is the

principle of giving form to noise in accordance with changing syntactic structures. The history of music is the 'Odyssey of a wandering, the adventure of its absences.'

However, the historical and musicological tradition would still, even today, like to retain an evolutionary vision of music, according to which it is in turn 'primitive,' 'classical,' and 'modern.' This schema is obsolete in all of the human sciences, in which the search for an evolution structured in a linear fashion is illusory. Of course, one can perceive strong beats, and we will even see later on that every major social rupture has been preceded by an essential mutation in the codes of music, in its mode of audition, and in its economy. For example, in Europe, during three different periods with three different styles (the liturgical music of the tenth century, the polyphonic music of the sixteenth century, and the harmony of the eighteenth and twentieth centuries), music found expression within a single, stable code and had stable modes of economic organization; correlatively, these societies were very clearly dominated by a single ideology. In the intervening periods, times of disorder and disarray prepared the way for what was to follow. Similarly, it seems as though a fourth (and shorter) period was ushered in during the 1950s, with a coherent style forged in the furnace of black American music; it is characterized by stable production based on the tremendous demand generated by the youth of the nations with rapidly expanding economies, and on a new economic organization of distribution made possible by recording.

STEFAN GEORGE
A Child's Calendar

Our memory of Epiphany and the weeks that followed yield little more than the exotic sight of the Three Wise Men with their gold, frankincense and myrrh, and then the sleigh rides across the frozen river, now one with the level shores. Round Candlemas there was much talk of longer light and the hope of winter's ending. Early in the morning we went to see the wax consecrated. The next day candles were held up before us, and we received a blessing. The carnival at which we wore strange and manycoloured disguises, showed us a topsy-turvy world with men changed into women and human beings into beasts. At dawn, when it was still quite dark, children who carried round loaves speared on tall poles, ushered in Shrove Tuesday. On Ash Wednesday we went up to the altar where the priest dipped his fing-

ers in ashes to sign our foreheads with the Cross. After Mid-Lent-Sunday we watched the farmers start their work in the fields again, and when the sun rose in the trees we sat in a clump of willows, loosened the bark from the shoots by beating them for a long time, and cut notches for flutes and pipes. The swallows returned and the storks. Holy Week came: Altars were stripped, the organ stood silent. The sound of wooden clappers took the place of bells and chimes. On Good Friday we followed the priest and the acolytes and threw ourselves down in the choir to kiss the Cross now laid on the floor. The dusk resounded with the age-old lament over the destruction of the sacred city. Then came Saturday when the Cross was unveiled and Easter heralded with jubilant trumpets. On White Sunday anthems from the tower wakened us early. We went out to see a train of small brides and grooms going forth to partake of the Lord's fare for the first time. They were pale with fear and awe, and this was the only day in the year when even the most stolid among the children were touched with beauty.

End of April we took to the hills and meadows again. Our mother taught us the names and virtues of flowers and herbs, and we were shown the place, high up and hard to get to, where the rare plant dittany grows whose cup brims with white flame by night. Toward evening, in Mary's month, we went to the chapel with wreaths and masses of lilacs to adorn the image of the Queen of Heaven. Here we were taught the two attitudes of prayer: the one with fingers intertwined and lowered to express submission and gratitude, the other with fingers close, tips touching and lifted in praise and supplication. On Corpus Christi a vast procession accompanied the monstrance as it was borne through festive streets, flower-strewn and fragrant with incense, and in the Te Deum our high voices merged with the deeper notes of the men.

Pentecost marked the beginning of summer. The woods and the banks of the river were again alive with song. We carried wine uphill in big stone jugs, were told to cool it in the brook, and then settled down to a merry meal in a round clearing between the spruces. On Saint John's Day we went from house to house to collect kindling and logs. The wood was then loaded on carts, built into great pyres on the hilltops, and lit when it grew dark. We liked to thrust our naked arms through the tongues of fire. During the harvest we went into the fields when the heat of day was over and wove wreaths out of cornflowers. Someone showed us how to make little princesses from poppies turned upside down. There we once heard the reapers sing a song about Woden and did not know why we were suddenly awe-

struck and afraid. It did not occur to us until much later that it was because a god dethroned thousands of years ago was still remembered, while one of today was already being forgotten. Toward the middle of August we followed while the image of the patron saint of our city was carried aloft on a platform from the church to the chapel on the mountain. He wore a mantle of purple velvet, over his shoulders hung the first clusters of ripening grapes. We had put on pilgrims' cloaks trimmed with scallop shells, and each of us held a staff and a bottle of water. But the row of Sundays from Pentecost until Advent brought little change in our year, and they have already paled in our memory. In between came Trinity Sunday – on which sleepwalkers are born and those who foresee the future – the harvesting of the grapes and All Saints' Day, the last festival before the onslaught of fog and cold. During Advent we needed lanterns to go to early Mass when the hymn *Rorate caeli desuper...* was sung, and long weeks were filled with the expectancy of coming Christmas.

ALDO ROSSI

from *A Scientific Autobiography*

One morning, as I was passing through the Grand Canal in Venice on a *vaporetto,* someone suddenly pointed out to me Filarete's column and the Vicolo del Duca and the humble houses constructed where the ambitious palace of this Milanese lord was to have been. I always observe this column and its base, this column that is both a beginning and an end. This document or relic of time, in its absolute formal purity, has always seemed to me a symbol of architecture consumed by the life which surrounds it. I have rediscovered Filarete's column in the Roman ruins at Budapest, in the transformation of certain amphitheaters, and above all as one possible fragment of a thousand other buildings. Probably, too, I am fond of fragments for the same reason that I have always thought that it was good luck to meet a person with whom one has broken ties: it shows confidence in a fragment of ourselves.

But the question of the fragment in architecture is very important since it may be that only ruins express a fact completely. Photographs of cities during war, sections of apartments, broken toys. Delphi and Olympia. This ability to use pieces of mechanisms whose

44

overall sense is partly lost has always interested me, even in formal terms. I am thinking of a unity, or a system, made solely of reassembled fragments. Perhaps only a great popular movement can give us the sense of an overall design; today we are forced to stop ourselves at certain things. I am convinced, however, that architecture as totality, as a comprehensive project, as an overall framework, is certainly more important and, in the final analysis, more beautiful. But it happens that historical obstacles – in every way parallel to psychological blocks or symptoms – hinder every reconstruction. As a result, I believe that there can be no true compensation, and that maybe the only thing possible is the addition that is somewhere between logic and biography.

From *The New York Times,* 11 November, 1991

ITALO CALVINO

from *Invisible Cities*

CITIES & NAMES

Clarice, the glorious city, has a tormented history. Several times it decayed, then burgeoned again, always keeping the first Clarice as an unparalleled model of every splendour, compared to which the city's present state can only cause more sighs at every fading of the stars.

In its centuries of decadence, emptied by plagues, its height reduced by collapsing beams and cornices and by shifts of the terrain, rusted and stopped up through neglect or the lack of maintenance men, the city slowly became populated again as the survivors emerged from the basements and lairs, in hordes, swarming like rats, driven by their fury to rummage and gnaw, and yet also to collect and patch, like nesting birds. They grabbed everything that could be taken from where it was and put it in another place to serve a different use: brocade curtains ended up as sheets; in marble funerary urns they planted basil; wrought-iron gratings torn from the harem windows were used for roasting cat-meat on fires of inlaid wood. Put together with odd bits of the useless Clarice, a survivors' Clarice was taking shape, all huts and hovels, festering sewers, rabbit cages. And yet, almost nothing was lost of Clarice's former splendour; it was all there, merely arranged in different order, no less appropriate to the inhabitants' needs than it had been before.

The days of poverty were followed by more joyous times: a sumptuous butterfly-Clarice emerged from the beggared chrysalis-Clarice. The new abundance made the city overflow with new materials, buildings, objects; new people flocked in from outside; nothing, no one had any connection with the former Clarice, or Clarices. And the more the new city settled triumphantly into the place and the name of the first Clarice, the more it realized it was moving away from it, destroying it no less rapidly than the rats and the mould. Despite its pride in its new wealth, the city, at heart, felt itself incongruous, alien, a usurper.

And then the shards of the original splendour that had been saved, by adapting them to more obscure needs, were again shifted. They were now preserved under glass bells, locked in display cases, set on velvet cushions, and not because they might still be used for anything, but because people wanted to reconstruct through them a city of which no one knew anything now.

46

More decadences, more burgeonings have followed one another in Clarice. Populations and customs have changed several times; the name, the site, and the objects hardest to break remain. Each new Clarice, compact as a living body with its smells and its breath, shows off, like a gem, what remains of the ancient Clarices, fragmentary and dead. There is no knowing when the Corinthian capitals stood on the top of their columns: only one of them is remembered, since for many years, in a chicken run, it supported the basket where the hens laid their eggs, and from there it was moved to the Museum of Capitals in line with other specimens of one collection. The order of the eras' succession has been lost; that a first Clarice existed is a widespread belief, but there are no proofs to support it. The capitals could have been in the chicken runs before they were in the temples, the marble urns could have been planted with basil before they were filled with dead bones. Only this is known for sure: a given number of objects is shifted within a given space, at times submerged by a quantity of new objects, at times worn out and not replaced; the rule is to shuffle them each time, then try to assemble them. Perhaps Clarice has always been only a confusion of chipped gimcracks, ill-assorted, obsolete.

The South Bank, London, around 1945

ROBERT SMITHSON

from 'A Tour of the Monuments of Passaic, N. J.', In *Blasted Allegories:*
An Anthology of Writings by Contemporary Artists

After that I returned to Passaic, or was it the *hereafter* – for all I know that unimaginative sub-
urb could have been a clumsy eternity, a cheap copy of The City of the Immortals. But who
am I to entertain such a thought? I walked down a parking lot that covered the old railroad
tracks which at one time ran through the middle of Passaic. That monumental parking lot
divided the city in half, turning it into a mirror and a reflection – but the mirror kept chang-
ing places with the reflection. One never knew what side of the mirror one was on. There
was nothing *interesting* or even strange about that flat monument, yet it echoed a kind of
cliché idea of infinity; perhaps the 'secrets of the universe' are just as pedestrian – not to say
dreary. Everything about the site remained wrapped in blandness and littered with shiny
cars – one after another they extended into a sunny nebulosity. The indifferent backs of the
cars flashed and reflected the stale afternoon sun. I took a few listless, entropic snapshots of
that lustrous monument. If the future is 'out of date' and 'old fashioned,' then I had been in
the future. I had been on a planet that had a map of Passaic drawn over it, and a rather imper-
fect map at that. A sidereal map marked up with 'lines' the size of streets, and 'squares' and
'blocks' the size of buildings. At any moment my feet were apt to fall through the cardboard
ground. I am convinced that the future is lost somewhere in the dumps of the nonhistorical
past; it is in yesterday's newspapers, in the *jejune* advertisements of science-fiction movies, in
the false mirror of our rejected dreams. Time turns metaphors into *things,* and stacks them
up in cold rooms, or places them in the celestial playgrounds of the suburbs.

GABRIEL GARCÍA MÁRQUEZ
from *One Hundred Years of Solitude*

When José Arcadio Buendía realized that the plague had invaded the town, he gathered
together the heads of families to explain to them what he knew about the sickness of insom-
nia, and they agreed on methods to prevent the scourge from spreading to other towns in

the swamp. That was why they took the bells off the goats, bells that the Arabs had swapped them for macaws, and put them at the entrance to town at the disposal of those who would not listen to the advice and entreaties of the sentinels and insisted on visiting the town. All strangers who passed through the streets of Macondo at that time had to ring their bells so that the sick people would know that they were healthy. They were not allowed to eat or drink anything during their stay, for there was no doubt but that the illness was transmitted by mouth, and all food and drink had been contaminated by insomnia. In that way they kept the plague restricted to the perimeter of the town. So effective was the quarantine that the day came when the emergency situation was accepted as a natural thing and life was organized in such a way that work picked up its rhythm again and no one worried any more about the useless habit of sleeping.

It was Aureliano who conceived the formula that was to protect them against loss of memory for several months. He discovered it by chance. An expert insomniac, having been one of the first, he had learned the art of silverwork to perfection. One day he was looking for the small anvil that he used for laminating metals and he could not remember its name. His father told him: 'Stake.' Aureliano wrote the name on a piece of paper that he pasted to the base of the small anvil: *stake.* In that way he was sure of not forgetting it in the future. It did not occur to him that this was the first manifestation of a loss of memory, because the object had a difficult name to remember. But a few days later he discovered that he had trouble remembering almost every object in the laboratory. Then he marked them with their respective names so that all he had to do was read the inscription in order to identify them. When his father told him about his alarm at having forgotten even the most impressive happenings of his childhood, Aureliano explained his method to him, and José Arcadio Buendía put it into practice all through the house and later on imposed it on the whole village. With an inked brush he marked everything with its name: *table, chair, clock, door, wall, bed, pan.* He went to the corral and marked the animals and plants: *cow, goat, pig, hen, cassava, caladium, banana.* Little by little, studying the infinite possibilities of a loss of memory, he realized that the day might come when things would be recognized by their inscriptions but that no one would remember their use. Then he was more explicit. The sign that he hung on the neck of the cow was an exemplary proof of the way in which the inhabitants of Macondo were prepared to fight against loss of memory: *This is the cow. She must be milked every morning so that she will produce milk, and the milk must be boiled in order to be mixed with coffee to make coffee and*

milk. Thus they went on living in a reality that was slipping away, momentarily captured by words, but which would escape irremediably when they forgot the values of the written letters.

At the beginning of the road into the swamp they put up a sign that said Macondo and another larger one on the main street that said God exists. In all the houses keys to memorizing objects and feelings had been written. But the system demanded so much vigilance and moral strength that many succumbed to the spell of an imaginary reality, one invented by themselves, which was less practical for them but more comforting. Pilar Ternera was the one who contributed most to popularize that mystification when she conceived the trick of reading the past in cards as she had read the future before. By means of that recourse the insomniacs began to live in a world built on the uncertain alternatives of the cards, where a father was remembered faintly as the dark man who had arrived at the beginning of April and a mother was remembered only as the dark woman who wore a gold ring on her left hand, and where a birth date was reduced to the last Tuesday on which a lark sang in the laurel tree. Defeated by those practices of consolation, José Arcadio Buendía then decided to build the memory machine that he had desired once in order to remember the marvellous inventions of the gypsies. The artifact was based on the possibility of reviewing every morning, from beginning to end, the totality of knowledge acquired during one's life. He conceived of it as a spinning dictionary that a person placed on the axis could operate by means of a lever, so that in very few hours there would pass before his eyes the notions most necessary for life. He had succeeded in writing almost fourteen thousand entries when along the road from the swamp a strange-looking old man with the sad sleepers' bell appeared, carrying a bulging suitcase tied with a rope and pulling a cart covered with black cloth. He went straight to the house of José Arcadio Buendía.

Visitación did not recognize him when she opened the door and she thought he had come with the idea of selling something, unaware that nothing could be sold in a town that was sinking irrevocably into the quicksand of forgetfulness. He was a decrepit man. Although his voice was also broken by uncertainty and his hands seemed to doubt the existence of things, it was evident that he came from the world where men could still sleep and remember. José Arcadio Buendía found him sitting in the living-room fanning himself with a patched black hat as he read with compassionate attention the signs pasted to the walls. He greeted him with a broad show of affection, afraid that he had known him at another time

and that he did not remember him now. But the visitor was aware of his falseness. He felt himself forgotten, not with the irremediable forgetfulness of the heart, but with a different kind of forgetfulness, which was more cruel and irrevocable and which he knew very well because it was the forgetfulness of death. Then he understood. He opened the suitcase crammed with indecipherable objects and from among them he took out a little case with many flasks. He gave José Arcadio Buendía a drink of a gentle colour and the light went on in his memory. His eyes became moist from weeping even before he noticed himself in an absurd living-room where objects were labelled and before he was ashamed of the solemn nonsense written on the walls, and even before he recognized the newcomer with a dazzling glow of joy. It was Melquíades.

Aldo Rossi, *Geometria della memoria 2*, 1981

DR. JUDITH RAPOPORT

from 'Paul: Stuck in a Doorway', in *The Boy Who Couldn't Stop Washing*

Paul, aged sixteen, was transferred to our ward from a local psychiatric hospital. They were stymied. Paul 'got stuck in doorways' and they weren't sure how to handle him. At almost any hour, Paul could be found in a doorway, slightly swaying back and forth, with his eyes fixed at the upper corner of the door frame. 'What are you doing?' a ward attendant would ask. 'I'm stuck,' Paul whispered back, without moving. 'I have to do it over again to get it right; I have to do it a certain, a special way.'

'Have to do what?' the attendant would ask.

'Get through the door right,' Paul would answer.

At the NIMH Paul settled into his new room quickly. He politely admired the view, and was pleased with the TV. But Paul's large brown eyes stared out anxiously from under long uncombed bangs, and his brown beret never left his head. After introductions had been made and his mother had left, we came back to talk with Paul. He was no longer fiddling with the TV. Paul was standing motionless in the doorway, looking up and towards the right-hand corner of the door frame. He looked as if he were concentrating terribly hard. But when I spoke, he was completely and adequately in contact. He was surprised when we asked if he was seeing things. 'Of course not, Dr. Rapoport. I just have to do this.' I tugged at his elbow, and he came along with me with, I thought, a certain relief. We sat down to talk.

Paul looked disconcertingly like my younger son. He liked talking to me, was comfortable with my curiosity. He exuded a gentleness and respect that made him special. But Paul was stuck: the thoughts were repeating over and over in his head and his story was hard to follow. He stuttered a little as he told me how glad he was that we had other kids like him. He wanted to meet them. But it was hard for him to explain *how* he got so stuck. During his whole stay with us, he never could get across just what he was going through. Words were hard for him; we could see he was trying to explain. School was hard too. He had tried to write about it, but writing was not easy for him. Something stopped him from getting through doors. I couldn't get a coherent explanation because the situation wasn't coherent for him.

SIGMUND FREUD

from *Totem and Taboo*

No one can have failed to observe, in the first place, that I have taken as the basis of my whole position the existence of a collective mind, in which mental processes occur just as they do in the mind of an individual. In particular, I have supposed that the sense of guilt for an action has persisted for many thousands of years and has remained operative in generations which can have had no knowledge of that action. I have supposed that an emotional process, such as might have developed in generations of sons who were ill-treated by their father, has extended to new generations which were exempt from such treatment for the very reason that their father had been eliminated. It must be admitted that these are grave difficulties; and any explanation that could avoid presumptions of such a kind would seem to be preferable.

Further reflection, however, will show that I am not alone in the responsibility for this bold procedure. Without the assumption of a collective mind, which makes it possible to neglect the interruptions of mental acts caused by the extinction of the individual, social psychology in general cannot exist. Unless psychical processes were continued from one generation to another, if each generation were obliged to acquire its attitude to life anew, there would be no progress in this field and next to no development. This gives rise to two further questions: how much can we attribute to psychical continuity in the sequence of generations? and what are the ways and means employed by one generation in order to hand on its mental states to the next one? I shall not pretend that these problems are sufficiently explained or that direct communication and tradition – which are the first things that occur to one – are enough to account for the process. Social psychology shows very little interest, on the whole, in the manner in which the required continuity in the mental life of successive generations is established. A part of the problem seems to be met by the inheritance of psychical dispositions which, however, need to be given some sort of impetus in the life of the individual before they can be roused into actual operation. This may be the meaning of the poet's words:

'Was du ererbt von deinen Vätern hast,

Erwirb es, um es zu besitzen!'*

The problem would seem even more difficult if we had to admit that mental impulses could

be so completely suppressed as to leave no trace whatever behind them. But that is not the case. Even the most ruthless suppression must leave room for distorted surrogate impulses and for reactions resulting from them. If so, however, we may safely assume that no generation is able to conceal any of its more important mental processes from its successor. For psycho-analysis has shown us that everyone possesses in his unconscious mental activity an apparatus which enables him to interpret other people's reactions, that is, to undo the distortions which other people have imposed on the expression of their feelings. An unconscious understanding such as this of all the customs, ceremonies and dogmas left behind by the original relation to the father may have made it possible for later generations to take over their heritage of emotion.

* [Goethe, *Faust*, Part I: 'What thou hast inherited from thy fathers, acquire it to make it thine.']

Gary Hill, *Why Do Things Get in a Muddle? (Come on Petunia)*, 1984, still from videotape

MIRCEA ELIADE

from *Myths, Rites, and Symbols*

We cannot refrain from thinking of the significance that the 'return to the past' has acquired in modern therapeutics. Psychoanalysis especially has found out how to use, as its chief curative method, the memory, the recollection of the 'primordial events.' But, within the horizons of modern spirituality, and in conformity with the Judæo-Christian conception of historic and irreversible Time, the 'primordial' could mean only one's earliest childhood, the true individual *initium.* Psychoanalysis, therefore, introduces historical and individual time into therapeutics. The patient is no longer seen as an individual who is suffering only because of contemporary and objective events (accidents, bacteria, etc.) or by the fault of others (heredity), as he was supposed to be in the pre-psychoanalytic age; he is also suffering the after-effects of a shock sustained in his own temporal duration, some personal trauma that occurred in the *illud tempus* of childhood – a trauma that has been forgotten or, more exactly, has never come to consciousness. And the cure consists precisely in a 'return to the past'; a retracing of one's steps in order to re-enact the crisis, to relive the psychic shock and bring it back into consciousness. We might translate the operative procedure into terms of archaic thought, by saying that the cure is to begin living all over again; that is, to repeat the birth, to make oneself contemporary with 'the beginning': and this is no less than an imitation of the supreme beginning, the cosmogony. At the level of archaic thought, owing to its cyclic conception of Time, the repetition of the cosmogony presented no difficulty: but for the modern man, personal experience that is 'primordial' can be no other than that of infancy. When the psyche comes to a crisis, it is to infancy that he must return in order to relive, and confront anew, the event from which that crisis originated.

Freud's was a most audacious undertaking: it introduced Time and History into a category of phenomena that had previously been approached from without, rather in the way that a naturalist treats his subject. One of Freud's discoveries above all has had portentous consequences, namely, that for man there is a 'primordial' epoch in which all is decided – the very earliest childhood – and that the course of this infancy is exemplary for the rest of life. Restating this in terms of archaic thinking, one might say that there was once a 'paradise' (which for psychoanalysis is the prenatal period, or the time before weaning), ending with a

'break' or 'catastrophe' (the infantile trauma), and that whatever the adult's attitude may be towards these primordial circumstances, they are none the less constitutive of his being. One would be tempted to extend these observations to take in Jung's discovery of the collective unconscious, of the series of psychic structures prior to those of the individual psyche, which cannot be said to have been forgotten since they were not constituted by individual experiences. The world of the archetypes of Jung is like the Platonic world of Ideas, in that the archetypes are impersonal and do not participate in the historical Time of the individual life, but in the Time of the species – even of organic Life itself…

* * *

Such an urge to *descensus* corresponds to a general tendency of the Western mind at the beginning of the century. One cannot better describe the psychoanalytical technique elaborated by Freud than to say that it is a *decensus ad inferos,* a descent into the deepest and most dangerous zones of the human psyche. When Jung revealed the existence of the collective unconscious, the exploration of these immemorial treasures – the myths, symbols, and images of archaic humanity – began to resemble the techniques of oceanography and speleology. Just as descents into the depths of the sea or expeditions to the bottoms of the caves had revealed elementary organisms long vanished from the surface of the earth, so analysis retrieved forms of deep psychic life previously inaccessible to study. Speleology presented biologists with Tertiary and even Mesozoic organisms, primitive zoömorphic forms not susceptible of fossilization – in other words, forms that had vanished from the surface of the earth without leaving a trace. By discovering 'living fossils,' speleology markedly advanced our knowledge of archaic modes of life. Similarly, archaic modes of psychic life, 'living fossils' buried in the darkness of the unconscious, now become accessible to study through the techniques developed by Freud and other depth psychologists.

HERBERT MARCUSE

from *Eros and Civilization*

If memory moves into the center of psychoanalysis as a decisive mode of *cognition,* this is far more than a therapeutic device; the therapeutic role of memory derives from the *truth value*

Postcard from Hessisches Landesmuseum Darmstadt,
The Animals in Australia and New Zealand

of memory. Its truth value lies in the specific function of memory to preserve promises and potentialities which are betrayed and even outlawed by the mature, civilized individual, but which had once been fulfilled in his dim past and which are never entirely forgotten. The reality principle restrains the cognitive function of memory – its commitment to the past experience of happiness which spurns the desire for its conscious recreation. The psychoanalytic liberation of memory explodes the rationality of the repressed individual. As cognition gives way to re-cognition, the forbidden images and impulses of childhood begin to tell the truth that reason denies. Regression assumes a progressive function. The rediscovered past yields critical standards which are tabooed by the present. Moreover, the restoration of memory is accompanied by the restoration of the cognitive content of phantasy. Psychoanalytic theory removes these mental faculties from the noncommittal sphere of daydreaming and fiction and recaptures their strict truths. The weight of these discoveries must eventually shatter the framework in which they were made and confined. The liberation of the past does not end in its reconciliation with the present. Against the self-imposed restraint of the discoverer, the orientation on the past tends toward an orientation on the future. The *recherche du temps perdu* becomes the vehicle of future liberation.

JEAN PIAGET

from *The Child's Conception of the Universe*

Dan (14) knows nothing of the sociology of primitive peoples and comes of a family entirely free from superstition. The bonds of friendship and confidence which exist between us preclude the possibility of any attempt on his part to deceive us intentionally in relating the memories of his childhood. Dreams he says were for him 'real'. They were 'like another world'. 'Everyone went to bed (in reality) *about the same time and then either one was carried off to another world or else everything changed.*'Dan was quite aware that he remained in his bed, '*but all of myself was outside.*' (We shall find the same expressions given by a child of eight, Fav, in the following section.) The world of dreams was arranged in countries and Dan maintained that he could find the same places in one dream as in another. '*I often had the same dream, about cats. There was a wall, a little train and lots of cats on the wall and all the cats chased me.*' The dream of the cats used

SCARLETT

THE SEQUEL TO
MARGARET MITCHELL'S
GONE WITH THE WIND

BY ALEXANDRA RIPLEY

to frighten Dan, but to return to the real world he had a device which he used in the dream itself: *'I would throw myself on the ground* (in the dream) *and then I would wake up. I was still very frightened* (once awake). *I had the idea that I had been eaten up by the cats.'* A point of particular interest is that Dan used these ideas to explain the stories he was told and conversely he used the stories to coordinate his world of dreams. Thus, like nearly all the children we questioned on the subject, he would explain how fairies, ogres, etc., must at one time have existed, since they are still spoken of in stories today. But, according to Dan, this fairy world still survived in the world of dreams. In particular, the voyage which took one from one's bed to join the dream, 'had something to do with fairy-tales'. 'The magic voyages' of fairy-tales must once have been real, since they were still possible in the dream.

WILLIAM GIBSON
from *Mona Lisa Overdrive*

Tick groaned.

'Well,' Kumiko heard Colin say, 'isn't this interesting?' She turned to him there, astride one of the horses from the hunting print, a stylized representation of an extinct animal, its neck curved gracefully as it trotted toward them. 'Sorry it took me a moment to find you. This is a wonderfully complex structure. A sort of pocket universe. Bit of everything, actually.' The horse drew up before them.

'Toy,' said the thing with Kumiko's mother's face, 'do you dare speak to me?'

'Yes, actually, I do. You are Lady 3Jane Tessier-Ashpool, or rather the *late* Lady 3Jane Tessier-Ashpool, none too recently deceased, formerly of the Villa Straylight. This rather pretty representation of a Tokyo park is something you've just now worked up from Kumiko's memories, isn't it?'

'Die!' She flung up a white hand: from it burst a form folded from neon.

'No,' Colin said, and the crane shattered, its fragments tumbling through him, ghost-shards, falling away. 'Won't do. Sorry. I've remembered what I am. Found the bits they tucked away in the slots for Shakespeare and Thackeray and Blake. I've been modified to advise and protect Kumiko in situations rather more drastic than any envisioned by my original designers. I'm a tactician.'

'You are nothing.' At her feet, Tick began to twitch.

'You're mistaken, I'm afraid. You see, in here, in this ... folly of yours, 3Jane, I'm as real as you are. You see, Kumiko,' he said, swinging down from the saddle. 'Tick's mysterious macroform is actually a very expensive pile of biochips constructed to order. A sort of toy universe. I've run all up and down it and there's certainly a lot to see, a lot to learn. This ... person, if we choose to so regard her, created it in a pathetic bid for, oh, not *immortality,* really, but simply to have her way. Her narrow, obsessive, and singularly childish way. Who would've thought it, that Lady 3Jane's object of direst and most nastily gnawing envy would be Angela Mitchell?'

'Die! You'll die! I'm killing you! Now!'

'Keep trying,' Colin said, and grinned. 'You see, Kumiko, 3Jane knew a secret about Mitchell, about Mitchell's relationship to the matrix; Mitchell, at one time, had the potential to become, well, very central to things, though it's not worth going into. 3Jane was jealous...'

The figure of Kumiko's mother swam like smoke, and was gone.

'Oh dear,' Colin said. 'I've wearied her, I'm afraid. We've been fighting something of a pitched battle, at a different level of the command program. Stalemate, temporarily, but I'm sure she'll rally...'

Tick had gotten to his feet and was gingerly massaging his arm. 'Christ,' he said, 'I was sure she'd dislocated it for me...'

'She did,' Colin said, 'but she was so angry when she left that she forgot to save that part of the configuration.'

Kumiko stepped closer to the horse. It wasn't like a real horse at all. She touched its side. Cool and dry as old paper. 'What shall we do now?'

'Get you out of here. Come along, both of you. Mount up. Kumiko in front, Tick on behind.'

Tick looked at the horse. 'On that?'

C. G. JUNG

from *Flying Saucers: A Modern Myth of Things Seen in the Skies*

Things can be seen by many peoply independently of one another, or even simultaneously, which are not physically real. Also, the association processes of many people often have a parallelism in time and space, with the result that different people, simultaneously and independently of one another, can produce the same new ideas, as has happened numerous times in history.

In addition, there are cases where the same collective cause produces identical or similar effects, i. e., the same visionary images and interpretations in the very people who are least prepared for such phenomena and least inclined to believe in them. This fact gives the eyewitness accounts an air of particular credibility: it is usually emphasized that the witness is above suspicion because he was never distinguished for his lively imagination or credulousness but, on the contrary, for his cool judgment and critical reason. In just these cases the unconscious has to resort to particularly drastic measures in order to make its contents perceived. It does this most vividly by projection, by extrapolating its contents into an object, which then mirrors what had previously lain hidden in the unconscious. Projection can be observed at work everywhere, in mental illnesses, ideas of persecution and hallucinations, in so-called normal people who see the mote in their brother's eye without seeing the beam in their own, and finally, in extreme form, in political propaganda.

Projections have what we might call different ranges, according to whether they stem from merely personal conditions or from deeper collective ones. Personal repressions and things of which we are unconscious manifest themselves in our immediate environment, in our circle of relatives and acquaintances. Collective contents, such as religious, philosophical, political and social conflicts, select projection-carriers of a corresponding kind – Freemasons, Jesuits, Jews, Capitalists, Bolsheviks, Imperialists, etc. In the threatening situation of the world today, when people are beginning to see that everything is at stake, the projection-creating fantasy soars beyond the realm of earthly organizations and powers into the heavens, into interstellar space, where the rulers of human fate, the gods, once had their abode in the planets.

JUDITH WILLIAMSON

from 'Every Virus Tells a Story: The Meaning of HIV & Aids', in *Taking Liberties: AIDS & Cultural Politics*

Nothing could be more meaningless than a virus. It has no point, no purpose, no plan; it is part of no scheme, carries no inherent significance. And yet nothing is harder for us to confront than the complete absence of meaning. By its very definition, meaninglessness cannot be articulated within our social language, which is a system *of* meaning: impossible to include, as an absence, it is also impossible to exclude – for meaninglessness isn't just the opposite of meaning, it is the end of meaning and threatens the fragile structures by which we make sense of the world.

What has this to do with AIDS? As the intentionless HIV virus enters our highly coded culture, saturated as it is with teleological structures, narratives that seem to be going somewhere, that impossible conflict between meaninglessness and meaning can go in two directions which are not alternatives but feed off each other and oscillate endlessly. Both have a profound effect on the way in which our society represents and perceives AIDS – and, more specifically, the HIV virus, whose attack on the immune system results in the conditions that characterize the syndrome.

In one version, the virus becomes endowed with the purpose it lacks: at its crudest, this can be seen in the retribution theories peddled by Moral Majority figures like Jerry Falwell, who claims that God sent AIDS as a punishment to homosexuals (though babies and haemophiliacs pose more of a problem). But while it is relatively easy to counter hysterical conservatism, it is less easy to pin down the wider sense in which AIDS takes its place within the narrative systems along whose tracks events seem to glide quite naturally, whether in news reports, movie plots or everyday explanations. But even as AIDS is invested with meaning through these structures, that meaninglessness which is thereby negated lurks ominously at the edges of perception, at once a threat, and a constant spur, to the formation of explanatory fictions.

Of course, there are many things besides the HIV virus which threaten established patterns of thinking. In particular, sex and death are always liable to tear through that familiar fabric which clothes our naked experience – yet these are precisely the events that are most highly coded, most central to so many fictions. They are also inevitably linked with

AIDS: sex as a means of HIV transmission, death as its probable outcome. It is no coincidence that sex and death are events of the body; the point at which we meet, and are a part of, the material world, no longer imposers of meaning on it but imposed upon by its meaninglessness.

Homosexuality, too, which threatens the socially endorsed structure of the family (also a narrative: grow up, get married, have children, repeat…) is inextricably linked with first-world perceptions of AIDS and HIV. So one way and another the AIDS discourse of our society is structured and coded precisely to fend off transgressions, or what Julia Kristeva has called 'the weight of meaninglessness', the *abject* which cannot be contemplated except as something to be ejected from the self.

My argument, then, is that in the dominant perceptions of HIV/AIDS in our culture two (related) things happen. On the one hand, the HIV virus enters a kind of Noddy-land of narrative meaning, where it takes on particular characteristics, goals and functions – even 'preferences'. On the other, however, it joins the morass of unthinkability in which homosexuality is already (for many people) placed, a Gothic territory where fears are flung out into a sort of mental wasteland beyond the castle walls of the ego. […]

After teaching and writing about films for many years I am convinced that the structures we call 'genres' within fiction are not restricted to movies and novels but also characterize the 'structures of feeling', to borrow Raymond Williams's phrase, of our everyday life. If a genre can broadly be defined as a pattern of narrative and imagery, then the patterns of almost all film genres can be found in press reporting, ordinary conversation, general perceptions of political and personal events. Narrative structures are enormously important to our way of thinking: we like things to have a beginning, a middle and an end, we like events to have a point, to seem to be going somewhere. *Closure* is the word used in literary criticism to describe this finished, purposeful feel of fictional narratives. And, of course, fictional structures *are* purposeful – nothing happens by chance in a book or film, every detail is there to further the story in some way.

So genres are groups of narratives that share a particular structure of concerns and characteristics, and involve particular sets of images. The two that I want to argue are most mobilized around AIDS are Horror and Melodrama. Horror in films is closely linked to the Gothic in novels, that genre which was so popular in the eighteenth and nineteenth centuries, where demons and monsters threaten the innocent, and nature – including human

nature – is constantly fearsome. The other modern genre of film and television which is constantly employed in 'sympathetic' understandings of AIDS is melodrama – a form whose sentimentality is in many ways the flip side of Horror's brutality. Historically, both the Gothic and the Sentimental were strands within Romanticism: a mode which above all else heroizes the individual and – as is evident in so many well-known Romantic poems – seeks a purpose in Nature. Cut off from society, the individual is located within a natural world which may threaten (in Gothic terms) or embrace (in Sentimental) him (and it usually is him); but this natural world is never neutral.

There is a further genre which is often associated with the writing and understanding of AIDS, and may also appear as an antidote or counter-plot in horror or melodrama, and that is the detective story. A search for sources is a large part of the teleological or goal directed mode of thinking which characterizes both rationalist/modernist thought, and, of course, all fictional narratives – which, being finished constructs, always *do* have a predetermined goal. But the classic horror film, for example, involves a search for specialist forms of knowledge: in most vampire films, a Goodie has at some stage to find an ancient, leather bound volume which explains how to put a stake through the heart of a vampire and usefully mentions that demons can't stand garlic or the sign of the cross. More recent forms of Horror also involve specialist knowledge, for example, that zombies don't like fire. These horror-knowledge antidotes are no more daft than some of the things people think will protect them against AIDS. The relevant point here is that in thinking of horror we are accustomed to expecting specialist knowledge to allow comprehension, control and, ultimately, elimination of the threat. Medical knowledge is most frequently seen in this light, as if each problem were a keyhole merely waiting for a particular key. And a central part of the knowledge that the detective/scientist must unravel is that of origins. Whodunnit?

Recorded in fall 1967 by Rosa Jean Tomlinson from Mary Minter, sixty-nine, a black resident of Atlanta who was reared near Jonesboro, Clayton County.

ANONYMOUS

'The Tar Baby', in *Story Tellers: Folktales & Legends from the South*

Well, once there was a rabbit bothering around and eating up a man's cabbages. So the man kept on, he could never catch him. He'd always try, try, and try. So he thought of a plan; he

fixed a tar baby. Took some tar and turpentine and made a little doll, and sit him out in the middle of the road to catch this rabbit.

The rabbit went to the little tar baby and says, 'Hey, what a pretty little girl. What's yo' name?' And the tar baby didn't say nothin'. So he said, 'What's your name, I ast you?' And he [the tar baby] didn't say nothin'. Say, 'You think you too cute to talk?' Say, 'Tell me your name, or I'm going to slap you.' So he slapped, and the hand stuck, you know, to the tar baby.

Say, 'Turn me a-loose; turn me a-loose, I said, or I'm going to slap you! I got another big ol' hand over here; I'm gonna slap you with it.' And he slapped him; that hand stuck.

He said, 'Turn me a-loose, turn me a-loose! I've got two hind feet back here; I'm going to kick the stuffings out of you!' So he kicked him, and them two feet stuck.

And so he said, 'Turn me loose, turn me loose! I got a big old head: I'm gonna butt your brains out!' The baby didn't say anything, so he butted him and his head stuck.

So a fox came by. The fox and the rabbit didn't get along so well nohow, so the fox was really glad to see him all there with the tar baby. It just tickled the fox, and he laid down and rolled, he just laughed, thinking of what to do with the rabbit. He was gonna get him, you know, gonna get away with him. So he says, 'I'm gonna pull you a-loose, and I'm gonna drown you.'

Rabbit says, 'Please drown me, just drown me; do anything but throw me in the briar patch.'

And the fox said, 'It ain't no water around here. I'm gonna hang you up in a tree.'

'Well, hang me up in a tree, hang me in a tree; just do anything except throw me in the briar patch.'

And so he says, 'Well, I'm gonna cut your ears off.'

'Cut 'em off, feet, everything, cut everything off; just don't throw me in the briar patch.'

And so the fox didn't have nothing to work with nohow, so he says, 'Well, I'm just gonna throw you in the briar patch.' So he slung him over in the briar patch.

And the rabbit jumped up and run around and says, 'Thank ya, thank ya, thank ya, for I was bred and borned in the briar patch, I was bred and borned in the briar patch!'

So the fox he watched, looked and looked; that rabbit sittin' there cross-legged with a chaw of tobacco in his mouth. And the fox was so sick; the rabbit, he just sittin' back laughing. 'Ha, ha, ha, ha, he, he, he, he!'

So that was the last of that.

TONI MORRISON

from *The Bluest Eye*

It had begun with Christmas and the gift of dolls. The big, the special, the loving gift was always a big, blue-eyed Baby Doll. From the clucking sounds of adults I knew that the doll represented what they thought was my fondest wish. I was bemused with the thing itself, and the way it looked. What was I supposed to do with it? Pretend I was its mother? I had no interest in babies or the concept of motherhood. I was interested only in humans my own age and size, and could not generate any enthusiasm at the prospect of being a mother. Motherhood was old age, and other remote possibilities. I learned quickly, however, what I was expected to do with the doll: rock it, fabricate storied situations around it, even sleep with it. Picture books were full of little girls sleeping with their dolls. Raggedy Ann dolls usually, but they were out of the question. I was physically revolted by and secretly frightened of those round moronic eyes, the pancake face, and orangeworms hair.

The other dolls, which were supposed to bring me great pleasure, succeeded in doing quite the opposite. When I took it to bed, its hard unyielding limbs resisted my flesh – the tapered fingertips on those dimpled hands scratched. If, in sleep, I turned, the bone-cold head collided with my own. It was a most uncomfortable, patently aggressive sleeping companion. To hold it was no more rewarding. The starched gauze or lace on the cotton dress irritated any embrace. I had only one desire: to dismember it. To see of what it was made, to discover the dearness, to find the beauty, the desirability that had escaped me, but apparently only me. Adults, older girls, shops, magazines, newspapers, window signs – all the world had agreed that a blue-eyed, yellow-haired, pink-skinned doll was what every girl child treasured. 'Here,' they said, 'this is beautiful, and if you are on this day 'worthy' you may have it.' I fingered the face, wondering at the single-stroke eyebrows; picked at the pearly teeth stuck like two piano keys between red bowline lips. Traced the turned-up nose, poked the glassy blue eyeballs, twisted the yellow hair. I could not love it. But I could examine it to see what it was that all the world said was lovable. Break off the tiny fingers, bend the flat feet, loosen the hair, twist the head around, and the thing made one sound – a sound they said was the sweet and plaintive cry 'Mama,' but which sounded to me like the bleat of a dying lamb, or, more precisely, our icebox door opening on rusty hinges in July. Remove the cold and stupid eyeball, it would bleat still, 'Ahhhhhh,' take off the head, shake out the saw-

dust, crack the back against the brass bed rail, it would bleat still. The gauze back would split, and I could see the disk with six holes, the secret of the sound. A mere metal roundness.

Grown people frowned and fussed: 'You-don't-know-how-to-take-care-of-nothing. I-never-had-a-baby-doll-in-my-whole-life-and-used-to-cry-my-eyes-out-for-them. Now-you-got-one-a-beautiful-one-and-you-tear-it-up-what's-the-matter-with-you?'

How strong was their outrage. Tears threatened to erase the aloofness of their authority. The emotion of years of unfulfilled longing preened in their voices. I did not know why I destroyed those dolls. But I did know that nobody ever asked me what I wanted for Christmas. Had any adult with the power to fulfill my desires taken me seriously and asked me what I wanted, they would have known that I did not want to have anything to own, or to possess any object. I wanted rather to feel something on Christmas day. The real question would have been, 'Dear Claudia, what experience would you like on Christmas?' I could have spoken up, 'I want to sit on the low stool in Big Mama's kitchen with my lap full of lilacs and listen to Big Papa play his violin for me alone.' The lowness of the stool made for my body, the security and warmth of Big Mama's kitchen, the smell of the lilacs, the sound of music, and since it would be good to have all of my senses engaged, the taste of a peach, perhaps, afterward.

From *The Dummy that Lived* by L. Frank Baum, Chicago, 1905

GEORGES BATAILLE

from *Visions of Excess*

Production is the basis of a social *homogeneity*. *Homogeneous* society is productive society, namely, useful society. Every useless element is excluded, not from all of society, but from its *homogeneous* part. In this part, each element must be useful to another without the *homogeneous* activity ever being able to attain the form of activity *valid in itself*. A useful activity has a *common denominator* with another useful activity, but not with activity *for itself*.

The common denominator, the foundation of social *homogeneity* and of the activity arising from it, is money, namely, the calculable equivalent of the different products of collective activity. Money serves to measure all work and makes man a function of measurable products. According to the judgment of *homogeneous* society, each man is worth what he produces; in other words, he stops being an existence *for itself:* he is no more than a function, arranged within measurable limits, of collective production (which makes him an existence *for something other than itself*).

But the *homogeneous* individual is truly a function of his personal products only in artisan production, where the means of production are relatively inexpensive and can be owned by the artisan. In industrial civilization, the producer is distinguished from the owner of the means of production, and it is the latter who appropriates the products for himself: consequently, it is he who, in modern society, is the function of the products; it is he – and not the producer – who founds social *homogeneity*.

Thus in the present order of things, the *homogeneous* part of society is made up of those men who own the means of production or the money *destined for their upkeep or purchase*. It is exactly in the middle segment of the so-called capitalist or bourgeois class that the tendential reduction of human character takes place, making it an abstract and interchangeable entity: a reflection of the *homogeneous things* the individual owns.

This reduction is then extended as much as possible to the so-called middle classes that variously benefit from realized profit. But the industrial proletariat remains for the most part irreducible. It maintains a double relation to homogeneous activity: the latter excludes it – not from work but from profit. As agents of production, the workers fall within the framework of the social organization, but the homogeneous reduction as a rule only affects their wage-earning activity; they are integrated into the psychological *homogeneity* in terms

of their behavior on the job, but not generally as men. Outside of the factory, and even beyond its technical operations, a laborer is, with regard to a *homogeneous* person (boss, bureaucrat, etc.), a stranger, a man of another nature, of a non-reduced, nonsubjugated nature.

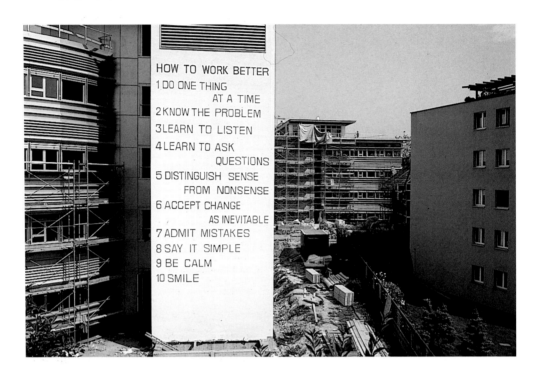

Peter Fischli / David Weiss,
commissioned work on the façade of an office building in Zürich, 1991

ELFRIEDE JELINEK
from *Lust*

The Direktor expects to be able to phone home at any time at all, including office hours, to check that he is being thought of. He is as inevitable as death. Always to be at the ready. To tear her heart out. To lay her heart on her tongue like the host, and to show that the rest of her body is in readiness for her lordandmaster, as he expects of his wife. To this end he keeps the bridle on his bride. He keeps her under his watchful eye. He sees everything, he has a right to examine whatever he wishes. For his prick it bloometh in its prickly bed, and on his

lips the kisses bud and blow. But first he has to take a good look at everything, to work up an appetite. For you eat with your eyes too. And nothing remains concealed, excepting heaven unto the eyes of the dead, who placed their hope in it at the last. Which is why the Man wants to show her heaven on earth. And why the woman cooks and bakes. You can get away with requesting it three times a week, her famous Linz gateau. And as for the famous Linz dictator, the Man can voice his regard for him in the back room at the pub, where those assembled take solace in History's merciful way of repeating itself, and look into a glass, darkly, to see what the future has in store for the leadership of the land.

VLADIMIR VOINOVICH

from *The Fur Hat*

Whenever Yefim Semyonovich Rakhlin was asked what his next book would be about, he lowered his eyes, smiled and replied, 'I always write about decent people.'

And his whole manner suggested that he wrote about decent people because he himself was decent and saw only the good in life, that the bad did not exist for him.

His heroes were members of the 'fearless' professions – geologists, mountain climbers, cave explorers, volcanologists, polar research workers – men who struggle against the elements, that is, against a force free of ideology. This allowed Yefim to tell stories in which regional, district, and Party committees were little involved (a point of great pride with him), and at the same time to get his books out as fast as he wrote them (approximately one book per year), without any trouble with the censor or editors. Many books went on to become plays, film scripts, and radio and television shows. This had a very positive effect on the author's standard of living.

His five-room apartment was packed with imports: the living-room set was Rumanian, the bed Arabian, the upright piano Czechoslovakian, the television Japanese, and the refrigerator was from Finland. He decorated the apartment with objects brought back from his many expeditions. Hung on walls, spread on the floor, arranged on windowsills, bookshelves, or special stands were antlers, a walrus tusk, a stuffed penguin, a polar-bear skin, a

giant tortoise shell, dried starfishes and sea urchins, skeletons of deep-sea fish, Nanay moccasins, and Buryat and Mongolian clay figurines. As he showed the collection to visitors, Yefim would say reverently, 'This was a gift from the petroleum workers. This, from the cartographers. This, from the speleologists.'

In the press, Yefim's works were usually received favorably. True, it wasn't the literary critics who reviewed them, as a rule, but those same spelunks (as his friend Kostya Baranov called all fearless people, regardless of their profession). The reviews – I suspect Yefim wrote them himself – were all similar and had titles like 'A Needed Book,' 'Useful Reading', or 'A Fact Everyone Should Know.' They said that the author knew the life of his heroes well and that he described the romance of their dangerous and difficult work authentically.

Yefim assured me that his characters – upright, handsome, one better than the next – were true to life. I was skeptical.

In my opinion, people everywhere are alike even on an iceberg, a Soviet collective will have its careerists and its stool pigeons, and at least one KGB agent. And then, under conditions of isolation and prolonged separation from their homeland, even people of great courage may finally weaken and exchange jokes of dubious political content. And if their iceberg drifts to some Western shore, they might not all return.

When I expressed this thought to Yefim, he told me hotly that I was wrong: under extreme conditions, decent people rose to the challenge.

'What challenge?' I asked. 'The challenge of returning or the challenge of not returning?'

In the end, Yefim would stop talking and purse his lips. There was no point arguing with me: in order to understand high ideals, one must have them oneself.

In Yefim's novels you invariably had a fire, blizzard, earthquake, or flood – with such medical consequences as burns, frostbitten limbs, and drowning victims in need of resuscitation. The decent people would run, fly, swim, or crawl for help, would unhesitatingly share their blood, skin, extra kidneys, and bone marrow, or display their fearlessness in some other admirable way.

Yefim himself was fearless. He could tumble off a Pamir cliff, nearly drown in a polynya, or get burned fighting a fire at an oil well. At that same time he dreaded the number thirteen, black cats, viruses, snakes, dogs – and tyrants. Everyone he had to ask a favor of was a tyrant. Tyrants, therefore, included magazine editors, the secretaries of the Writers' Union, policemen, janitors, ticket sellers, store clerks, and apartment-house managers.

Whether Yefim approached those tyrants with large or small requests, he would put on such a pitiful face that only the stoniest heart could refuse him. He was always groveling. He groveled for important things, like the reissuing of a book, and for the most unimportant, like a subscription to the magazine *Science and Life.* His campaign to have the *Literary Gazette* observe his fiftieth birthday with an announcement, a photograph, and some sort of medal – one could write an entire short story about that. Even a novella. Yefim was only partly victorious in that battle. The announcement appeared without a photograph, and instead of a medal he got only a certificate of distinction from the Central Trade Union Council.

Yefim did have some metal decorations. Toward the end of the war, by adding a couple of years to his age in his documents (he was fearless even then), he got into the army, although he never made it to the front – his troop train was bombed and he was wounded. For his failure to participate in the war he was given the Victory Over Germany medal. Twenty years and then thirty years later he received anniversary medals for the same thing. In 1970 he got a medal in honor of Lenin's centennial, and in 1971, the Opening Up the Oil and Gas Deposits of Western Siberia medal. This medal was pinned on Yefim by the minister of oil and gas in exchange for a copy of his novel *Oiler,* which had been dedicated, however, to the oil workers of Baku and not of western Siberia. The above-mentioned medals added shine to Yefim's résumé and permitted him to remark modestly in biographical blurbs, 'Have been decorated by the government.' Sometimes instead of 'government' he wrote 'the army.' It sounded better.

BRUCE CHATWIN

from *Utz*

The room was almost in darkness. It was a warm night, and a soft breeze ruffled the net curtains. On the carpet, the animals from the Japanese Palace shimmered like lumps of phosphorescence.

'Marta!' he called. 'A light please!'

Garry Winogrand, *Democratic National Convention*, 1960

The maid came in with a Meissen candlestick, and set it carefully in the centre of the table. She put a match to the candle. Innumerable points of flame were reflected in the walls.

Utz changed the record on the gramophone: to the recitative of Zerbinetta and Harlequin from Strauss's 'Ariadne auf Naxos'.

I have said that Utz's face was 'waxy in texture', but now in the candlelight its texture seemed like melted wax. I looked at the ageless complexion of the Dresden ladies. Things, I reflected, are tougher than people. Things are the changeless mirror in which we watch ourselves disintegrate. Nothing is more age-ing than a collection of works of art.

One by one, he lifted the characters of the Commedia from the shelves, and placed them in the pool of light where they appeared to skate over the glass of the table, pivoting on their bases of gilded foam, as if they would forever go on laughing, whirling, improvising.

Scaramouche would strum on his guitar.

Brighella would liberate people's purses.

The Captain would swagger childishly like all army officers.

The Doctor would kill his patient in order to rid him of his disease.

The coils of spaghetti would be eternally poised above Pulchinella's nostrils.

Pantaloon would gloat over his money-bags.

The Innamorata, like all transvestites everywhere, would be mobbed on his way to the theatre.

Columbine would be endlessly in love with Harlequin – 'absolutely mad to trust him'.

And Harlequin... *The* Harlequin... the arch-improviser, the zany, trickster, master of the volteface... would forever strut in his variegated plumage, grin through his orange mask, tiptoe into bedrooms, sell nappies for the children of the Grand Eunuch, dance in the teeth of catastrophe... Mr Chameleon himself!

And I realised, as Utz pivoted the figure in the candlelight, that I had misjudged him; that he, too, was dancing; that, for him, this world of little figures was the real world. And that, compared to them, the Gestapo, the Secret Police and other hooligans were creatures of tinsel. And the events of this sombre century – the bombardments, blitzkriegs, putsches, purges – were, so far as he was concerned, so many 'noises off'.

'And now,' he said, 'we shall go. We shall go for a walk.'

FEDERICO FELLINI
from *Totò*

The sense of wonder that Totò conveyed was the same as the one that children feel when confronted with a magical event, unusual figures or fantastic animals: the giraffe, the pelican, the sloth; and on top of this came the joy and gratitude at seeing the incredible, the marvellous, the fabulous, real, alive and in front of your very eyes. That unlikely face, a piece of clay that had fallen off the trestle table and been hastily picked up again before the sculptor came back and noticed; that boneless rubber body, the body of a robot, a martian, a cheerful nightmare, a creature from another dimension, that deep, distant, desperate voice; it all amounted to something so unexpected, unheard-of, unpredictable and different, so startlingly infectious, with a dumbstruck stupor, an oblivious feeling of rebellion, a sense of total liberation from plans, rules and taboos, everything legitimate, logically codified and authorized [...]

It has always been said, and you'll still hear it said, that Totò was ill-used by the cinema, and that he was only rarely offered opportunities worthy of his exceptional talent. I don't believe that Totò could have been better, braver, other than he was in the films he made. Totò could only be Totò just as Mr Punch can only be Mr Punch – what else could you expect them to do? The result of centuries of hunger, poverty, illness, the perfect product of an age-long sedimentation process, a kind of extraordinary diamond-forming secretion, a glorious stalactite – that's what Totò was. The arrival point of something lost in time, which ended up, in some sense, outside of time. To intervene in such a glorious end-result, to modify it and force it to become something different, giving it a different identity, a different credibility, granting it a psychology, feelings, enclosing it in a story, would have been not only stupid but damaging and sacrilegious. Short-sightedness on the part of the critics? But isn't that a part of our entire western education, so to speak, which encourages us not to accept things as they are, but to project ourselves into a different perspective, to superimpose ourselves on something alien, cerebral, intellectualized? We can no longer see that Totò is a natural fact, a cat, a bat, something complete in itself, something that is simply the way it is, which can't change – at best you can take a picture of it. In *Il Viaggio di G. Mastorne,* I thought about Totò, but about Totò as he really was. It was a memoir of Totò and Totò cropped up in it. I have never managed to think of a story that demanded the presence of Totò, because Totò didn't

need stories. What would be the point of a story if you had a character like that, with all the stories already written on his face? I would rather have dedicated a little cinematic essay to him, a portrait in motion that showed what he was like, how he was both inside and out, what his skeletal structure was like, what his most sensitive points were, his most resistant and mobile joints. I would have liked to show him in different postures, standing, sitting, horizontal, vertical, clothed, but naked as well, as in a documentary about giraffes, for example, or certain kinds of phosphorescent fish from the depths of the sea. It would have had to be a fantastic interview, an attempt to capture the sense of the extraordinary phenomenon that was Totò [...].

The last memory that I have of him is an edifying little memory straight from the heart. I'm dubbing *8 ½*, or perhaps it's another film, and we're taking a break, everyone sitting around in the little garden of the Scalera eating their lunch. I see Donzelli, a Neapolitan actor, leading Totò towards a little wall where there's a bit of sunlight, he's leading him by the hand, one step at a time as you guide a sick or a blind man. Totò's face is almost entirely hidden behind the big dark glasses that he has worn constantly for a number of years. Donzelli comes up to me and I ask him how Totò is: 'Nothing at all, he can't see us at all, absolutely nothing', and then in a loud voice, turning back to Totò, 'Chief, you know who's here? Fellino [sic], the director, and he's saying hello.' Totò lifts his head, looking up to the sky, and greets me warmly, trying to find my hands, we exchange a few words and then I sit in silence looking at him, he's more magical than ever, impalpable, unreachable. He smiles with that apathetic, resigned smile that the blind have. Then two people from the production team come to get him, one on one side and one on the other, and help him along, almost lifting him off the ground the way a saint would be carried in a procession, or a relic. Driven by a curiosity that is both scientific and sentimental, I go into the studio with them. I want to see how he's going to work under these conditions, I can't believe it. Everything's ready in the studio; helping him through the cables as if through a maze, they lead him to the centre of the powerfully-lit set, help him to put on his little tails jacket, put his bowler on his head, but he's still wearing the glasses over his eyes, he hasn't taken them off. Corbucci, I think it was a film by Corbucci, explains the scene to him. I hear him say to him, 'Go like this, go over there, stop there, tell the joke, then run up to where Enzo Turco is.' Enzo Turco speaks: 'Hi, over here,' making a gesture that disappears into the void. Everything in the right place? More lights go on. Shoot! Clack! And only now does Totò take off his glasses and it's a mira-

cle. The miracle that Totò can suddenly see us, he can see things and people, the plaster marks that set the boundaries of his journey, not two eyes but ten, seeing everything perfectly. And he jumps, pirouettes, escapes into a drawing room full of furniture, a fantastical little robot who throws plates and gives quickfire answers to the questions of Turco, Donelli, Castellani and the members of the troupe who are standing around, the electricians on the scaffolding are biting their lips to keep from laughing, hiding their faces between their hands. Cut. The scene's finished, they're doing a new shot. In the chaos that follows every cut Totò slowly puts his glasses back on and stands waiting for someone to come and get him, and they take him away very slowly, guiding him past the cables, the platforms, the people. That incredible little creature has come back, the one that was taking the sun in the garden not long ago, a disembodied little being, a very gentle ghost returning to darkness, obscurity, solitude.

Totò (BFI stills)

DAVE HILL

from *Prince, a Pop Life*

Then there was the question of race. Prince seems to have inherited the relatively light skin-colour of his natural parents, something which went some way towards helping him avoid being labelled 'black'. Both Mrs Shaw and Mr Nelson reportedly define themselves as black, as do people who know them. Given this, it is an education to observe how a succession of newspaper interviewers built up an image of Prince as some kind of exotic mulatto. 'My dad is black and Italian,' he explained to Dennis Hunt of the *Los Angeles Times* as the *Dirty Mind* tour hit the road in January 1981. The album was Prince's first to stand a real chance with the 'crossover' audience, and opting out of a decisively black identity did him no harm. 'My mum is a mixture of a bunch of things. I don't consider myself part of any race. I'm just a human being, I suppose.' He also declined to reveal his second name, and offered an explanation for inheriting his father's stage handle that was rich in intimations of wounding psychological conflict: 'I think my father was kind of lashing out at my mother when he named me Prince.'

By the time he got into *Rolling Stone* (19 February 1981), his genes had been juggled slightly. 'The son of a half-black father and an Italian mother,' ran the report. On 29 March, the New York *Daily News* had straightened daddy out: 'His mother is Italian. His father, black.' A dramatic picture emerged of underdog making good: 'His music is from the ghetto, with its punctuated street rhythms and simplistic charms.' Prince was, we learned, 'one of nine children struggling to survive, [but] Prince cut away from the hand me down home life to carve out a career of his own at the age of 17'. Pulsating stuff. You have to wonder just what kind of deadpan mischief was going on with some of those interviews. In the Boston *Real Paper* John Nelson was 'half black' again, and Prince was crediting Quaker Oats oatmeal with saving him from malnutrition. Then he was asked to define his greatest ambition. 'Senility,' said Prince; 'I'm close to it now.' [...]

Soon, every aspect of Prince's identity in the world's mind's eye would be bound up with a great morass of rumours and blurred identities, diversions from and refractions of the truth. But the fragments of dubious information that emerged as the reality of his early life are worth close consideration, if only as a yardstick of how far the mythology they comprised would ultimately be stretched. In the quest for biographical 'fact', it is easy to forget that the fictions which always attend celebrity comprise another kind of reality in them-

selves. At the point of actual consumption – when someone hands their cash over the counter and goes home to get cosy with their precious new disc – the legends which circulate round the maker of that record might be said to be the only 'truth' that really counts: the background (dis)information that can confer extra dimensions of meaning upon what is in the grooves.

The monarch of Paisley Park's inclination has been to revel in his own labyrinth of legend, and hide inside it, no matter who stepped up to add new twists from outside his immediate control. His retreat from the entire sector of the media world that deals with context, explanation and analysis would leave him vulnerable to exterior forces clouding the picture he wanted to project of himself. But the thing about that picture was that it was already pretty cloudy in the first place. So maybe nothing mattered so long as his own enigma was magnetic enough. All attempts to spoil the image he promoted could only draw people's gaze back to that image again and again. And that meant more raw material to conjure with. The important thing was to make that image *matter* – and never let it crack.

JEAN PAUL SARTRE

from Preface to *Portrait of a Man Unknown* by Nathalie Sarraute

Nathalie Sarraute seeks to safeguard her sincerity as a storyteller. She takes her characters neither from within nor from without, for the reason that we are, both for ourselves and for others, entirely within and without at the same time. The without is neutral ground, it is the *within* of ourselves that we should like to be for others and that others encourage us to be for ourselves. This is the realm of the *commonplace.* For this excellent word has several meanings. It designates, of course, our most hackneyed thoughts, inasmuch as these thoughts have become the meeting place of the community. It is here that each of us finds himself as well as the others. The commonplace belongs to everybody and it belongs to me; in me, it belongs to everybody, it is the presence of everybody in me. In its very essence it is generality; in order to appropriate it, an act is necessary, an act through which I shed my particularity in order to adhere to the general, in order to become generality. Not at all *like* everybody, but, to be exact, the *incarnation* of everybody. Through this eminently social type of adher-

ence, I identify myself with *all* the others in the indistinguishableness of the universal. Nathalie Sarraute seems to distinguish three concentric spheres of generality: the sphere of character, the sphere of the moral commonplace, and the sphere of art – in particular, of the novel. If I pretend to be a rough diamond, like the father in the *Portrait of a Man Unknown,* I confine myself to the first sphere; if a father refuses to give money to his daughter, and I declare: 'He ought to be ashamed of himself; and she's all he's got in the world... well, he can't take it with him, that's certain,' then I take my position in the second sphere; and if I say of a young woman that she is a Tanagra, of a landscape that it is a Corot, or of a family chronicle that it's like something from Balzac, I am in the third. Immediately the others, who have easy access to these domains, approve and understand what I say: upon thinking over my attitude, my opinon, and my comparison, they give it sacred attributes. This is reassuring for others and reassuring for me, since I have taken refuge in this neutral and common zone which is neither entirely objective – since after all I am there as the result of a decree – nor entirely subjective – since I am accessible to everybody and everybody is at home there – but which might be called both subjectivity of the objective and objectivity of the subjective. And since I make no other claim, since I protest that I have nothing up my sleeve, I have the right, on this level, to chatter away, to grow excited, indignant even, to display my own personality, and even to be an 'eccentric,' that is to say, to bring commonplaces together in a hitherto unknown way; for there is even such a thing as the 'hackneyed paradox.' In other words, I am left the possibility of being subjective within the limits of objectivity, and the more subjective I am between these narrow frontiers, the more pleased people will be; because in this way I shall demonstrate that the subjective is nothing and that there is no reason to be afraid of it.

In her first book, *Tropismes,* Nathalie Sarraute showed that women pass their lives in a sort of communion of the commonplace: 'They were talking: "They had the most terrible scenes and arguments, about nothing at all. All the same, I must say, he's the one I feel sorry for. How much? At least two million. And that's only what Aunt Josephine left... Is that so...? Well, I don't care what you say, he won't marry her. What he needs is a wife who's a good housekepper, he doesn't even realize it himself. I don't agree with you. Now, you listen to what I say. What he needs is a wife who's a good housekeeper... housekeeper... housekeeper..." People had always told them so. That was one thing they had always heard. They knew it: life, love and the emotions, this was their domain, their very own.'

Here we have Heidegger's 'babble,' the 'they,' in other words, the realm of inauthenticity. Doubtless too, many writers, in passing, have brushed against the wall of inauthenticity, but I know of none who, quite deliberately, has made it the subject of a book: inauthenticity being anything but novelistic. Most novelists, on the contrary, try to persuade us that the world is made up of irreplaceable individuals, all exquisite, even the villains, all ardent, all different. Nathalie Sarraute shows us the wall of inauthenticity rising on every side. But what is behind this wall? As it happens, there's nothing, or rather almost nothing. Vague attempts to flee something whose lurking presence we sense dimly. *Authenticity,* that is, the real connection with others, with oneself and with death, is suggested at every turn, although remaining invisible. We feel it because we flee it. If we take a look, as the author invites us to do, at what goes on inside people, we glimpse a moiling of flabby, many-tentacled evasions: evasion through objects which peacefully reflect the universal and the permanent; evasion through daily occupations: evasion through pettiness. I know of few more impressive passages than the one which shows us 'the old man,' winning a narrow victory over the specter of death by hurrying, barefooted and in his nightshirt, to the kitchen, in order to make sure whether or not his daughter has stolen some soap. Nathalie Sarraute has a protoplasmic vision of our interior universe: roll away the stone of the commonplace and we find running discharges, slobberings, mucous; hesitant, amoeba-like movements. Her vocabulary is incomparably rich in suggesting the slow centrifugal creeping of these viscous, live solutions. 'Like a sort of gluey slaver, their thought filtered into him, stiching to him, lining his insides.' *(Tropismes, p. 11).* And here we have the pure woman-girl, 'silent in the lamplight, resembling a delicate, gentle, underseas plant, entirely covered with live, sucking valves' *(idem, p. 50).* The fact is that these groping, shamefaced evasions, which seek to remain nameless, are also relationships with others. Thus the sacred conversation, the ritualistic exchange of commonplaces, hides a 'half-voiced conversation,' in which the valves touch, lick and inhale one another. There is first a sense of *uneasiness:* if I suspect that you *are not,* quite simply, quite entirely, the commonplace that you are saying, all my flabby monsters are aroused: I am afraid. [...]

Nathalie Sarraute's books are filled with these impressions of terror: people are talking, something is about to explode that will illuminate suddenly the glaucous depths of a soul, and each of us feels the crawling mire of his own. Then, no: the threat is removed, the danger is avoided, and the exchange of commonplaces begins again. Yet sometimes these

commonplaces break down and a frightful protoplasmic nudity becomes apparent. […] Nothing happens, in fact: nothing ever happens. With one accord, the speakers draw the curtain of generality before this temporary weakness. Thus we should not look in Nathalie Sarraute's book for what she does not want to give us: for her the human being is not a character, not first and foremost a story, nor even a network of habits, but a continual coming and going between the particular and the general. Sometimes the shell is empty. Suddenly there enters a 'Monsieur Dumontet,' who having knowingly rid himself of the particular, is reduced to a delightful, lively assemblage of generalities. Whereupon everybody takes a deep breath and hope returns: so it was possible, so it was still possible! A deathly calm accompanies him into the room. […]

Is this psychology? Perhaps Nathalie Sarraute, who is a great admirer of Dostoïevsky, would like to have us believe that it is. For my part, I believe that by allowing us to sense an intangible authenticity, by showing us the constant coming and going from the particular to the general, by tenaciously depicting the reassuring, dreary world of the inauthentic, she has achieved a technique which makes it possible to attain, over and beyond the psychological, human reality in its very *existence*.

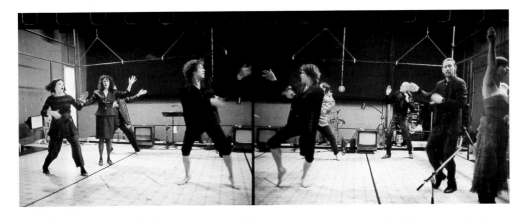

From *Brace up!* The Wooster Group, directed by Elizabeth LeCompte, 1991
(Photo: Paula Court)

RUPERT SHELDRAKE

from introduction to *The Presence of the Past: Morphic Resonance and the Habits of Nature*

> 'They say that habit is second nature.
> Who knows but nature is only first habit?' Blaise Pascal, *Pensées*

This book explores the possibility that memory is inherent in nature. It suggests that natural systems, such as termite colonies, or pigeons, or orchid plants, or insulin molecules, inherit a collective memory from all previous things of their kind, however far away they were and however long ago they existed. Because of this cumulative memory, through repetition the nature of things becomes increasingly habitual. Things are as they are because they were as they were.

Thus habits may be inherent in the nature of all living organisms, in the nature of crystals, molecules, and atoms, and indeed in the entire cosmos.

A beech seedling, for example, as it grows into a tree takes up the characteristic shape, structure, and habits of a beech. It is able to do so because it inherits its nature from previous beeches; but this inheritance is not just a matter of chemical genes. It depends also on the transmission of habits of growth and development from countless beech trees that existed in the past.

Likewise, as a swallow grows up, it flies, feeds, preens, migrates, mates, and nests as swallows habitually do. It inherits the instincts of its species through invisible influences, acting at a distance, that makes the behaviour of past swallows in some sense present within it. It draws on and is shaped by the collective memory of its species.

All humans too draw upon a collective memory, to which all in turn contribute.

If this view of nature is even approximately correct, it should be possible to observe the progressive establishment of new habits as they spread within a species.

For example, when birds such as blue tits learn a new habit, such as stealing milk from milk bottles by tearing off the bottle caps, then blue tits elsewhere, even beyond the range of all normal means of communication, should show an increasing tendency to learn the same thing.

When people learn something new, such as wind-surfing, then as more people learn to do it, it should tend to become progressively easier to learn, just because so many other people have learned to do it already.

When crystals of a newly synthesized chemical substance, for example a new kind of drug, arise for the first time they have no exact precedent; but as the same compound is crystallized again and again, the crystals should tend to form more readily all over the world, just because they have already formed somewhere else.

In the same way that this inheritance of habits may depend on direct influences from previous similar things in the past, so the memory of individual organisms may depend on direct influences from their *own* past. If memory is inherent in the nature of things, then the inheritance of collective habits and the development of individual habits, the development of the individual's 'second nature,' can be seen as different aspects of the same fundamental process, the process whereby the past in some sense becomes present on the basis of similarity.

Thus, for example, our own personal habits may depend on cumulative influences from our past behaviour to which we 'tune in.' If so, there is no need for them to be stored in a material form within our nervous systems. The same applies to our conscious memories – of a song we know, or of something that happened last year. The past may in some sense become present to us directly. Our memories may not be stored inside our brains, as we usually assume they must be.

All these possibilities can be conceived of in the framework of a scientific hypothesis, which I call the hypothesis of formative causation. According to this hypothesis, the nature of things depends on fields, called morphic fields. Each kind of natural system has its own kind of field: there is an insulin field, a beech field, a swallow field, and so on. Such fields shape all the different kinds of atoms, molecules, crystals, living organisms, societies, customs, and habits of mind.

Morphic fields, like the known fields of physics, are non-material regions of influence extending in space and continuing in time. They are localized within and around the systems they organize. When any particular organized system ceases to exist, as when an atom splits, a snowflake melts, an animal dies, its organizing field disappears from that place. But in another sense, morphic fields do not disappear: they are potential organizing patterns of influence, and can appear again physically in other times and places, wherever and whenever the physical conditions are appropriate. When they do so they contain within themselves a memory of their previous physical existences.

The process by which the past becomes present within morphic fields is called morphic resonance. Morphic resonance involves the transmission of formative causal influences

through both space and time. The memory within the morphic fields is cumulative, and that is why all sorts of things become increasingly habitual through repetition. When such repetition has occurred on an astronomical scale over billions of years, as it has in the case of many kinds of atoms, molecules, and crystals, the nature of these things has become so deeply habitual that it is effectively changeless, or seemingly eternal.

All this obviously contrasts with currently orthodox theories. There is no such thing in contemporary physics, chemistry, or biology as morphic resonance; and the known fields of physics are generally assumed to be governed by eternal laws of nature. By contrast, morphic fields arise and evolve in time and space, and are influenced by what has actually happened in the world. Morphic fields are conceived of in an evolutionary spirit, but the known fields of physics are not. Or at least, until quite recently they were not.

Until the 1960s, the universe was generally believed by physicists to be eternal; so were the properties of matter and of fields; so were the laws of nature. They always had been and always would be the same. But the universe is now thought to have been born in a primordial explosion some fifteen billion years ago and to have been growing and evolving ever since.

Now, in the 1980s, theoretical physics is in ferment. Theories are reaching back into the first moments of creation. Entirely new, evolutionary conceptions of matter and of fields are coming into being.

The cosmos now seems more like a growing and developing organism than like an eternal machine. In this context, habits may be more natural than immutable laws.

PINCKNEY BENEDICT

from 'Washman', in *The Wrecking Yard*

The girl Gandy had called Clementine stood before Washman. She had a big gold pocket watch in her hand, and she dangled it by its chain. It was one of the things that she had brought with her from the house in the valley. She flicked the watch with her finger, and it spun. The sun danced on its bright casing.

'It don't work,' she said. 'There's something wrong with it.'

Washman's back was turned to her. He leaned against the mule's flank, holding its right forefoot between his warped knees, filing the hoof. His canes were on the ground beside him. Washman and the girl were in the shed that stood behind Washman's two-room house. He had told the girl that he raised up the whole homestead himself. She had asked him why this place, and he showed her where a clear stream gushed from a rock face two dozen paces from his door. That was all the answer he gave her.

The mule's ear, the one that Gandy had put a bullet through, was infected, and the side of the mule's head was swollen. The girl thought it looked peculiar and comical with the flesh all taut and bulbous on that side, and the one eye squeezed shut. Washman had told her it would either cure itself or it wouldn't.

Washman wore a plain cotton shirt and a jacket in the cool highland morning. The jacket was tight across his broad humped back. From behind him the girl couldn't see his head, it hung so low. He grunted, put the mule's foot back on the ground, picked up his canes. He turned to face her.

'What don't work?' he said.

'The watch,' she said. 'It runs backward sometimes, and then it runs forward but real, real slow. And one time yesterday I looked and it was running ahead of itself. The minute hand went around three times while I counted ten.'

Washman took the watch from her and inspected it. There was a firebird design on the hinged cover, and Washman admired the filigree, but he didn't recognize it as a match to the crest on Gandy's silk shirt. He popped the heavy watch open, and a little music box inside played a waltz that he enjoyed. He imagined dancing to the tune with the girl, and wished that he had legs for dancing. He closed the watch and opened it again, and this time it played a different song. He smiled.

'It's got five songs that it plays,' the girl said. 'The part's working okay. It plays the tunes one right after the other.'

Washman handed the watch back to her. 'The clock part won't ever work here,' he said. 'I give up trying to have a clock in this place a long time ago. Use it for a music box, but don't bother keeping time with it. It's something in the rocks around here that jiggers the guts of a timepiece. It's a sort of magnetism.'

'Magnetism,' she said.

'The dirt's thin up here, and the rocks glow at night where they thrust up through it,' he

said. 'The will-o'-the-wisp flits from rock to rock and is never still.' He pointed to the watch. 'And it's got in your little ticker there and played hell with it.'

The girl spun away from him, whistling one of the watch's tunes. She had learned them all by heart sitting in the parlor of Gandy's house. They kept her company up here on the silent mountain and reminded her of those times. The strange spinning of the watch's hands had unhinged her notion of chronology, and she was not sure how long she had been with Washman.

ELAINE SCARRY

from *The Body in Pain: The Making and Unmaking of the World*

THE END OF WAR:

THE LAYING EDGE TO EDGE OF INJURED BODIES AND UNANCHORED ISSUES

The extent to which in ordinary peacetime activity the nation-state resides unnoticed in the intricate recesses of personhood, penetrates the deepest layers of consciousness, and manifests itself in the body itself is hard to assess, for it seems at any given moment 'hardly' there, yet seems at many moments, however hardly, *there* in the metabolic mysteries of the body's hunger for culturally stipulated forms of food and drink, the external objects one is willing habitually to put into oneself; *hardly* there but *there* in the learned postures, gestures, gait, the ease or reluctance with which it breaks into a smile; *there* in the regional accent, the disposition of the tongue, mouth, and throat, the elaborate and intricate play of small muscles that may also be echoed and magnified throughout the whole body, as when a man moves across the room, there radiates across his shoulder, head, hips, legs, and arms the history of his early boyhood years of life in Georgia and his young adolescence in Manhattan.

The presence of learned culture in the body is sometimes described as an imposition originating from without: the words 'polis' and 'polite' are, as Pierre Bourdieu reminds us, etymologically related, and 'the concessions of politeness always contain political concessions.' But it must at least in part be seen as originating in the body, attributed to the refusal of the body to disown its own early circumstances, its mute and often beautiful insistence on

absorbing into its rhythms and postures the signs that it inhabits a particular space at a particular time. The human animal is in its early years 'civilized,' learns to stand upright, to walk, to wave and signal, to listen, to speak, and the general 'civilizing' process takes place within particular 'civil' realms, a particular hemisphere, a particular nation, a particular state, a particular region. Whether the body's loyalty to these political realms is more accurately identified as residing in one fragile gesture or in a thousand, it is likely to be deeply and permanently there, more permanently there, less easily shed, than those disembodied forms of patriotism that exist in verbal habits or in thoughts about one's national identity. The political identity of the body is usually learned unconsciously, effortlessly, and very early – it is said that within a few months of life British infants have learned to hold their eyebrows in a raised position. So, too, it may be the last form of patriotism to be lost; studies of third and fourth generation immigrants in the United States show that long after all other cultural habits (language, narratives, celebrations of festival days) have been lost or disowned, culturally stipulated expressions of physical pain remain and differentiate Irish-American, Jewish-American, or Italian-American.

What is 'remembered' in the body is well remembered. When a fifteen-year-old girl climbs off her bike and climbs back on at twenty-five, it may seem only the ten year interval that her body has forgotten, so effortless is the return to mastery – her body, however slender, hovering wide over the thin silver spin of the narrow wheels. So, too, her fingers placed down on piano keys may recover a lost song that was not available to her auditory memory and seemed to come into being in her fingertips themselves, coming out of them after the first two or three faltering notes with ease, as though it were only another form of breathing. Even these nearly 'apolitical' examples are not wholly apolitical, for at the very least there is registered in her body the fact that she lives in a culturally stipulated time (after the invention of bicycles and pianos) and place (a land where these objects are available to the general population rather than to the elite alone, for she is not a princess); someone from an earlier century or from a country without material objects might think – hearing the description of a girl gliding over the ground on round wings, her fingers fanning into ivory shafts that make music as they move – that it was an angel or a goddess that was being described. There exist, of course, forms of bodily memory that are anterior to, deeper than, and in ordinary peacetime contexts beyond the reach of culture. The body's self-immunizing antibody system is sometimes described as a memory system: the body, having once

encountered certain foreign bodies, will the next time recognize, remember, and release its own defenses. So, too, within genetic research, the DNA and RNA mechanisms for self-replication are together understood as a form of bodily memory.

What is remembered in the body is well remembered. It is not possible to compel a person to unlearn the riding of a bike, or to take out the knowledge of a song residing in the fingertips, or to undo the memory of antibodies or self-replication without directly entering, altering, injuring the body itself. So, too, the political identity of the body is not easily changed: if another flag is placed in front of British eyes, it will be looked at or looked away from with eyes looking out from under eyebrows held high. To the extent that the body is political, it tends to be unalterably political and thus acquires an apparent *apolitical* character precisely by being unsusceptible to, beyond the reach of, any *new* political imposition. It is not surprising, for example, that China's national birth control goals have not been easily accepted, 'embodied,' by the residents of Guangdon Province, where the seven-thousand-year-old feudal philosophy of child-bearing often makes ineffective the verbal advocacy of one-child-to-a-couple, even after ten visits, twenty visits, or a hundred visits to the couple from family planners, as well as pledge programs, the promise of bonuses to couples who comply, and the threat of forms of deprivation to erring couples, such as taking away a sewing machine or other important tool from the family household. If a new political philosophy is to be absorbed by a country's population, it is best introduced to those who have not yet absorbed the old philosophy: that is, it is most easily learned by the country's children, whether the shift is in the direction of radical justice (the teaching of racial equality to United States children through school integration) or instead in the direction of radical injustice (the teaching of racial hatred to German children in the Hitler Youth Corps). As Bourdieu writes of even the passing on of cultural 'manners' from one generation to the next, 'The principles em-bodied in this way are placed beyond the grasp of consciousness, and hence cannot be touched by voluntary, deliberate transformation, cannot even be made explicit; nothing seems more ineffable, more incommunicable, more inimitable, and therefore, more precious, than the values given body, *made* body by the transubstantiation achieved by the hidden pedagogy, capable of instilling a whole cosmology, an ethic, a metaphysic, a political philosophy, through injunctions as insignificant as "stand up straight" or "don't hold your knife in your left hand."' Of the many things that might be said about the nature of injury in war, a small number may begin to lead to an explanation for the over-

arching question that confronts us here: the question of how injuring creates an abiding outcome, an outcome that is 'as though' the losers were deprived of the capacity to renew the activity of injuring, even though in almost no case is the losing side actually placed in that position. First, it is not the case that the body is normally apolitical and only becomes political at the moment of war. Not only is a specific culture absorbed at an early age by those dwelling within its boundaries, but (particularly if there is no change in political philosophy) the nation-state will without notice continue to interact on a day-to-day basis with its always embodied citizens. [...]

It may be that the degree to which body and state are interwoven with one another can be most quickly appreciated by noticing the most obvious and ongoing manifestation of that relation such as the fact that one's citizenship ordinarily entails physical *presence* within the boundaries of that country, a relation between body and state that can be overlooked by being too obvious. Or it may instead be that it can best be appreciated by noticing almost random instances of the intricate and specific locations of contact between them. In the United States law of torts, for example, rulings about product liability first began with objects that entered the human body (food, drink) or were directly applied to the body's surface (cosmetics, soap) before being extended to objects in less immediate relation to the body (the container for the food; the lights in a shopping market parking lot there to assure vision and visibility to the shoppers). In United States criminal law, people accused of committing crimes cannot be compelled to incriminate themselves verbally, but can be compelled to incriminate themselves physically (to be physically present for identification in the courtroom, for example, or to provide a sample of blood or hair that may match fragments of these substances found near the person hurt). In United States constitutional law, again to take only one specific example, cases in which the Supreme Court has invoked the 'right of privacy' have tended to be on subjects, directly connected to the human body (issues of conception, contraception, definition of generational relations) rather than issues of psychology, religion, or profession. The specific and intricate interaction of body and state would have equivalents in any nation. It is precisely because political learning is, even in peacetime, deeply embodied that the alteration of the political configuration of a country, continent, or hemisphere so often appears to require the alteration of human bodies through war. But the fact that the human body is political in peace as well as in war (and here we arrive at a second, more important point) does not mean that the body-state relation is in

the two conditions continuous. The nature of that relation in ordinary life, far from norma-lizing what occurs in war, makes compellingly visible by contrast the exceptional nature of going to war. What is first of all visible is the extremity with which or the extreme literalness with which the nation inscribes itself in the body; or (to phrase it in a way that acknow-ledges the extraordinary fact of *the consent* of the participating populations in conventional war) the literalness with which the human body opens itself and allows 'the nation' to be registered there in the wound. While in peacetime a person may literally absorb the political reality of the state into his body by lifting his eyebrows – by *altering* for the sake of and in unselfconscious recognition of his membership in the larger political community the reflex of a small set of muscles in his forehead – now in war he is agreeing by entering a certain ter-rain and participating in certain acts to the tearing out of his forehead, eyebrows, and eyes. That is, though in peace and in war his existence as a political being entails (not simply disembodied beliefs, thoughts, ideas but also) actual physical self-alteration, the form and degree of alteration are incomparable, as is the temporal duration of the alteration. The nation may ordinarily be registered in his limbs in a particular kind of handshake or saluta-tion performed for a few seconds each day, or absorbed into his legs and back in a regional dance performed several days each year; but the same arms and legs lent out to the state for seconds or minutes and then reclaimed may in war be permanently loaned in injured and amputated limbs. That the adult human being cannot ordinarily without his consent be phy-sically 'altered' by the verbal imposition of any new political philosophy makes all the more remarkable, genuinely awesome, the fact that he sometimes agrees to go to war, agrees to permit this radical self-alteration to his body. Even in the midst of the collective savagery and stupidity of war, the idiom of 'heroism,' 'sacrifice,' 'dedication,' 'devotion,' and 'bravery' conventionally invoked to describe the soldier's individual act of consent over his own body is neither inappropriate nor false.

The answer to the question about the duration of the outcome of war in part resides in the duration of the contest activity. What is remembered in the body is well remembered; the bodies of massive numbers of participants are deeply altered; those new alterations are carried forward into peace. So, for example, the history of the United States participation in numerous twentieth-century wars may be quietly displayed across the surviving generations of any American family – a grandfather whose distorted feet permanently memorialize the location and landing site of a piece of shrapnel in France, the feet to which there will always

cling the narration of a difficult walk over fields of corn stubble; a father whose heart became an unreliable pennywhistle because of the rheumatic fever that swept through an army training camp in 1942, at once exempting him from combat and making him lethally vulnerable to the Asian flu that would kill him several decades later; a cousin whose damaged hip and permanent limp announce in each step the inflection of the word 'Vietnam,' and along with the injuries of thousands of his peers assures that whether or not it is verbally memorialized, the record of war survives in the bodies, both alive and buried, of the people who were hurt there. If the war involves a country's total population or its terrain, the history may be more widely self-announcing. Berlin, orange and tawny city, bright, modern, architecturally 'new,' confesses its earlier devastation in the very 'newness' necessitated by that devastation, and in the temporal discrepancy between its front avenues where it is strikingly 'today,' nineteen sixty, seventy, now eighty-five, and the courtyards immediately behind these buildings where time, as though held in place by the still unrepaired bullet holes, seems to have stopped at nineteen forty-five. Berlin, bombed from above and taken block by block. Or again Paris, architecturally ancient, silver-white and violet-blue, announces in the very integrity of its old streets and buildings (their stately exteriors undisturbed by war except by the occasional insertion here and there of a plaque to a fallen member of the Resistance) its survival, its capitulation; just as the very different history of World War I, in which two out of every three young Frenchmen either died or lost a limb, is still visible in all the windows of the subways cars – 'LES PLACES NUMÉROTÉES SONT RÉSERVÉES PAR PRIORITÉ 1° AU MUTILÉS DE GUERRE …' – an inscription that each day runs beneath the standing city as though in counterpoint to and partial explanation for that later story recorded above.

From *Achterland,*
choreography by Anne Teresa
de Keersmaeker, 1991
(Photo: Herman Sorgeloos)

DONNA HARAWAY

from an interview with Constance Penley & Andrew Ross, in *Technoculture*

Andrew Ross: It seems that you are increasingly, in your work, sympathetic to the textualist or constructionist positions, but it's clear also that you reject the very easy path of radical constructionism, which sees all scientific claims about the object world as merely persuasive rhetoric, either weak or strong depending on their institutional success in claiming legitimacy for themselves. Your view seems to be: that way lies madness...

Donna Haraway: Or that way lies cynicism, or that way lies the impossibility of politics. That's what worries me.

Andrew Ross: And your way of retaining political sanity is?

Donna Haraway: Politics rests on the possibility of a shared world. Flat out. Politics rests on the possibility of being accountable to each other, in some nonvoluntaristic 'I feel like it today' way. It rests on some sense of the way that you come into the historical world encrusted with barnacles. Metaphorically speaking, I imagine a historical person as being somehow like a hermit crab that's encrusted with barnacles. And I see myself and everybody else as sort of switching shells as we grow. [laughter] But every shell we pick up has its histories, and you certainly don't choose those histories – this is Marx's point about making history, but not any way you choose. You have to account for the encrustations and the inertias, just as you have to remain accountable to each other through learning how to remember, if you will, which barnacles you're carrying. To me, that is a fairly straightforward way of avoiding cynical relativism while still holding on, again, to contingency.

Constance Penley: In an essay on the history of the sex/gender split you argue that one of the unfortunate results of the antiessentialist position of feminist constructionists is that biology (which you equate with the 'sex' side of the sex/gender split) has been undervalued as a realm of investigation, where it really ought to have been seen as a much more active site for contesting definitions of 'nature' that concern women quite directly. We can see where a sustained investigation of biology is useful for revealing historical and ideological links within science between 'nature' and 'femininity,' but we'd like you to say what role you see biology playing in the future 'reinvention of nature.'

Donna Haraway: This is actually very close to my heart, because there's that cryptobiologist lurking under the culture critic. The simplest way to approach that question is by

remembering that biology is not the body itself, but a discourse. When you say that my biology is such-and-such – or, I am a biological female and so therefore I have the following physiological structure – it sounds like you're talking about the thing itself. But, if we are committed to remembering that biology is a *logos,* is literally a gathering into knowledge, we are not fooled into giving up the contestation for the discourse. I subscribe to the claim of Foucault and others that biopolitical modes of fields of power are those which determine what *counts* in public life, what counts as a citizen, and so on. We cannot escape the salience of the biological discourses for determining life chances in the world – who's going to live and die, things like that, who's going to be a citizen and who's not. So not only do we literally have to contest for the biological discourses, there's also tremendous pleasure in doing that, and to do that you've go to understand how those discourses are enabled and constrained, what their modes of practice are. We've got to learn how to make alliances with people who practice in those terrains, and not play reductive moves with each other. We can't afford the versions of the 'one-dimensional-man' critique of technological rationality, which is to say, we can't turn scientific discourses into the Other, and make them into the enemy, while still contesting what nature will be for us. We have to engage in those terms of practice, and resist the temptation to remain pure. You do that as a finite person, who can't practice biology without assuming responsibility for encrusted barnacles, such as the centrality of biology to the construction of the raced and sexed bodies. You've got to contest for the discourse from within, building connections to other constituencies. This is a collective process, and we can't do it solely as critics from the outside. Gayatri Spivak's image of a shuttle, moving between inside and outside, dislocating each term in order to open up new possibilities, is helpful.

Constance Penley: Well, this brings us to the role of the Cyborg Manifesto in the 'reinvention of nature.' One of the most striking effects of the Cyborg Manifesto was to announce the bankruptcy of an idea of nature as resistant of the patriarchal capitalism that had governed the Euro-American radical feminist counterculture from the early 70s to the mid-80s. In the technologically mediated everday life of late capitalism, you were pointing out that nature was not immune to the contagions of technology, that technology was part of nature conceived as everyday social relations, and that women, especially, had better start using technologies before technology starts using them. In other words, we need technorealism to replace a phobic naturalism. Do you see the cyborg formulation of the nature/technology

question as different from, or falling into the same alignment as, the nature/culture question that you had spent much more of your time exploring as a historian of science?

Donna Haraway: That's an interesting way to put it. I'm not sure what to say about that. What I was trying to do in the cyborg piece, in the regions that you're citing there, is locate myself and us in the belly of the monster, in a technostrategic discourse within a heavily militarized technology. Technology has determined what counts as our own bodies in crucial ways – for example, the way molecular biology had developed. According to the Human Genome Project, for example, we become a particular kind of text which can be reduced to code fragments banked in transnational data storage systems and redistributed in all sorts of ways that fundamentally affect reproduction and labor and life chances and so on. At an extremely deep level, nature for us has been reconstructed in the belly of a heavily militarized, communications-system-based technoscience in its late capitalist and imperialist forms. How can one imagine contesting for nature from that position? Is there anything other than a despairing location? And, in some perverse sense which, I think, comes from the masochism I learned as a Catholic, there's always the desire to want to work from the most dangerous place, to not locate oneself outside but inside the belly of the monster. [laughter]

J.G. BALLARD
from *The Ultimate City*

It was at this time, shortly after he left the cloverleaf by an emergency staircase, that Halloway came across the first of the strange monuments he was later to find all over the city. As he stepped down from the pedestrian exit, he noticed that a nearby parking-lot had been used as a municipal dump. Old tyres, industrial waste and abandoned domestic appliances lay about in a rusty moraine. Rising from its centre was a pyramid of television sets some sixty feet high, constructed with considerable care and an advanced sense of geometry. The thousand or so sets were aligned shoulder to shoulder, their screens facing outwards, the combinations of different models forming decorative patterns on the stepped sides. The whole structure, from base to apex, was invaded by wild elders, moss and firethorn, the clouds of berries forming a huge cascade.

Halloway stared up at the rows of television sets, a pyramid of dead eyes in their worm-riddled cabinets, like the eggs of some voracious reptile waiting to be born from the bland globes embedded in this matrix of rotting organic matter. Pulled apart by the elders, many of the sets revealed their internal wiring. The green and yellow circuitry, the blue capacitors and modulators, mingled with the bright berries of the firethorn, rival orders of a wayward nature merging again after millions of years of separate evolution.

Little more than half a mile away, in a plaza between two office buildings, Halloway found a second pyramid. From a distance it resembled a funeral pyre of metal scrap built from hundreds of typewriters, telex machines and duplicators taken from the offices around the plaza, a monument to the generations of clerks and typists who had worked there. A series of narrow terraces rose one above the other, the tiers of typewriters forming ingenious baroque columns. Brilliant climbing plants, lobster-clawed clematis and honeysuckle with pink and yellow flowers, entwined themselves around the metal colonnades, the vivid blooms illuminating this memorial of rust.

WILLIAM H. GASS

from *Monumentality/Mentality*

LEST WE FORGET. Even when we haven't forgotten (the founding of our country, for example), it is sometimes vitally necessary to focus the thoughts of a group upon some past person or event, to get people to *remember together,* perhaps because we have a new and common enterprise in mind which demands we act together, but often simply because the unity of the group is thereby affirmed, and in that way kept in strength and readiness, inasmuch as social unity is called upon subtly during every moment of community life. The commemorative medal or stamp or celebration revitalizes not a natural but an artificial memory, since none of us really remembers the founding of our country; what we recall is the *fact* it was founded, as well as some accounts of the occurrence. These patriotic stories (Hancock signing the Declaration of Independence in a large round hand, Molly Pitcher with her pails of water, Paul Revere spreading the alarm, and so on) reduce history to a series of vivid simplicities which are then impressed upon the imagination like a decal, and can be easily

re-imaged, indeed, *re-seen:* the fifer, the drummer, the fellow with the tattered flag. Such historical images are souvenirs, too, manufactured like our little Eiffel, of confusions society has implicitly determined to hold in common; of lies society has decided to tell itself until they become the national truth. Both public and private monuments have as much to do with these fictions as with the dead they presumably memorialize, and the ideals they are said to enshrine.

That bracelet of bright hair about the bone which John Donne's lover wears, even into the grave as a token of his love, was a sacred souvenir for him, but to those surprised spades which unearthed his body while looking for a place to bury yet another, it was a relic of that love, and brought like a gift to the King. A relic must be an actual piece of the thing itself: body, building, boat, true cross; but to be a relic the object it was once a part of must now be dead or destroyed. The fingertip the terrorists cut off is not a relic – at least not yet. Lenin's embalmed body is not a relic, because his corpse is still intact, although, in another sense, he may be regarded as a relic of the revolution. However, shards from some common pot cannot claim this status: barnacles from beneath any boat, nails through a cheap crook's foot. Having been wrapped around a miracle like the linen of the Lord, they have miraculous powers. There is something talismanic about them; they bring good luck; even a piece of sea-worn wood, if it keeled the ark, can cure the itch; therefore pilgrims travel to touch them; then the halt walk, skip; the ugliest crone grows young; so the reliquaries which house such objects are not only rich in precious stones and metals, but are often made in the form of miniature monuments, temples, tombs; and designed, needless to say, by artisans whose tools are sanctified by their task. The forsaken lover in another of Donne's poems (one supposes it is the same unhappy man) suggests that a wreath of his beloved's hair be buried with him because, since he is a martyr to her cause,

> 'it might breed idolatrie,
> If into other hands these Reliques came.'

It is only within the context of a developed ideology that relics are properly produced; an ideology which is politically structured, socially supported, and generally held. The cock of Casanova, however well-preserved, and whatever you or I might devoutly believe about its feats of love in life – and no doubt a princely penis with many amorous felicities it could confer upon male and female alike – cannot really be a relic without a large community of

conviction, a widely-held system of superstition, of awe and dread, in which its worship would be explicable, and its powers would be, among many, only its own.

Candida Höfer, *Sorbonne, Paris*, 1989, colour photograph

JUAN MUÑOZ

'A Stone', in *Trans/Mission: Art in Intercultural Limbo*

The picture is clear. The lecturer's table far away. A gathering of heads together in the foreground so it was impossible to see his face. The voice of the Mexican poet Octavio Paz is telling, slowly, the story about a statue. The image of the voice is still clear. So may this circumlocution be like an accumulation of echoes resounding and dying away into something unintelligible.

In August 1790, some street repairs were being done in the centre of Mexico City. When the ground level at the Plaza Mayor was raised, a stone statue with a height of about two and a half metres was found under the earth.

A few years before, a large collection of plaster replicas of different Greek and Roman sculptures had been placed in the showrooms of the Royal University of Mexico. The statue of the goddess Coatlique was brought there and was placed in this unprecedented company as 'a monument from the antiquity'.

When a few months had passed, the doctors of the University decided that such a work among the masterpieces of classicism was an affront to the very concept of beauty. And, besides, the goddess might revive such ideas among the Indians which the viceroys thought should preferably be forgotten. Thus, the professors decided that Coatlique was to be buried again in the same hole where she had been found.

A few years later, it seems that Baron Alexander von Humboldt, during a temporary stay in Mexico, came across the notes and the description made by Antonio de Léon y Gama before the statue was again buried. Humboldt managed to have the statue unearthed once more, so he could examine it. When this was done, the statue was buried anew.

Coatlique was a stone block, vaguely resembling a human being, and she had been placed at the top of the Great Temple of Tenochtitlan. There, she was anointed by the Aztec priest with blood and copal incense. She was wearing the attributes of divinity – fangs, serpents, skulls – all of it carved true to life. Bones, wood, feathers were petrified in the Mexican sculpture. 'Fusion of matter and feeling' says here, exactly, the poet's voice 'the stone is idea, and the idea is transformed into stone'.

Years after the independence of Mexico, Coatlique was unearthed for good. Back in the University, she was first left abandoned in a backyard; then she was placed in a passage, partially hidden behind a screen, suggesting, behind curiosity, a feeling of embarrassment and shame. Finally, after having spent some time in a small room like an object of doubtful artistic value, she was moved to occupy the central position in the main showroom for Aztec art in the National Museum of Anthropology.

From her beginning as a goddess on the top of a truncated pyramid to her present position as a masterpiece of anthropological historiography, Coatlique remains indifferent to the plurality of interpretations made from the perspective of each period of history.

To the catholic missionary, this stone was the very incarnation of Evil, in firm opposition to the Aztec priest who venerated it as the bearer of divine values. To them both, however, the statue in itself meant the presence of something supernatural. Coatlique was a presence which condensed and irradiated 'a tremendous mystery'.

The observers able to perceive this supernatural presence in the stone figure were already gone forever when Coatlique entered the maze of aesthetic discourse towards the end of the eighteenth century, and the stony paths of anthropological speculation in the twentieth.

Century upon century, what changed was not the real appearance of the statue, but the understanding of reality. And all along this road from the religion to secularization, from the Aztec priest to Humboldt and to the visitor at the Museum of Anthropology, Coatlique appears clearly as a mystery. From its statuary autonomy, the stone of human appearance brings us back to the mystery of seeing, encompassed by our gaze. As the centuries went by, the veneration of the Aztec was joined by the horror provoked by such a buried religious legacy. And to the disdain of the aesthetes was added the curiosity of the scientists, and they all applied the same intellectual criteria.

Before this adding and subtracting of significances, before the changing ages to which each casual observer belongs, this block of stone in its immobility inspires a unique feeling: the enigma of the arousal of feelings.

Now let us take a few steps forward or perhaps aside, to add another possibility from the present time to this trail of four hundred years.

Before for ever leaving behind us the Aztec statue and so many sociology- and information-laden sculptures, it is worthwhile to turn our gaze on another statue. Any one general in the centre of any square in a city anywhere, on an equally immobile horse. A statue which does not inspire us with any feeling of respect, because no one alive remembers any longer after which glorious battle this little heap of stone and bronze was placed precisely there. And we don't feel any animosity, because neither is the enemy there any longer, nor any aesthetic fervour or even scientific curiosity. A statue which possesses but one value: the one of not having allowed time to hide it from our eyes.

We certainly do not intend to save the image of any bronze general from oblivion, or bring back into the records of art a forgotten statue, immobile, hidden in the air in a square somewhere. Neither do we intend, through the story of Coatlique, to call attention to the fact that a block of stone can be worth a discourse on different interpretations. Because, behind all these additions and subtractions we are left with a unique understanding: we have come together only to try to grasp its presences. Thus, from the present, lost in a city, crossing a square, gazing. How should we interpret this concealment?

ROBERTO CALASSO

from *Le Nozze di Cadmo e Armonia*

And Diodoro Siculo: 'They also say that the honours given to the gods and the sacrifices and rites of the mysteries originally came down to other men from Crete, and in making this claim they offer what they believe is an extremely strong argument. The initiatory rite that the Athenians celebrate in Eleusis, the most illustrious one might say of all rites, and again the Samothracians rite and the rite begun by Orpheus in Thrace amongst the Ciconi, all these rites are passed on from one initiate to another in secret. But in Knossus, Crete, it has always been the custom to practise such initiatory rites in broad daylight and to let everybody know about them. What is considered unnameable amongst other peoples, is available for all who want to hear in Crete.'

Mystery, in Crete, was made plain, no one tried to hide it. The 'unnameable things,' that abounded in Attica, were laid open to everybody. But there was no sense of challenge about this. Crete, with its hundred cities and not a defensive wall between them, looked like a huge plaything. Only a tidal wave, or dark raiders striking from the sea could have been its doom, not the audacity of the sort of civilization that seeks self knowledge, and in so doing destroys itself.

A few thousand years later, a famous expert on the development of civilizations was to be baffled by Crete, for having studied the whole multitude of Cretan remains he could find not a single indication of any historical, political or even biographical consciousness, whereas such notions had always dominated Egyptian thought. For a man eager to uncover the grandiose signs of great civilizations, Crete had something childish about it, something elusive, something below par.

UMBERTO ECO

from *Travels in Hyperreality*

Fisherman's Wharf, in San Francisco, is an Eldorado of restaurants, shops selling tourist trinkets and beautiful seashells, Italian stands where you can have a crab cooked to order, or eat a lobster or a dozen oysters, all with sourdough French bread. On the sidewalks, blacks and hippies improvise concerts, against the background of a forest of sailboats on one of the

THOSE WERE THE DAYS

Words and Music by
GENE RASKIN

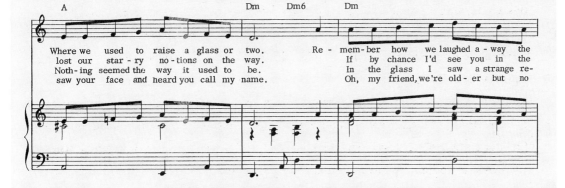

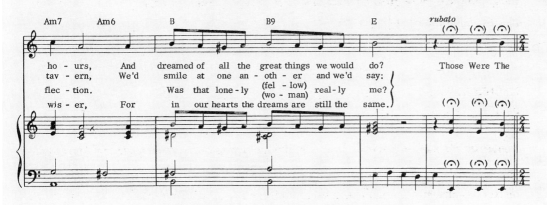

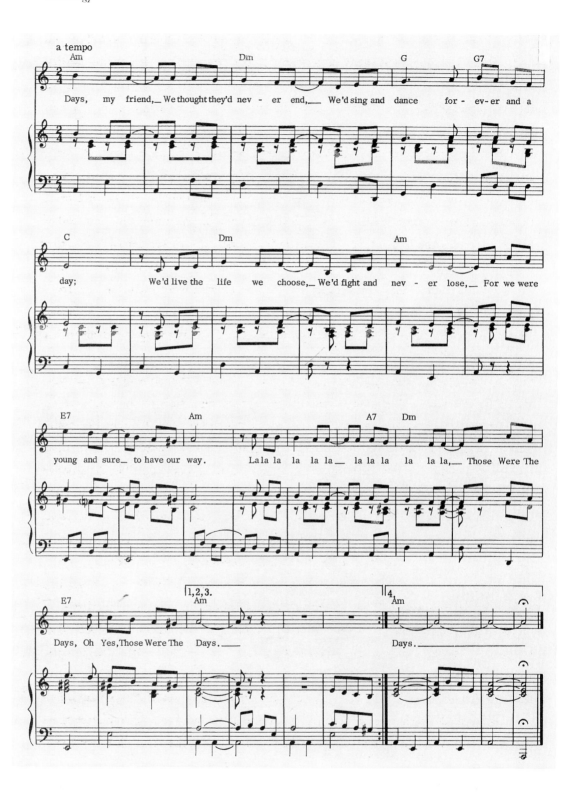

a tempo

Days, my friend,— We thought they'd nev - er end,— We'd sing and dance for - ev - er and a

day; We'd live the life we choose,— We'd fight and nev - er lose,— For we were

young and sure— to have our way. La la la la la la— la la la la la la,— Those Were The

Days, Oh Yes, Those Were The Days.— Days.—

world's loveliest bays, which surrounds the island of Alcatraz. At Fisherman's Wharf you find, one after another, four waxwork museums. Paris has only one, as do London, Amsterdam, and Milan, and they are negligible features in the urban landscape, on side streets. Here they are on the main tourist route. And, for that matter, the best one in Los Angeles is on Hollywood Boulevard, a stone's throw from the famous Chinese Theatre. The whole of the United States is spangled with wax museums, advertised in every hotel – in other words, attractions of considerable importance. The Los Angeles area includes the Movieland Wax Museum and the Palace of Living Arts; in New Orleans you find the Musée Conti; in Florida there is the Miami Wax Museum, Potter's Wax Museum of St. Augustine, the Stars Hall of Fame in Orlando, the Tussaud Wax Museum in St. Petersburg. Others are located in Gatlinburg, Tennessee, Atlantic City, New Jersey, Estes Park, Colorado, Chicago, and so on.

The contents of a European wax museum are well-known: 'live' speaking images, from Julius Caesar to Pope John XXIII, in various settings. As a rule, the environment is squalid, always subdued, diffident. Their American counterparts are loud and aggressive, they assail you with big billboards on the freeway miles in advance, they announce themselves from the distance with glowing signs, shafts of light in the dark sky. The moment you enter you are alerted that you are about to have one of the most thrilling experiences of your life; they comment on the various scenes with long captions in sensational tones; they combine historical reconstruction with religious celebration, glorification of movie celebrities, and themes of famous fairytales and adventure stories; they dwell on the horrible, the bloody; their concern with authenticity reaches the point of reconstructive neurosis. At Buena Park, California, in the Movieland Wax Museum, Jean Harlow is lying on a divan; on the table there are copies of magazines of the period. On the walls of the room inhabited by Charlie Chaplin there are turn-of-the-century posters. The scenes unfold in a full continuum, in total darkness, so there are no gaps between the niches occupied by the waxworks, but rather a kind of connective décor that enhances the sensation. As a rule there are mirrors, so on your right you see Dracula raising the lid of a tomb, and on the left your own face reflected next to Dracula's, while at times there is the glimmering figure of Jack the Ripper or of Jesus, duplicated by an astute play of corners, curves, and perspective, until it is hard to decide which side is reality and which illusion. Sometimes you approach an especially seductive scene, a shadowy character is outlined against the background of an old cemetery, then you discover that this character is you, and the cemetery is the reflection of the next scene,

105

which tells the pitiful and horrifying story of the grave robbers of Paris in the late nineteenth century.

Then you enter a snowy steppe where Zhivago is getting out of a sleigh, followed by Lara, but to reach it you have to pass the cabin where the lovers will go and live, and from the broken roof a mountain of snow has collected on the floor. You experience a certain emotion, you feel very Zhivago, you wonder if this involvement is due to the lifelike faces, to the natural poses, or to 'Lara's Theme,' which is being played with insinuating sweetness; and then you realize that the temperature really is lower, kept below zero centigrade, because everything must be like reality. Here 'reality' is a movie, but another characteristic of the wax museum is that the notion of historical reality is absolutely democratized: Marie Antoinette's boudoir is recreated with fastidious attention to detail, but Alice's encounter with the Mad Hatter is done just as carefully.

When you see Tom Sawyer immediately after Mozart or you enter the cave of *The Planet of the Apes* after having witnessed the Sermon on the Mount with Jesus and the Apostles, the logical distinction between Real World and Possible Worlds has been definitively undermined. Even if a good museum (with sixty or seventy scenes and two or three hundred characters) subdivides its space, separating the movie world from religion and history, at the end of the visit the senses are still overloaded in an uncritical way; Lincoln and Dr. Faustus have appeared reconstructed in the same style, similar to Chinese socialist realism, and Hop o' My Thumb and Fidel Castro now belong forever to the same ontological area.

This anatomical precision, this maniacal chill, this exactness of even the most horrifying detail (so that a disemboweled body displays the viscera neatly laid out as if for a medical-school lecture) suggest certain models: the neoclassical waxworks of the Museo della Specola in Florence, where Canovan aspirations join with Sadean shudders; and the St. Bartholomews, flayed muscle by muscle, that adorn certain anatomy lecture-halls. And also the hyperrealistic ardors of the Neapolitan crèche. But in addition to these memories in the minor art of Mediterranean countries, there are others, more illustrious: the polychrome wood sculpture of German churches and city halls, the tomb figures of the Flemish-Burgundian Middle Ages. Not a random reference, because this exacerbated American realism may reflect the Middle European taste of various waves of immigration. Nor can one help recalling Munich's Deutsches Museum, which, in relating with absolute scientific precision the history of technology, not only uses dioramas on the order of those at the Museum of the

City of New York, but even a reconstruction of a nineteenth-century mine, going dozens of meters underground, with the miners lying in passages and horses being lowered into the pits with windlasses and straps. The American wax museum is simply less hidebound; it shows Brigitte Bardot with a skimpy kerchief around her loins, it rejoices in the life of Christ with Mahler and Tchaikovsky, it reconstructs the chariot race from *Ben Hur* in a curved space to suggest panoramic Vista Vision, for everything must equal reality even if, as in these cases, reality was fantasy.

SUSAN STEWART

from *On Longing: Narratives of the Miniature, the Gigantic, the Souvenir, the Collection*

SEPARATION AND RESTORATION

The delicate and hermetic world of the souvenir is a world of nature idealized; nature is removed from the domain of struggle into the domestic sphere of the individual and the interior. The souvenir is used most often to evoke a voluntary memory of childhood, a model we find either in souvenirs, such as scrapbooks, of the individual life history or in the larger antiquarian theme of the childhood of the nation/race. This childhood is not a childhood as lived; it is a childhood voluntarily remembered, a childhood manufactured from its material survivals. Thus it is a collage made of presents rather than a reawakening of a past. As in an album of photographs or a collection of antiquarian relics, the past is constructed from a set of presently existing pieces. There is no continuous identity between these objects and their referents. Only the act of memory constitutes their resemblance. And it is in this gap between resemblance and identity that nostalgic desire arises. The nostalgic is enamored of distance, not of the referent itself. Nostalgia cannot be sustained without loss. For the nostalgic to reach his or her goal of closing the gap between resemblance and identity, *lived* experience would have to take place – an erasure of the gap between sign and signified, an experience which would cancel out the desire that is nostalgia's reason for existence.

In the cultivation of distance which we find in the uses of the souvenir – the distance of childhood and the antique – the third fact is distance in space – the souvenir of the exotic.

Just as authenticity and interiority are placed in the remote past, the exotic offers an authenticity of experience tied up with notions of the primitive as child and the primitive as an earlier and purer stage of contemporary civilization. Jean Baudrillard writes in *Le Système des objets* that the exotic object, like the antique, functions to lend authenticity to the abstract system of modern objects, and he suggests that the indigenous object fascinates by means of its anteriority. This anteriority is characteristic both of the exotic object's form and its mode of fabrication and links it to the analogously anterior world of childhood and its toys. Thus the authenticity of the exotic object arises not in the conditions authored by the primitive culture itself but from the analogy between the primitive/exotic and the origin of the possessor, the authentic 'nature' of that radical otherness which is the possessor's own childhood. In Baudrillard's terms, modern is 'cold' and the antique and the exotic are 'warm' because contemporary mythology places the latter objects in a childhood remote from the abstractions of contemporary consumer society. Such objects allow one to be a tourist of one's own life, or allow the tourist to appropriate, consume, and thereby 'tame' the cultural other.

Just as in reverie, narrative is used to invent the symbolic, so by a similar process travel writing functions to miniaturize and interiorize those distanced experiences which remain outside contemporary lived relations. The tourist seeks out objects and scenes, and the relation between the object and its sight is continued, indeed articulated, in the operation of the souvenir. Robert Jennings and Company's tourist books from the 1830's are typical of this romantic genre. In *The Tourist in Biscay and the Castilles,* Thomas Roscoe writes of Bayonne: 'Being involuntarily detained, we employed the leisure thus created in seeking out the picturesque, which generally lurks, like unassuming characters, in quiet and out-of-the-way places. Nor were we by any means unsuccessful in our pilgrimage, though dire was the number of dirty lanes and alleys, both within and without the walls, which we threaded in search of it. In spite of the spirit of improvement, numbers of antique houses, not at all dilapidated, are still found here, and each of these would form an interesting study for the pencil.' While Roscoe emphasizes the picturesque, W. H. Harrison, in *The Tourist in Portugal,* has a more antiquarian focus, concluding that the reader has been presented with 'all the objects we deemed worthy of his attention... and all we know about them.' The function of the tour is the estrangement of objects – to make what is visible, what is surface, reveal a profound interiority through narrative. This interiority is that of the perceiving subject; it is gained at

the expense of risking *contamination* (hence the dire and dirty lanes) and the dissolution of the boundary of that subject. The process is later recapitulated more safely within the context of the familiar, the home, by means of the souvenir.

The exotic object represents distance appropriated; it is symptomatic of the more general cultural imperialism that is tourism's stock in trade. To have a souvenir of the exotic is to possess both a specimen and a trophy; on the one hand, the object must be marked as exterior and foreign, on the other it must be marked as arising directly out of an immediate experience of its possessor. It is thus placed within an intimate distance; space is transformed into interiority, into 'personal' space, just as time is transformed into interiority in the case of the antique object. Consider Gulliver's souvenirs of his adventures: from Lilliput the cattle, sheep, gold pieces, and 'his Majesty's picture at full length'; from Brobdingnag 'the small collection of rarities' – 'the comb I had contrived out of the stumps of the King's Beard; and another of the same Materials, but fixed into a paring of her Majesty's Thumb-nail, which served for the Back,' the collection of needles and pins, some combings from the queen's hair and her rings, a corn cut from a maid of honor's toe, his breeches made of mouse's skin, and a footman's tooth. These souvenirs serve as evidence of Gulliver's experience and as measurements of his own scale just as the giant's ring and booklet serve to authenticate the audience's experience. Like all curiosities, these souvenirs function to generate narrative. More than the souvenirs of Lilliput, which are most often whole and animal and serve as models and representative elements of sets, the souvenirs of Brobdingnag are partial and human; they are samples of the body which simultaneously estrange us from the body. But unlike the souvenirs of mortality discussed earlier, these souvenirs are taboo items collected from the body's refuse. These beard stumps, nail parings, hair combings, and corns do not diminish the body by their absence or appropriation; rather, they speak to its dual capacities of excess and regeneration. They transform the human into the other and yet allow the possessor to intimately know that other in parts. Gulliver's souvenirs of Brobdingnag are not 'ordinary': they speak to his degree of involvement with the Brobdingnagians – his partial yet intimate vision. They are 'authentic' souvenirs in the same way that the objects of magical tasks in fairy tales ('you must bring me three hairs from the giant's head') are evidence of an experience that is not vicarious but lived within an estranged or dangerous intimacy. They acquire their value only within the context of Gulliver's narrative; without such a narrative, they are not only meaningless, they are also exaggerations of the disposable.

Unlike the ancient object, which, though it arises from the distant past, is endowed with a familiarity more 'warm' than the present, the exotic object is to some degree dangerous, even 'hot.' Removed from its context, the exotic souvenir is a sign of survival – not its own survival, but the survival of the possessor outside his or her own context of familiarity. Its otherness speaks to the possessor's capacity for otherness: it is the possessor, not the souvenir, which is ultimately the curiosity. The danger of the souvenir lies in its unfamiliarity, in our difficulty in subjecting it to interpretation. There is always the possibility that reverie's signification will go out of control here, that the object itself will take charge, awakening some dormant capacity for destruction. This appropriation of reverie by the object forms the basis for certain horror stories: 'The Monkey's Paw,' or the ghost stories of M. R. James, for example. In such tales curiosity is replaced by understanding only at the expense of the possessor's well-being.

In most souvenirs of the exotic, however, the metaphor in operation is again one of taming; the souvenir retains its signifying capacity only in a generalized sense, losing its specific referent and eventually pointing to an abstracted otherness that describes the possessor. Nelson Graburn, writing on 'fourth world arts,' has suggested:

> As 'civilized societies' come to depend more and more upon standardized mass-produced artifacts, the distinctiveness of classes, families, and individuals disappears, and the importation of foreign exotic arts increases to meet the demand for distinctiveness, especially for the snob or status market. One gains prestige by association with these objects, whether they are souvenirs or expensive imports; there is a cachet connected with international travel, exploration, multiculturalism, etc. that these arts symbolize;

at the same time, there is the nostalgic input of the *handmade* in a 'plastic world.'
Thus such objects satisfy the nostalgic desire for use value at the same time that they provide an exoticism of the self. Ironically, the demand for such objects creates a souvenir market of goods distinct from authentic traditional crafts, that is, crafts designed in light of use value. And these souvenir goods are often characterized by new techniques of mass production. There is thus a directly proportional relationship between the availability of the exotic experience and the availability of 'exotic objects.' Once the exotic experience is readily purchasable by a large segment of the tourist population, either more and more exotic experiences are sought (consider travel posters advertising the last frontier or the last unspoiled island) or, in a type of reverse snobbery, there is a turning toward 'the classic' of the consumer's

native culture. In those cities where one finds a wide range of 'ethnic' restaurants frequented by those not of the same ethnicity, one is also likely to find restaurants advertising 'classic American cuisine,' a phrase which itself cannot work without a French deglazing.

For the invention of the exotic object to take place, there must first be separation. It must be clear that the object is estranged from the context in which it will be displayed as a souvenir; it must be clear that use value is separate from display value. There is perhaps no better example of this process than the radical generational separation in America which results in certain nostalgic forms of lawn art. While we see the exotic and the cultural other explored in forms such as pink flamingos and slumbering Mexicans, the most common forms are antiquarian ones such as wagon wheels, donkey carts, sleighs, and oxen yokes. These metonymic forms are the articulation of abandoned use value. Prominently displayed, they speak to the industrialization of the occupants of the house, occupants who have become tourists of their parents' ways of life.

Yet to create 'tourist art' is to create display value from the outset and to by-pass this gradual transformation. Separation is accomplished spatially rather than temporally here. Thus it is necessary to invent the pastoral and the primitive through an illusion of a holistic and integrated cultural other. As for tourist souvenirs themselves, they increasingly tend in both form and content to be shaped by the expectations of the tourist market that will consume them. Graburn points out that since makers of souvenirs must compete with imported, manufactured souvenirs, native arts tend toward smaller sizes – not simply small souvenirs, but miniatures of traditional artifacts, as we saw in the basket-maker example earlier. Among the advantages of miniaturized articles are 'applicability for decorative use, economy of materials, and a doll-like, folkloristic quality not associated with the real article.' Those qualities of the object which link it most closely to its function in native context are emptied and replaced by both display value and the symbolic system of the consumer. William Bascom has found that in African art this tourist influence has resulted in three stylistic trends, all arising out of Western aesthetic principles. First, there is a tendency toward Western ideas of naturalism and realism; traditional modes of stylization were replaced by nineteenth-century European conventions of the picturesque. Second, there is a tendency toward an opposite extreme: the grotesque. Bascom concludes that this work 'may reflect both European preconceptions about the savagery or strength of African sculpture as well as the influence of German Expressionism on European artistic taste.' The third tendency is

toward gigantification. Yoruba carvers, for example, reproduce bells or clappers used in Ifa divination – bells that are normally 8 – 16 inches long and 1 inch in diameter – in versions that are 3 feet long and 3 inches in diameter. Gigantification allows the maker to charge more for his product, yet at the same time may involve less labor because it requires less attention to detail. Similarly, Graburn writes that 'Eskimo soapstone sculptors and Cordova *sauteros* calculate that far less time and effort is spent making large, expensive carvings than the more typical small ones.' Thus the tourist aesthetic ensures that the object is continually exoticized and estranged. And, ironically, objects that are originally valued by tourists precisely because of their connections to a traditional, holistic, and paradisal culture are transformed, exaggerated, and modified by the fluctuating demands of that same tourist market.

In the uses of the souvenir, the other side of separation is restoration – here the false promise of restoration. The souvenir must be removed from its context in order to serve as a trace of it, but it must also be restored through narrative and/or reverie. What it is restored to is not an 'authentic,' that is, a native, context of origin but an imaginary context of origin whose chief subject is a projection of the possessor's childhood. Restoration can be seen as a response to an unsatisfactory set of present conditions. Just as the restoration of buildings, often taking place within programs of 'gentrification' in contemporary cities, has as its basis the restoration of class relationships that might otherwise be in flux, so the restoration of the souvenir is a conservative idealization of the past and the distanced for the purposes of a present ideology. We thus might say that all souvenirs are souvenirs of a nature which has been invented by ideology. This conclusion speaks not only to the display of Victorian sea shells under glass but also to the broader tendency to place all things natural at one degree of removal from the present flow of events and thereby to objectify them.

The only proper context for the souvenir is the displacement of reverie, the gap between origin/object/subject which fields desire. Whereas the collection is either truly hidden or prominently displayed, the souvenir, so long as it remains 'uncollected,' is 'lost,' removed from any context of origin and use value in such a way as to 'surprise' and capture its viewer into reverie. The actual locale of the souvenir is often commensurate with its material worthlessness: the attic and the cellar, contexts away from the business and engagement of everyday life. Other rooms of a house are tied to function (kitchen, bath) and presentation (parlor, hall) in such a way that they exist within the temporality of everyday life, but the attic and the cellar are tied to the temporality of the past, and they scramble the past

into a simultaneous order which memory is invited to rearrange: heaven and hell, tool and ornament, ancestor and heir, decay and preservation. The souvenir is destined to be forgotten; its tragedy lies in the death of memory, the tragedy of all autobiography and the simultaneous erasure of the autograph. And thus we come again to the powerful metaphor of the unmarked grave, the reunion with the mother with no corresponding regeneration of the symbolic.

Letter E in the encyclopedic dictionary *Petit Larousse illustré,* Paris, 1925

PRIMO LEVI
from *The Mnemogogues*

'Morandi, did you ever notice how powerfully certain smells evoke certain memories?'

The blow was unexpected. Morandi swallowed with an effort; he said that he had noticed and also that he had made an effort to explain it.

He could not explain the change in subject. Within himself he concluded that, at bottom, this must be only some sort of fixation, such as all doctors have after reaching a certain age. Like Andriani: at sixty-five, rich in fame, money and patients, he had just barely enough time to cover himself with ridicule because of that business of the neural field.

Montesanto had gripped the corners of his desk with both hands and was staring into the void, wrinkling his brow. Then he went on:

'I will show you something unusual. During the years of my work as an associate in pharmacology I studied rather thoroughly the action of adrenaline absorbed through the nose. From this I did not glean anything useful for humanity except for a single, as you will see, rather indirect result.

113

'Also in the years that followed I devoted a good deal of my time to the problem of olfactory sensations, and their relation to molecular structure. This, in my opinion, is a most fruitful field, as well as one open to researchers equipped with modest means. Even recently I've been pleased to see that some people take an interest in it, and I am also up-to-date on your electronic theories; but by now the one aspect of the problem that interests me is something else. Today I possess what I believe no one else in the world possesses.

'There are those who take no interest in the past and let the dead bury the dead. However, there are also those who care about the past and are saddened by its continuous fading away. Furthermore, there are those who are diligent enough to keep a diary, day by day, so as to save everything of theirs from oblivion, and preserve their materialized memories in their home and on their person; a dedication in a book, a dried flower, a lock of hair, photographs, old letters.

'I by my nature can only think with horror of the eventuality that even a single one of my memories should be erased, and I have adopted all those methods, but I've also created a new one.

'No, what is involved is not a scientific discovery: I simply have used to best advantage my experience as a pharmacologist and have reconstructed, with exactitude and in preservable form, a number of sensations that mean something to me.

'I call them – but I repeat, don't think that I often speak of them – I call them mnemogogues: "arousers of memories." Would you mind coming with me?'

He rose and headed down the hallway. Halfway along he turned and added, 'As you can well imagine, they must be used parsimoniously, if you don't want their evocative power to weaken; what's more, I don't have to tell you that they are unavoidably personal. Absolutely. One might actually say that they are my very person, since I, at least in part, am formed out of them.'

He opened a cupboard. Inside there were about fifty small bottles with ground stoppers, all numbered.

'Please, pick one.'

Morandi looked at him perplexed; he extended a hesitant hand and chose a small bottle.

'Open it and sniff it. What do you smell?'

Morandi inhaled deeply several times, first keeping his eyes on Montesanto, then tilting back his head in the posture of someone searching his memory.

'This would seem to be the smell of a barracks.'

Montesanto in his turn sniffed. 'Not exactly,' he answered. 'Or at least not so for me. It is the odor of elementary school rooms; in fact, of my room in my school. I won't expatiate on its composition; it contains volatile fatty acids and an unsaturated ketone. I understand that for you it's nothing: for me it's my childhood.

'I'm also preserving the photograph of my thirty-seven classmates in the first grade, but the scent from this small bottle is enormously quicker in recalling to my mind the interminable hours of tedium spent over the spelling primer; the particular state of mind of children (and of the child!) during the terrifying suspense before the first dictation test. When I sniff it – not now: obviously a certain degree of concentration is necessary – when, as I was saying, I sniff it, my innards are convulsed in just the way they were at the age of seven as I waited to be called up to be interrogated. Would you like to pick another one?'

'I think I remember ... wait ... In my grandfather's villa, in the country, there was a small room where fruit was stored to ripen ...'

'Perfect,' Montesanto said with sincere satisfaction. 'Exactly as the treatises state. I'm so pleased that you hit on a professional odor; this is the breath of a diabetic in the acetonemia phase. With a few more years of practice you would have certainly figured it out yourself. As you well know, an ominous clinical sign, the prelude of things to come.

'My father died from diabetes fifteen years ago; it was neither a brief nor a merciful death. My father meant much to me. I sat up with him for many, many nights, impotently watching the progressive obliteration of his personality; those hours of vigil were not sterile. Many of my beliefs were shaken by them, much of my world changed. So for me it is neither a matter of apples nor diabetes, but the solemn, purifying travail, unique in life, of a religious crisis.'

'... This can only be carbolic acid!' Morandi exclaimed, sniffing the third bottle.

'Exactly. I thought that this odor would mean something to you too; but, come to think of it, it isn't a year yet that you finished your shifts in hospital, the memory has not yet matured. For I'm sure that you have noticed, haven't you? that the evocative mechanism of which we are speaking requires that the stimuli, after having acted repeatedly in connection with a certain environment or a certain state of mind, then cease to operate for rather a long period of time. In any event, it is a matter of common observation that memories, in order to be suggestive, must have an antique flavor.

'I too worked shifts in the hospital and have filled my lungs with carbolic acid. But this happened a quarter of a century ago, and in any case since then carbolic acid has ceased to represent the foundation of antisepsis. But in my time it was: so that even to this day I cannot smell it (not chemically pure carbolic acid, but this sort, to which I've added traces of other substances that make it specific for me) without a complex picture arising in my mind, a picture that includes a tune fashionable at that time, my youthful enthusiasm for Biagio Pascal, a certain springlike languor in my loins and knees, and a female classmate who, so I've heard, has recently become a grandmother.'

This time he himself had chosen a small bottle; he handed it to Morandi. 'I must confess to you that I'm still rather proud of this preparation. Even though I never published its results, I consider this to be my true scientific success. I would like to hear your opinion.'

Morandi sniffed with the greatest care. It certainly was not a new smell: one might call it scorched, dry, warm…

'… When you strike together two flint stones?'

'Yes, that too. I congratulate you on your olfactory prowess. One often smells this odor high in the mountains when the rocks warm under the sun, especially when there is a scree of stones. I assure you that it wasn't easy to reproduce in vitro and to stabilize the substances that constitute it without altering the sensible properties.

'There was a time when I often went up into the mountains, mostly alone. After reaching the peak I would lie down beneath the sun in the still and silent air, and it seemed to me that I had attained a goal. At those moments, and only if I set my mind to it, I would perceive this slight odor that one rarely smells elsewhere. As far as I'm concerned, I ought to call it the odor of peace achieved.'

Having overcome his initial uneasiness, Morandi was taking an interest in the game. At random he unstoppered a fifth bottle and handed it to Montesanto. 'And what about this?'

From it emanated a light airy smell of clean skin, powder and summer. Montesanto sniffed, put back the small bottle and said curtly, 'This is neither a place nor a time, it is a person.'

He closed the cupboard: he had spoken in a definitive tone. Morandi had mentally prepared some expressions of interest and admiration, but he was unable to overcome a strange inner barrier and gave up on articulating them. He hastily look his leave with a vague promise of another visit, rushed down the stairs and out into the sun. He sensed that he had blushed deeply.

SOURCES OF TEXTS AND IMAGES

Jacques Attali, *Noise: The Political Economy of Music* (1977), trans. Brian Massumi, The University of Minnesota Press, Minneapolis, 1985, pp. 9–10

Stefan George, 'A Child's Calendar', *The Works of Stefan George,* trans. Olga and Ernst Morwitz, Chapel Hill/ University of North Carolina Press, 1974, pp. 423–4

Aldo Rossi, *A Scientific Autobiography,* trans. Lawrence Venuti, Oppositions Books, The MIT Press, Cambridge, Mass. and London, 1981, pp. 6–8

Italo Calvino, *Invisible Cities* (1972), trans. William Weaver, Pan Books Ltd. (Picador), London, 1979, pp. 86–7

Robert Smithson, 'A Tour of the Monuments of Passaic, N. J.' (1967), *Blasted Allegories: An Anthology of Writings by Contemporary Artists,* The New Museum/The MIT Press, Cambridge, Mass. and London, 1987, pp. 78–9

Gabriel García Márquez, *One Hundred Years of Solitude* (1967), trans. Gregory Rabassa, Pan Books Ltd., London, 1978, pp. 45–7

Dr. Judith Rapoport, 'Paul: Stuck in a Doorway', *The Boy Who Couldn't Stop Washing,* Collins, London, 1990, pp. 63–4

Sigmund Freud, *Totem and Taboo,* trans. James Strachey, W. W. Norton & Co. Inc., New York, copyright Routledge & Keegan Paul Ltd., 1950, pp. 157–8

Mircea Eliade, *Myths, Rites and Symbols: A Mircea Eliade Reader,* trans. Wendell C. Beane and William G. Doty, Harper & Row, New York, 1976, pp. 85–7

Herbert Marcuse, *Eros and Civilization,* Vintage Books, a division of Random House, New York, p. 18

Jean Piaget, *The Child's Conception of the Universe* (first Eng. ed. 1929), trans. Joan and Andrew Tomlinson, Paladin, London, 1973, p. 128

William Gibson, *Mona Lisa Overdrive,* Bantam Books, a division of Bantam Doubleday Dell Publishing Group, Inc., New York, 1988, pp. 267–8

Carl Jung, *Flying Saucers: A Modern Myth of Things Seen in the Skies,* trans. R. F. C. Hull, Signet Books, The New American Library, New York, pp. 24–5

Judith Williamson, 'Every Virus Tells a Story: The Meaning of HIV & AIDS', *Taking Liberties: AIDS & Cultural Politics,* ed. Erica Carter and Simon Watney, Serpent's Tail/ICA, London, 1989, pp. 69–72

Anonymous, 'The Tar Baby', in *Storytellers: Folktales and Legends from the South,* ed. John A. Burrison, University of Georgia Press, Athens, Georgia, 1989, pp. 153–4

Toni Morrison, *The Bluest Eye* (1970), Triad/Panther Books, London, 1981, pp. 22–4

Georges Bataille, 'The Psychological Structure of Fascism', *Visions of Excess: Selected Writings, 1927–1939,* trans. Allan Stoekl, The University of Minnesota Press, Minneapolis, 1985, p. 138

Elfriede Jelinek, *Lust,* trans. Michael Hulse, Serpent's Tail, London, 1992

Vladimir Voinovich, *The Fur Hat,* trans. Susan Brownsberger, Harcourt Brace Jovanovich, San Diego, New York and London, pp. 1–4

Bruce Chatwin, *Utz,* Pan Books Ltd. (Picador), London, 1988, pp. 112–14

Federico Fellini, *Totò,* trans. Shaun Whiteside for the South Bank Centre (1991) from the Italian, copyright Diogenes Verlag, Zürich, 1981

Dave Hill, *Prince, a Pop Life,* Faber and Faber Ltd., London, 1989, pp.71–3

Jean-Paul Sartre, preface to *Portrait of a Man Unknown* by Nathalie Sarraute, trans. Maria Jolas, copyright this translation George Braziller Inc., 1958, pp. iv–xiv. Reproduced by permission of Calder Publications Ltd., London.

Rupert Sheldrake, *The Presence of the Past: Morphic Resonance and the Habits of Nature,* First Vintage Books Edition, New York, 1988, pp. xvii–xix

Pinckney Benedict, 'Washman', *The Wrecking Yard,* Secker & Warburg Ltd., London/Bantam Doubleday Dell, New York, 1992, pp.75–7

Elaine Scarry, *The Body in Pain: The Making and Unmaking of the World,* Oxford University Press, New York and Oxford, 1985, pp.108–13

Donna Haraway, 'Cyborgs at Large', an interview with Constance Penley and Andrew Ross, *Technoculture,* ed. C.Penley and A.Ross, The University of Minnesota Press, Minneapolis, 1991, pp.4–6

J.G. Ballard, 'The Ultimate City', *Low Flying Aircraft,* copyright 1976 by J.G. Ballard. Published by HarperCollins, London, reproduced by permission of the author and Casarotto Co. Ltd.

William H. Gass, 'Monumentality/Mentality', *Oppositions,* No. 25, Fall 1982, pp.130–1

Juan Muñoz, 'A Stone', *Trans/Mission: Art in Intercultural Limbo,* catalogue, ed. Lars Nittve, Rooseum, Malmö, 1991, pp. 107–13

Roberto Calasso, *Le Nozze di Cadmo e Armonia,* trans. Tim Parks, Jonathan Cape Ltd., London, 1992

Umberto Eco, *Travels in Hyperreality* (1967), trans. William Weaver, Pan Books Ltd. (Picador), London, 1987, pp.12–15

Susan Stewart, *On Longing: Narratives of the Miniature, the Gigantic, the Souvenir, the Collection,* Johns Hopkins University Press, Baltimore, 1984, pp.145–51

Primo Levi, 'The Mnemogogues', *The Sixth Day* (1966), trans. Raymond Rosenthal, Michael Joseph Ltd., London, 1990, pp.14–17

Louise Bourgeois, *Le Défi,* glass, wood, electrical light, 171.4 x 147.3 x 66 cm, 1991, courtesy Robert Miller Gallery, New York

Cover of Alexandra Ripley's *Scarlett,* 1991, illustration David Bergen, reproduced by kind permission of Macmillan London

Illustration to L. Frank Baum, 'The Dummy that Lived', *American Fairy Tales* (1901), copyright Dover Publications, Inc., New York, 1978

Garry Winogrand photograph, courtesy Fraenkel Gallery, San Francisco, and The Estate of Garry Winogrand

Artists' Plates

Münster Projekt, 1987
Städelgarten Projekt (Nischenfigur), 1991

STEPHAN BALKENHOL

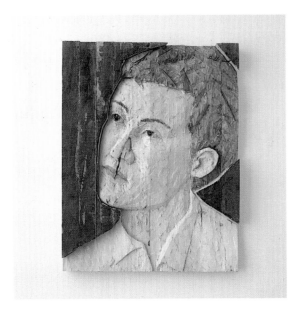

Grosses Kopfrelief (Mann), 1991
Grosser Kopf (Mann), 1991

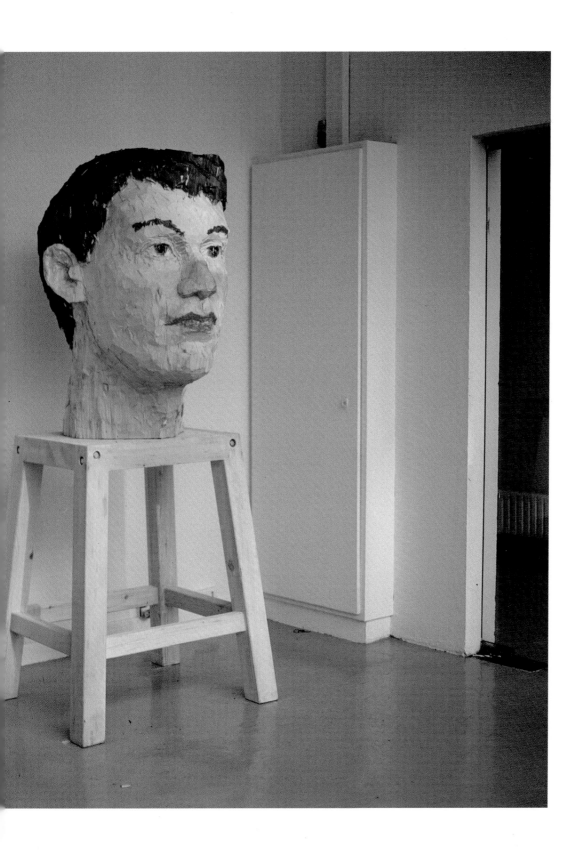

SOPHIE CALLE

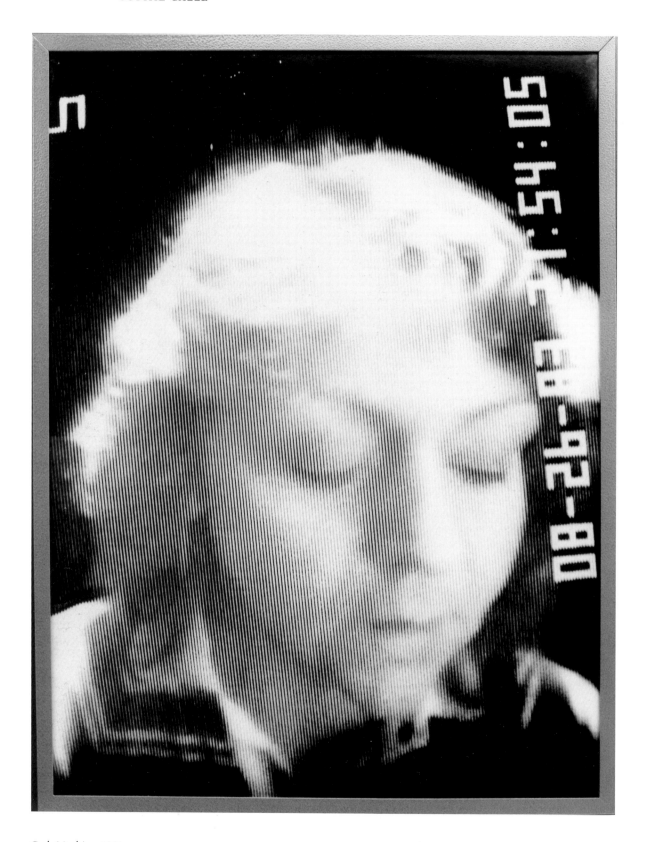

Cash Machine, 1991

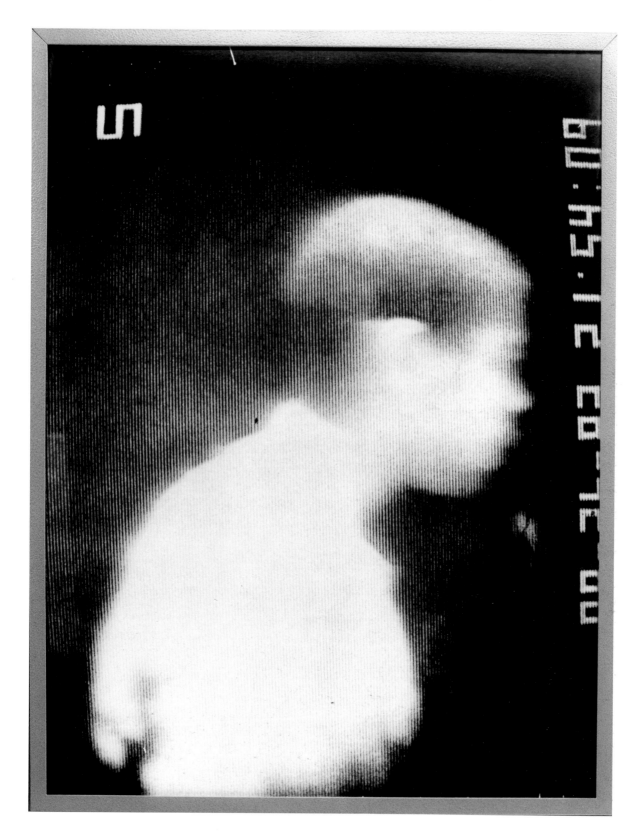

SOPHIE CALLE

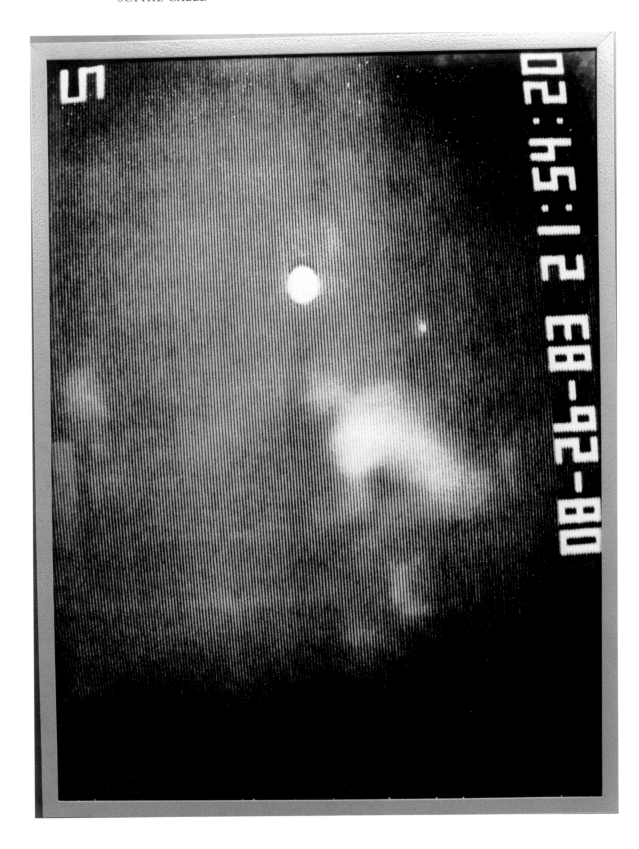

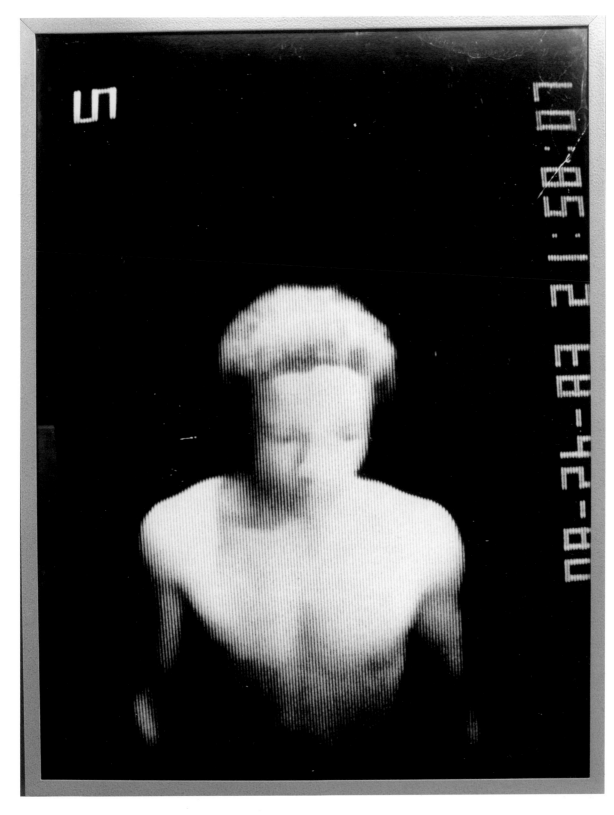

Soap Elephant, 1987

Iron Baby, 1987

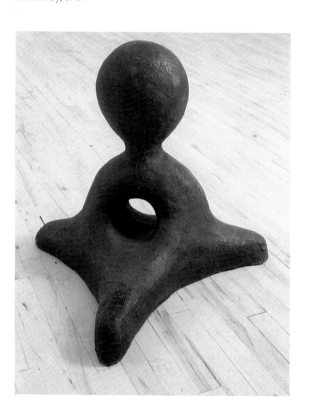

128

Washdog, 1990

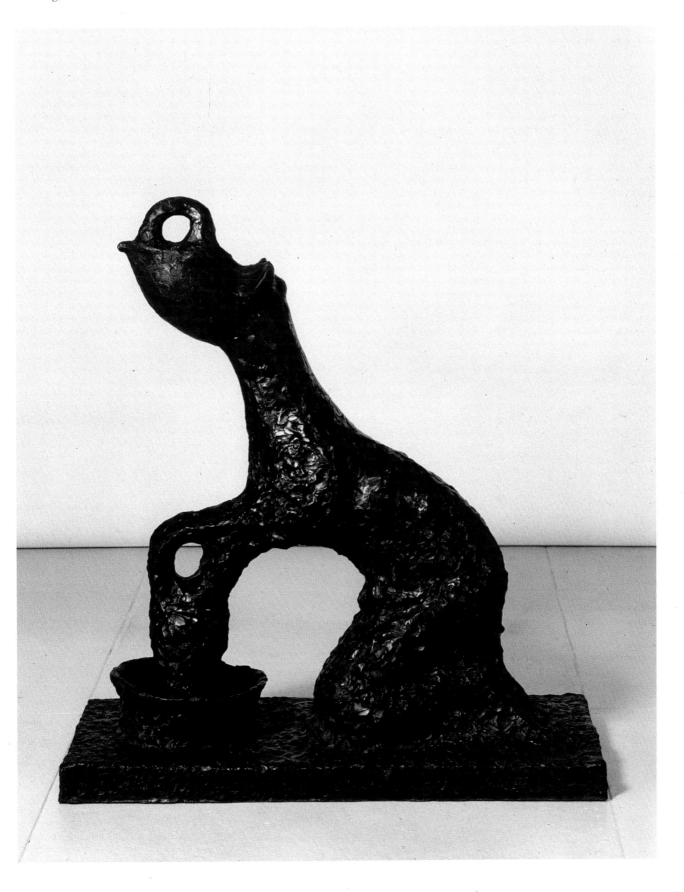

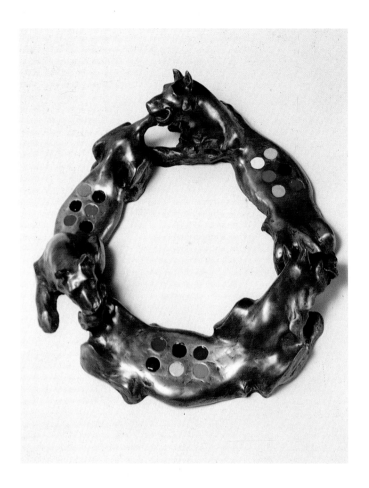

Aquarella, 1990

Guardian Angel, 1990

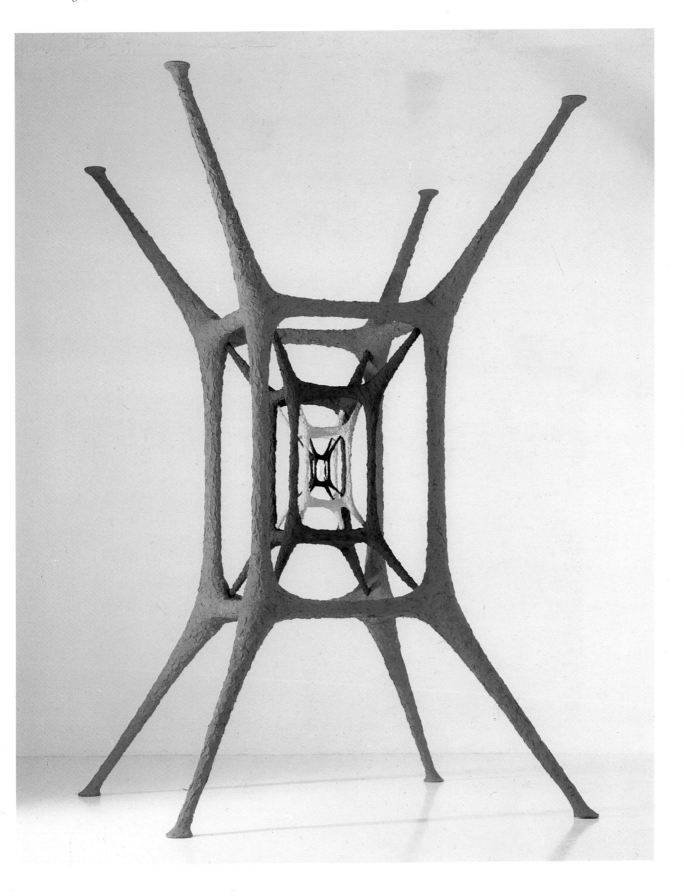

PETER FISCHLI / DAVID WEISS

Untitled Installation, Cham, Switzerland, 1991

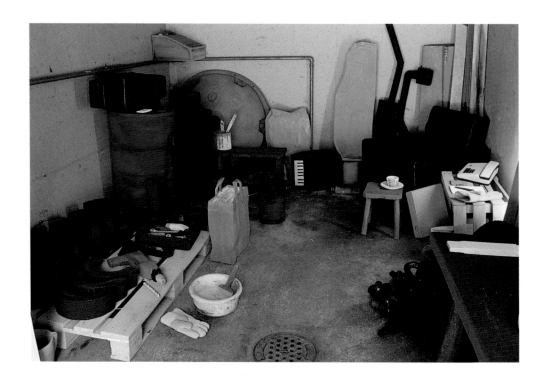

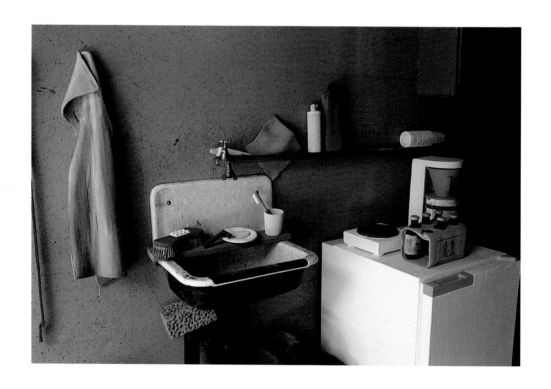

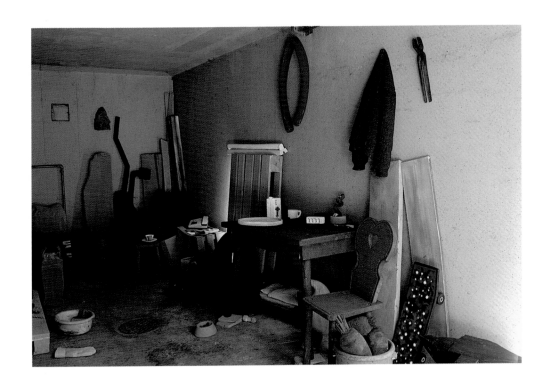

STEFAN GEORGE

DER KINDLICHE KALENDER

Die ersten wochen nach Erscheinung des Herrn hatten ausser den fremdländischen gesichten der drei Weisen mit gold weihrauch und mirren kaum andere erinnerungen als die schlittenfahrten über den zugefrorenen strom · der mit der ebene eines geworden war. Um Mariä Lichtmess hörten wir viel von der zunehmenden helligkeit und der hoffnung auf winters ende. In der frühe gingen wir zur weihe des wachses und empfingen tags drauf den segen der kerzen. Der Fasching wo wir mit bunten und seltsamen kleidern einherzogen brachte uns die schau einer umgekehrten welt · wo sich männer in weiber und menschen in tiere verwandelten. Morgens noch als es dunkelte · sagten kinder die auf hohen stangen aufgespiesste brote trugen singend die Fastnacht an. Am Aschermittwoch traten wir zum altar und der priester zeichnete unsre stirnen mit dem aschenkreuz. Um Lätare beobachteten wir die ersten arbeiten auf dem feld und als der saft in den bäumen stieg sassen wir im weidicht und schnitten aus den lockergeklopften rinden uns flöten und pfeifen. Die schwalben und die störche kehrten wieder. Die Heilige Woche kam mit ihren zerstörten altären · der verstummten orgel und dem tönen der klapper statt der klingeln und glocken. Am Karfreitag lagen wir · nachdem pfarrer und messner vorangegangen waren · der länge nach ausgestreckt auf dem chor und küssten das niedergelegte Heilige Holz. In der dämmerung erklangen die uralten klageweisen über den untergang der Stadt. Darauf der Samstag mit der enthüllung des kreuzes und den posaunen der osterfreude. Am Weissen Sonntag weckten uns in der frühe die choräle von den türmen und wir stellten uns auf um den zug der kleinen bräutigame und bräute zu sehen die zum erstenmal zum Tisch des Herrn zogen. Alle hatten sie auf ihren stirnen die blässe der angst und andacht und dies war der einzige tag wo auch die plumpen kinder des volkes schön wurden. Ende april begannen wieder unsere regelmässigen fahrten in die wiesen und auf die berge. Unsere mutter lehrte uns die namen und die kräfte der blumen und kräuter und wir bekamen die schwer zugängliche kuppe gezeigt wo die seltene blume diptam wächst aus der des nachts weisse flammen perlen. Im monat der Maria gingen

wir des abends mit kränzen und grossen fliederbüschen zur kapelle um das bild der himmelskönigin zu schmücken. Hier wurden uns die beiden gebärden des gebetes gewiesen: die eine mit ineinandergeschlungenen geneigten fingern um ergebenheit und dank auszudrücken · die andere mit aufrechten aneinandergelegten zu bitte und preis. Am Fronleichnam wurde in grossem aufzug das Allerheiligste durch die bestreuten und geschmückten weihrauchduftenden strassen geführt und mit den dumpfen männerstimmen vereinigten sich unsre helleklingenden zum Tedeum. Mit Pfingsten begann der sommer und die gesänge im wald und am flusse. In grossen steinkrügen trugen wir den wein bergaufwärts · wir durften ihn in den bächen kühlen und lagerten uns auf dem grunde zu den frohen abendmahlzeiten im tannenrund. An Johanni sammelten wir von haus zu haus holz und reisig. Es wurde auf karren geladen und auf den höhen in grossen haufen aufgeschichtet. Nach einbruch der dunkelheit wurde es entzündet und wir liebten es unsre nackten arme in die freie züngelnde flamme zu schnellen. In den erntetagen wenn die hitze etwas nachgelassen hatte gingen wir in die flur und flochten uns kränze von kornblumen · und die leute zeigten uns wie man aus umgestülpten mohnrosen kleine prinzessinnen macht. Dort hörten wir einmal wie die schnitter ein lied vom Wote sangen und konnten uns unser grauen und unsere verwunderung nicht erklären. Erst viel später fiel uns der grund ein: dass ein seit jahrtausenden entthronter Gott noch in erinnerung sein sollte während ein heutiger schon in vergessenheit geriet. Mitte august begleiteten wir die auf einem gerüst getragene bildsäule des Stadt-Heiligen von der kirche zur bergkapelle. Er war in einen dunkelpurpurnen sammtmantel gekleidet und um seine schultern hingen die ersten reifenden trauben. Wir hatten pilgerkutten angelegt mit aufgenähten muscheln und führten in der hand flasche und stab. In langer reihe kamen dann die vielen sonntage nach Pfingsten die wenig abwechslung brachten im kindlichen jahre und blasser im gedächtnis blieben — bis zum Advent. Dazwischen war der Dreifaltigkeitstag an dem die nachtwandrer und hellseher geboren werden · die zeit der weinlese und Allerheiligen · das lezte fest vor dem einbruch des nebels und der kälte. Während der Kunfttage gingen wir mit lampen zur frühmette · wo der psalm wiederholt wurde ›Tauet himmel den Gerechten‹ .. und lange wochen waren erfüllt von den erwartungen der nahen Weihnacht.

Hellgrünes Bild, 1991

Oranges Bild, 1991

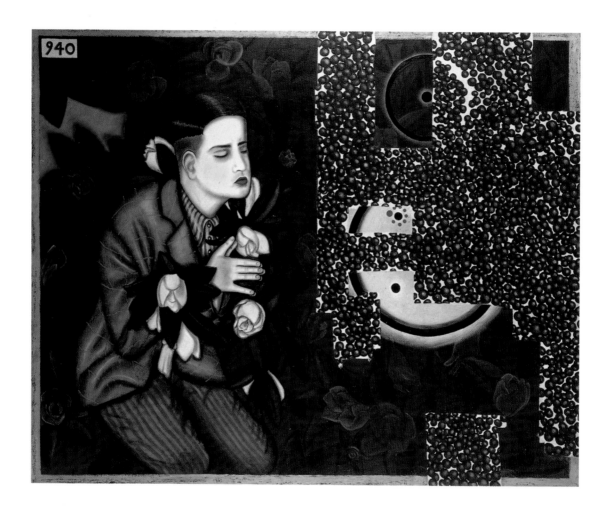

Boy Crying Magnolias (940), 1988

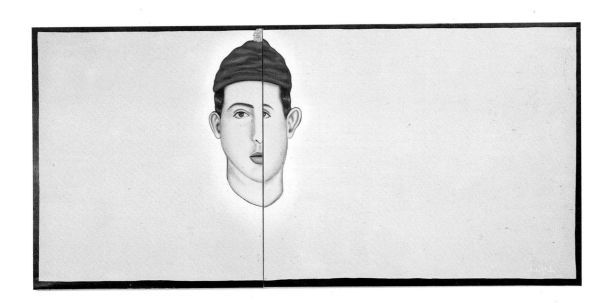

Hice Bien Quererte, 1990

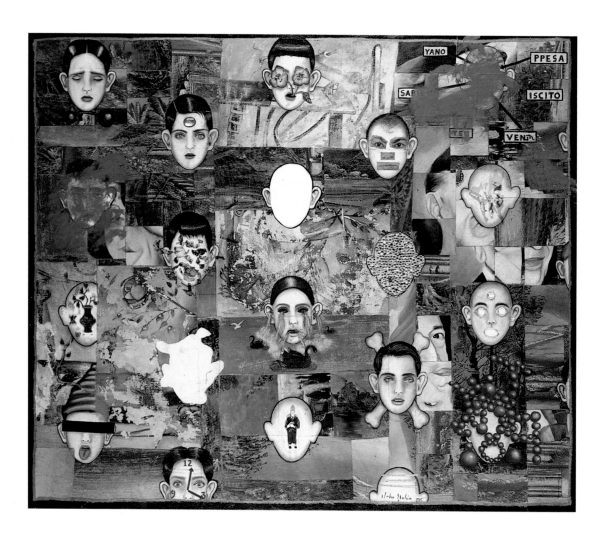

Ya No, 1988

142

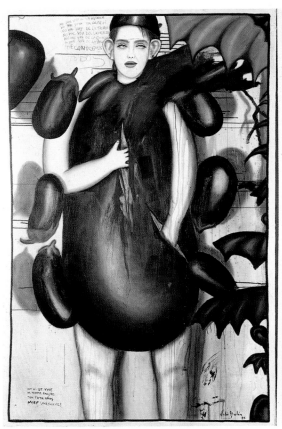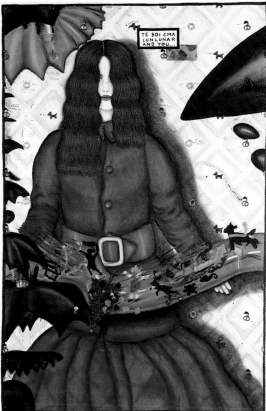

El Hermano (Niño Berengena y Niña Santa Claus), 1985

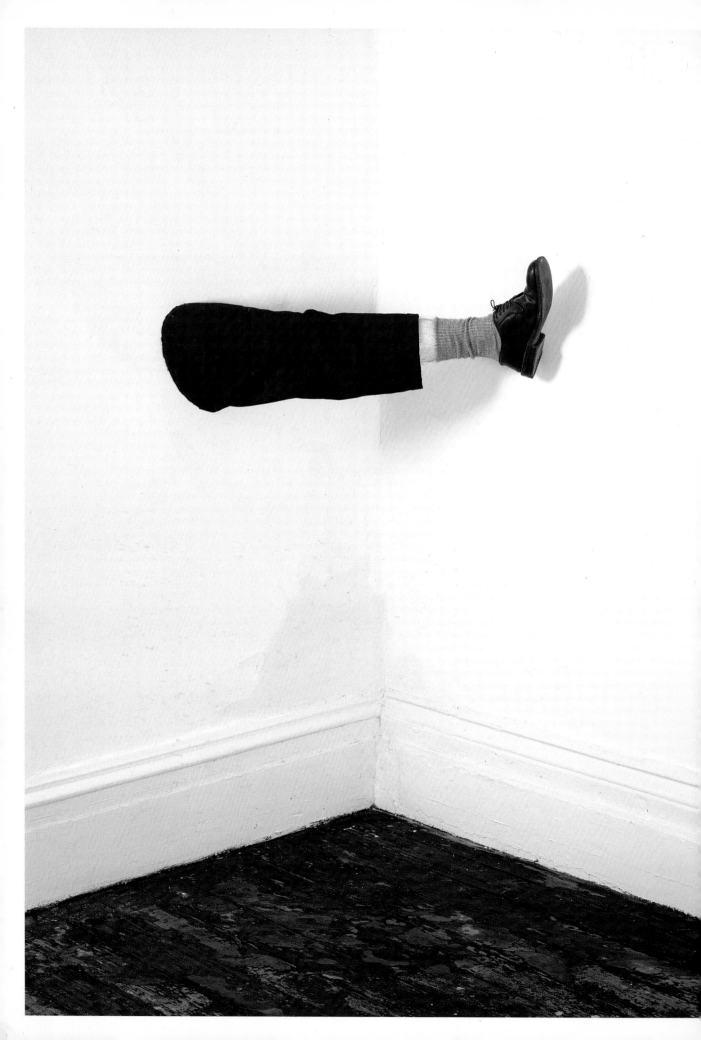

Untitled, 1991
Untitled, 1991

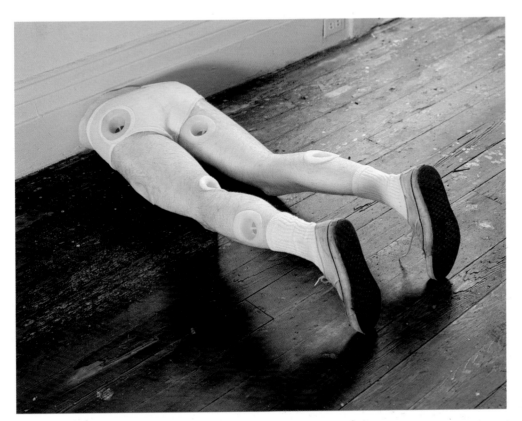

Snapshots of works in progress

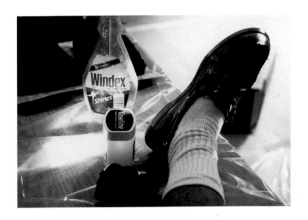
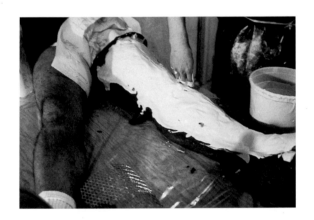
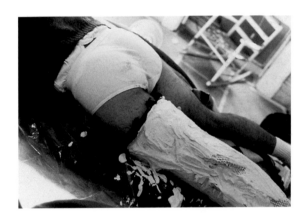
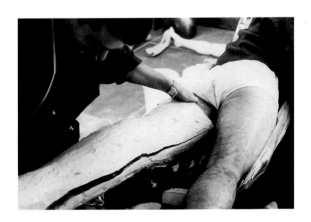

Karlsruhe, 1990

Börse, New York, 1991

Hechingen, 1990

Bremen, Autobahn, 1991

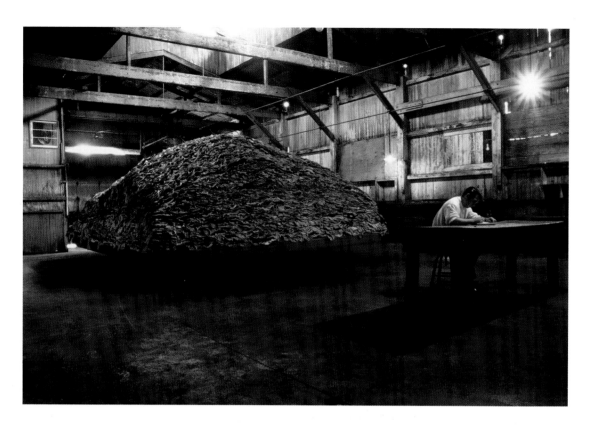

indigo blue, 1991, Places with a Past, Charleston, South Carolina

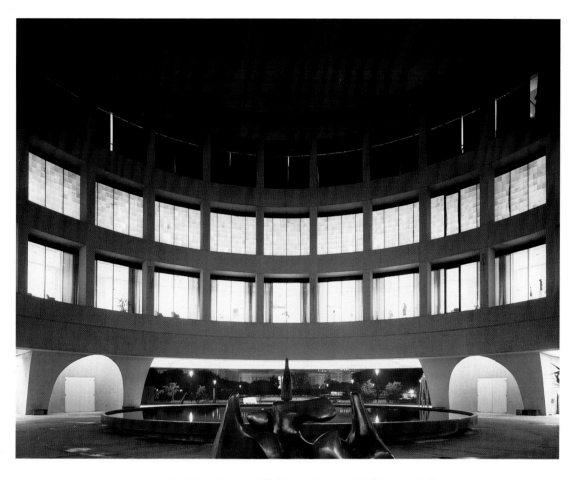

view, 1991, Works Project, Hirshhorn Museum, Washington, D.C.

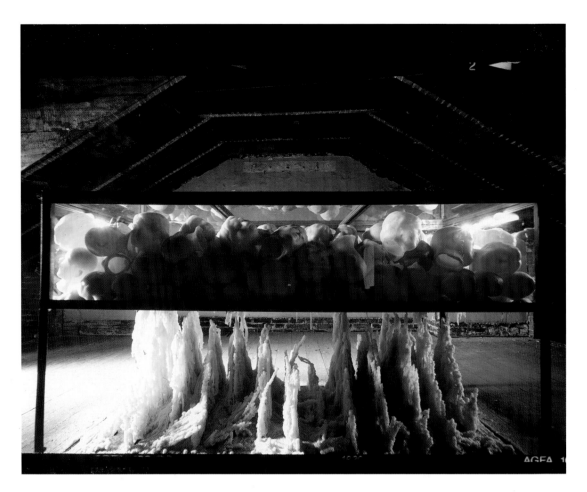

offerings, 1991–92, The Carnegie International, Pittsburgh

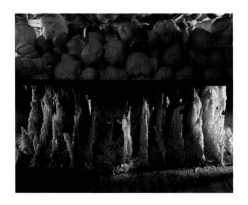

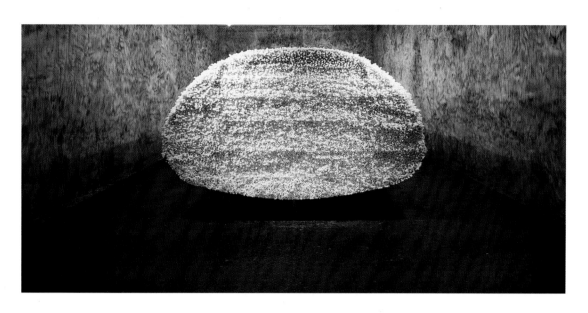

parallel lines, 1991, São Paulo Bienal

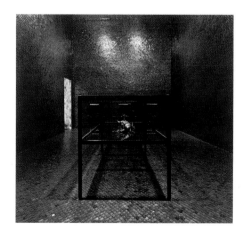

GARY HILL

Beacon (Two Versions of the Imaginary), 1990

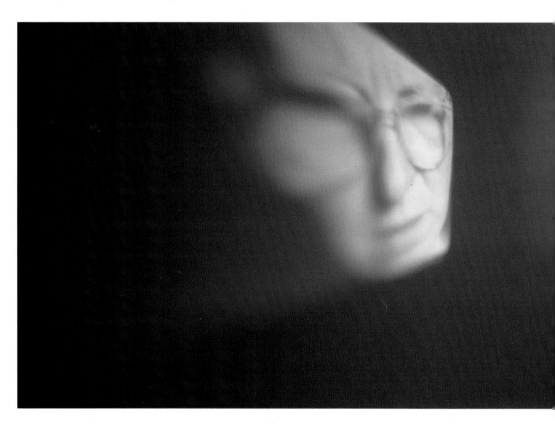

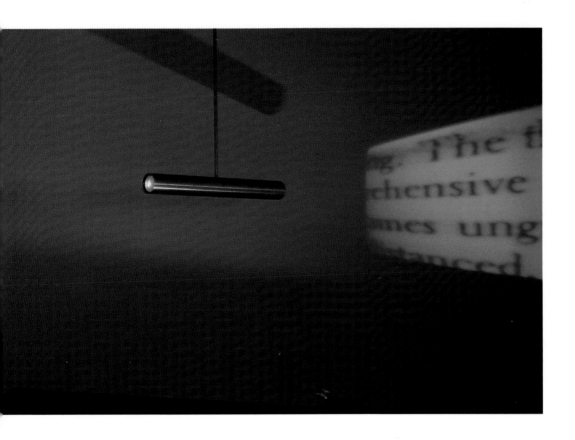

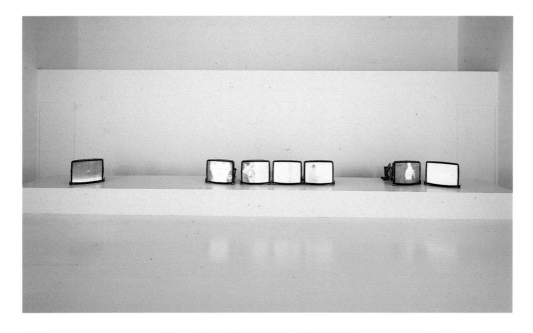

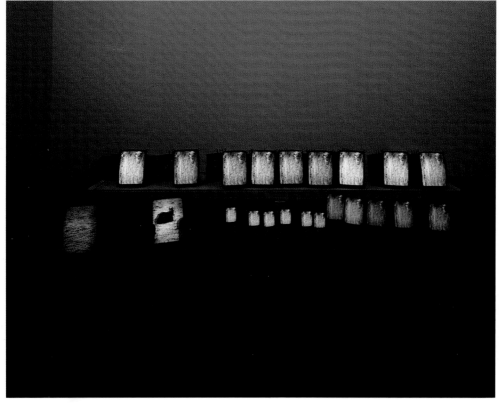

Disturbance (among the jars), 1988
Between Cinema and a Hard Place, 1991

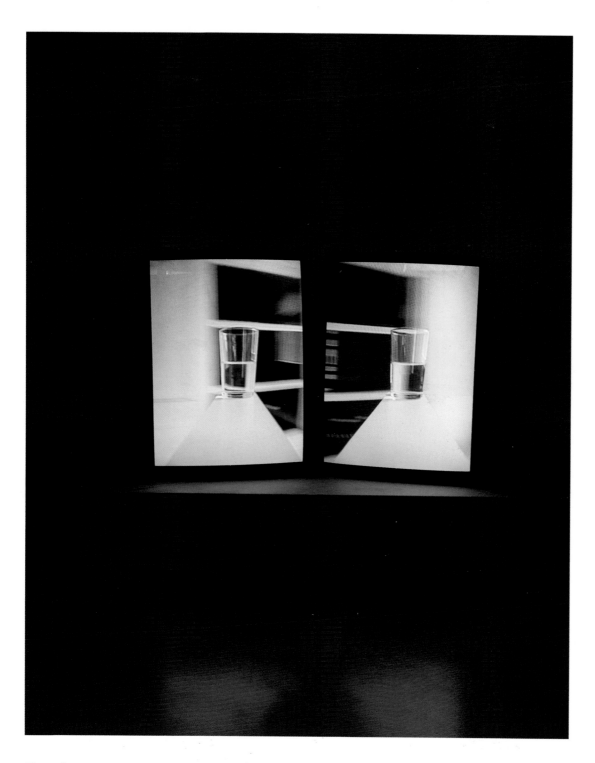

Glasses from Core Series, 1991

...WANT TO SCARE THE GIRLS AWAY
FROM DOING THE DELICIOUS
THINGS THEY'RE DOING.

...SWEETNESS, SCORN LIGHT. IT'S A
QUESTION OF FORM AS MUCH AS FUNCTION.
IT IS A MATTER OF REVULSION.

A REAL TORTURE WOULD BE TO
BUILD A SPARKLING CAGE WITH
2-WAY MIRRORS AND STEEL BARS.
IN THERE WOULD BE GOOD-LOOKING
AND YOUNG GIRLS WHO'LL THINK
THEY'RE IN A REGULAR MOTEL
ROOM SO THEY'LL TAKE THEIR
CLOTHES OFF AND DO THE
DELICATE THINGS THAT GIRLS DO
WHEN THEY'RE SURE THEY'RE
ALONE. EVERYONE WHO WATCHES
WILL GO CRAZY BECAUSE THEY
WON'T BE BELIEVING WHAT THEY'RE
SEEING BUT THEY'LL SEE THE BARS
AND KNOW THEY CAN'T GET IN.
AND, THEY'LL BE AFRAID TO
MAKE A MOVE BECAUSE THEY DON'T
WANT TO SCARE THE GIRLS AWAY
FROM DOING THE DELICIOUS
THINGS THEY'RE DOING.

DESTROY SUPERABUNDANCE. STARVE THE
FLESH, SHAVE THE HAIR, EXPOSE THE
BONE, CLARIFY THE MIND, DEFINE THE
WILL, RESTRAIN THE SENSES, LEAVE
THE FAMILY, FLEE THE CHURCH, KILL
THE VERMIN, VOMIT THE HEART, FORGET
THE DEAD. LIMIT TIME, FORGO
AMUSEMENT, DENY NATURE, REJECT
ACQUAINTANCES, DISCARD OBJECTS,
FORGET TRUTHS, DISSECT MYTH, STOP
MOTION, BLOCK IMPULSE, CHOKE SOBS,
SWALLOW CHATTER. SCORN JOY, SCORN
TOUCH, SCORN TRAGEDY, SCORN
LIBERTY, SCORN CONSTANCY, SCORN HOPE,
SCORN EXALTATION, SCORN REPRODUCTION,
SCORN VARIETY, SCORN EMBELLISHMENT,
SCORN RELEASE, SCORN REST, SCORN
SWEETNESS, SCORN LIGHT. IT'S A
QUESTION OF FORM AS MUCH AS FUNCTION.
IT IS A MATTER OF REVULSION.

A REAL TORTURE WOULD BE TO
BUILD A SPARKLING CAGE WITH

DESTROY SUPERABUNDANCE. STARVE THE
FLESH, SHAVE THE HAIR, EXPOSE THE

Inflammatory Essays, 1978–79, MOCA Los Angeles

THE MOUTH IS INTERESTING
BECAUSE IT IS ONE OF THOSE
PLACES WHERE THE DRY
OUTSIDE MOVES TOWARD
THE SLIPPERY INSIDE.

The Living Series, 1981–82

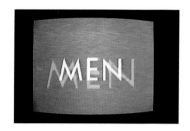

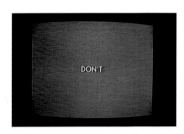

The Survival Series, 1983–85
(Men Don't Protect You Anymore)

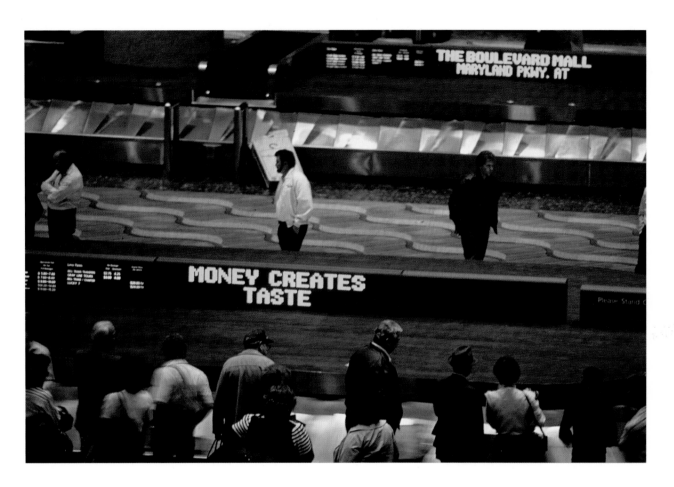

Truisms, 1986, McCarran Airport, Las Vegas

Domain Road & Environs: A Distanced View, 1987

North Terrace & Environs: A Distanced View, 1987

NARELLE JUBELIN

Sydney Heads & Environs: A Distanced View, 1987

Port Adelaide Light: A Distanced View, 1987

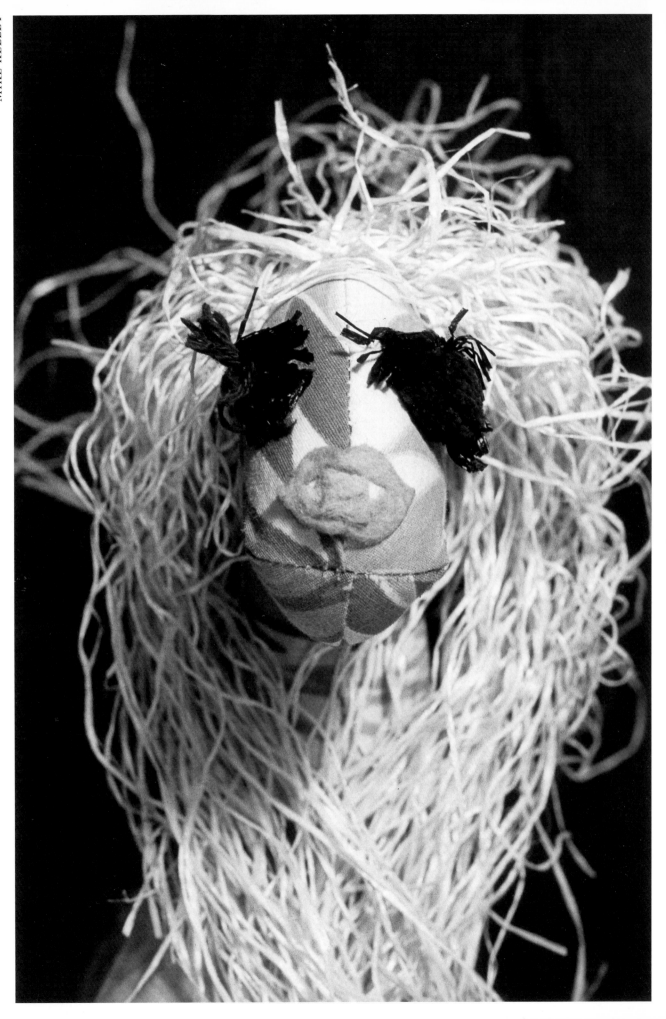

MIMI
CASE

VICKI
DAY

JULIE CRAWFORD

DEBBIE
MAY

TO A * * * * * * * * * * * * * * * *

* * * * * * * *

KATHI TARANTOLA

TO LAURA
* * * * * * * * * *
ALWAYS
* * * * * * * *
* * * * * * * *

TO A
UBB
NUT
LUV
KIM

LUCK
WITH
TOM
NANCY
MAXWELL

JAN
PE* * * * *
J* * * * *
* * * * * * * *
SHERRIE
McCLEAVE

SUE CASE

* * * * * * * * *
YOU K* * * * * *

BEAUTIFUL

BARBARA
McCLEAVE

* * * * * * * *
LUV IN
* * * * * * * *
* * * * * *
* * * *

* * * *
* * * *

LUV
JANE
DAVIE
McMAHON

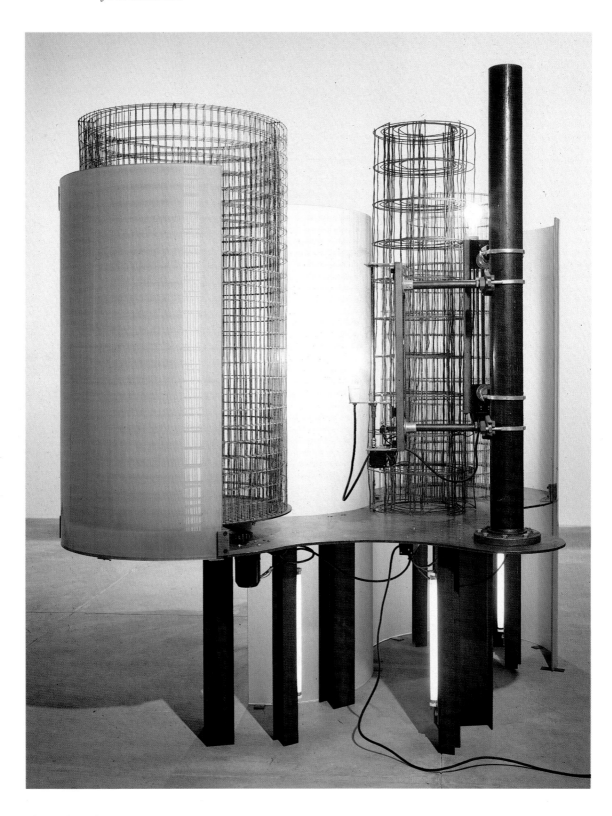

The Decline of the West, 1991

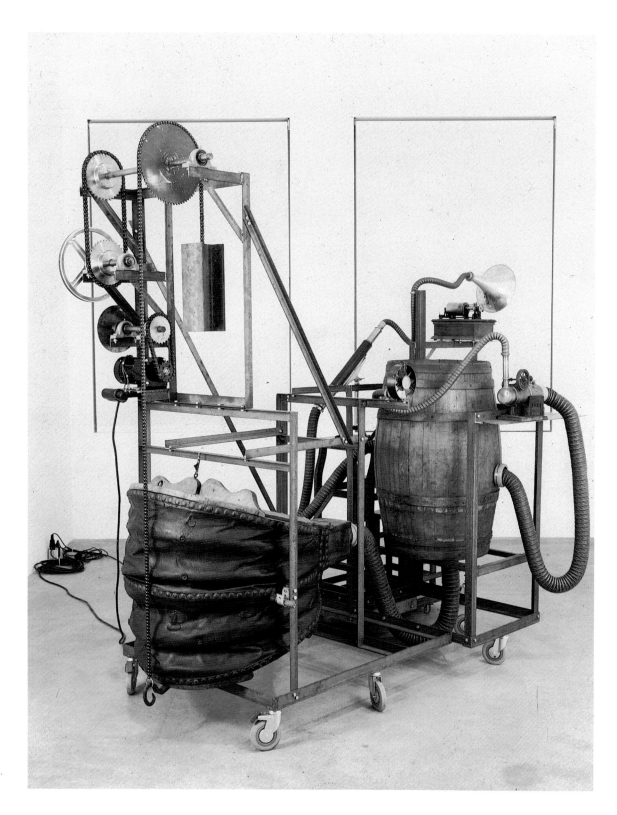

Arts et Metiers, 1989

JON KESSLER City, 1989

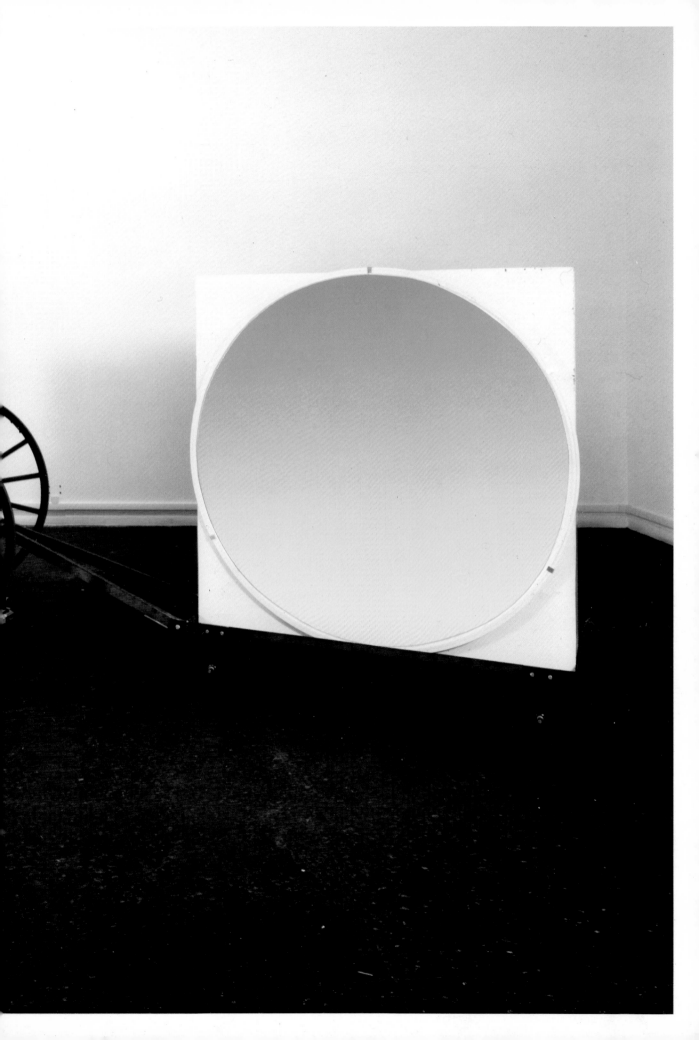

JEFF KOONS

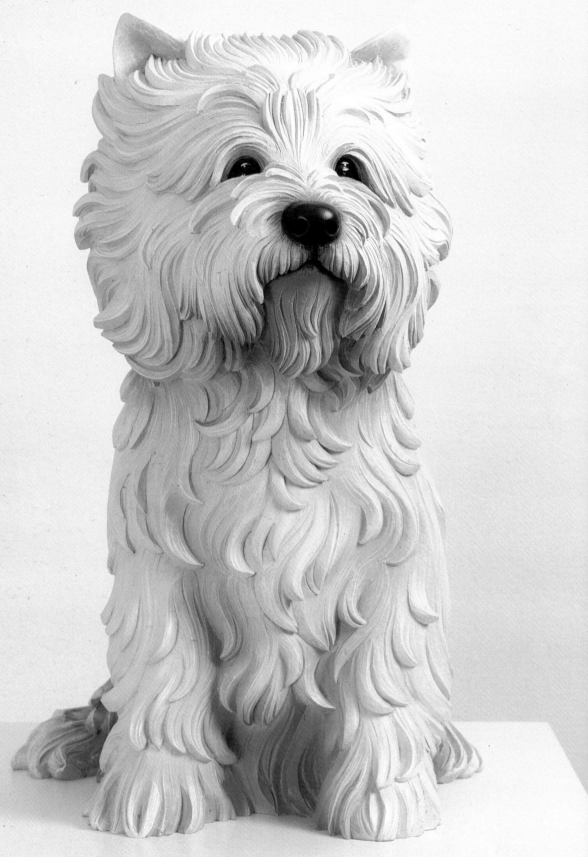

White Terrier

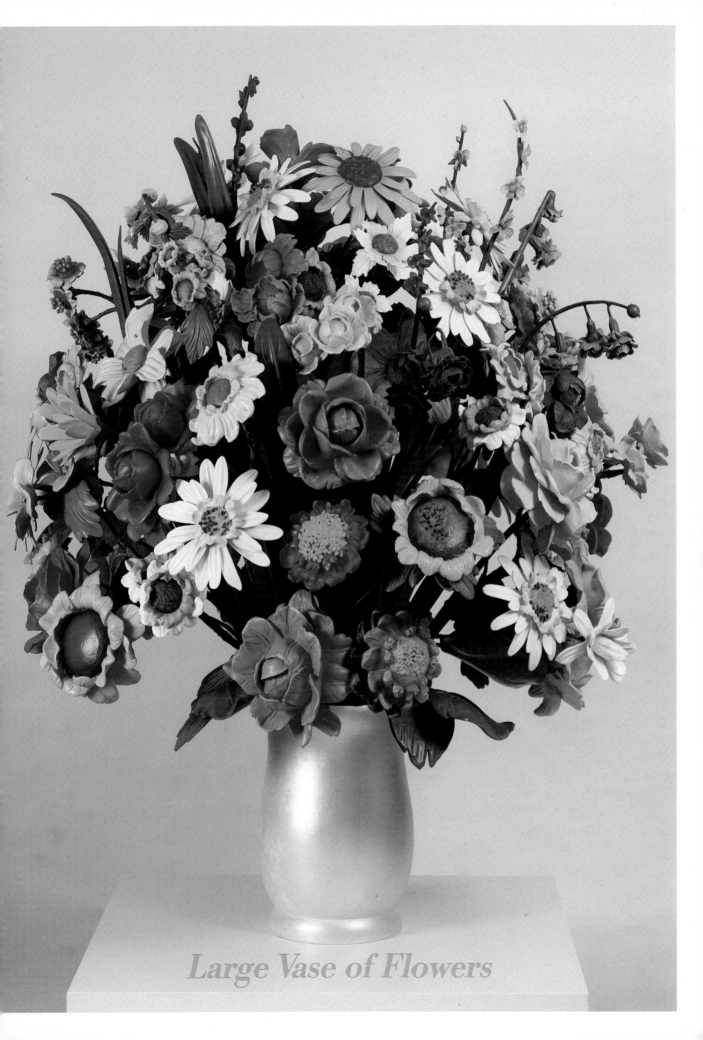

Large Vase of Flowers

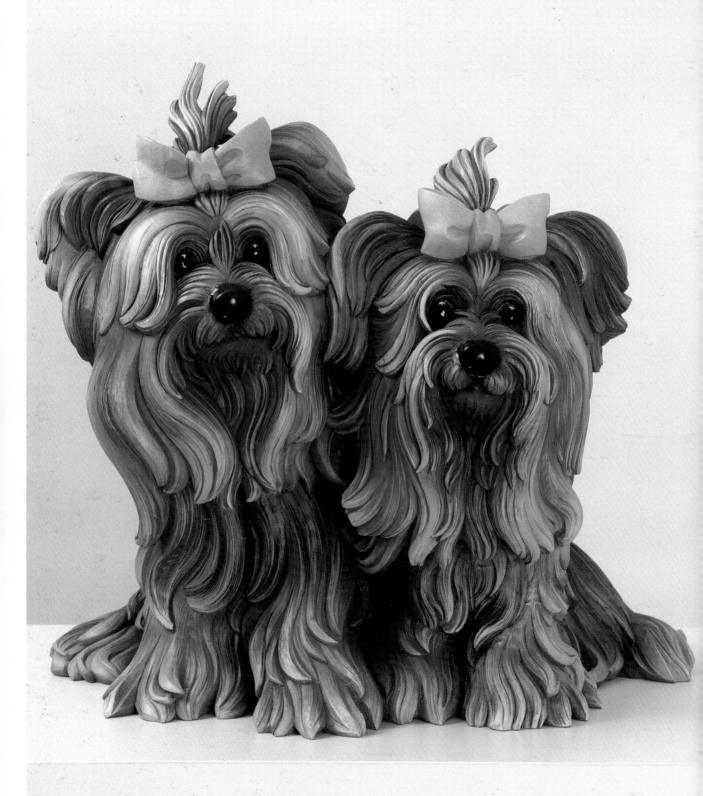

Yorkshire Terriers

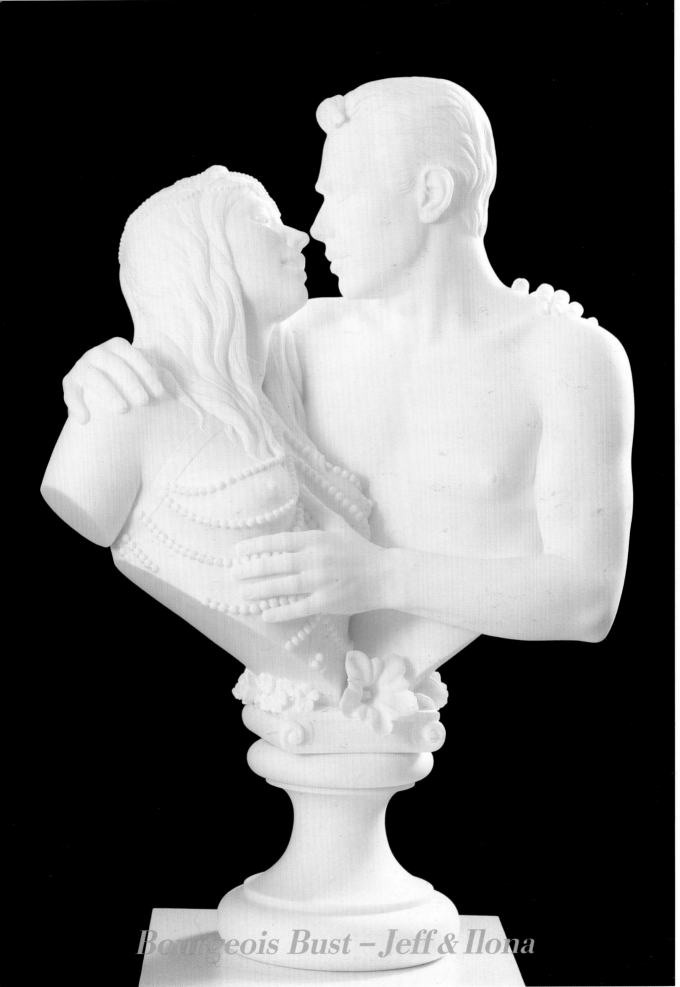

Bourgeois Bust – Jeff & Ilona

He is one of the four defendants
who live at the Schomberg Plaza
a tan high rise overlooking a
drained pool at the northern
end of Central Park. The fif-
teen year old, who is charged
with raping and beating the
victim with a pipe, was des-
cribed as a particularly shy boy.
Neighbors said his father, who
they said was a madman, en-
forced curfews for Steve and
his two younger brothers.
Neighbors said the boy's mot-
her worried about negative
influences. "He was always
at home, his mother raised him
at home," said a woman in the
building. A member of the Ten-
ants Council, Marilyn Davis, at
the building, added "He's so
shy he didn't even look at girls.
A young girl who gave her name
as Michelle and who lives in the
Schomberg Plaza said she had
always thought of the youth
as a loner who would shoot
baskets by himself. There was
something sad about him, she
said "I think he wanted to be liked

A Loner, Shy and Sad, 1990–91

Antron, 15, lives at 40-44 West
111th Street, around the corner
from the Schombery towers in
a well-kept two-story complex
of rehabilitated apartments. His
mother, Linda, works in a day
care center, and his father, Bob-
by, is a mechanic who coaches
a local baseball team called
Vago Vejo. Antron played third
base for the team, which last
year traveled to a tournament
in Puerto Rico. The father was
well known in the neighbor-
hood as a role model and dis-
ciplinarian. "If he were to see
some kids doing something
wrong, he would jump right in,"
said Anthony Ortiz, 16. Other
neighbors said they saw young
McCray headed for school each
day. He was a student at J.H.S.
117, attending a program known
as the Career Academy. Another
neighborhood youth, Jimmy San-
tiago, said McCray's parents im-
posed a midnight curfew. Most
friends said that they were
shocked and spoke of the youth
as a well-behaved young man.

However, Sandra Thomas, 15, said
she thought of him as aggressive.
"He had an attitude," she said.
"He liked to joke but he was
a little wild."

Son of a Role Model, 1990–91

SPEECHLESS To dream that you are unable to speak is a sign of adversity and shame 348

To regain your voice denotes others will no longer speak for you

No. 348 (from Dreambook series), 1990

HISTORY To dream of
reading or studying history
denotes you will visit histor-
ical scenes 333

Some of these scenes will be
terribly impressive.

No. 333 (from Dreambook series), 1990

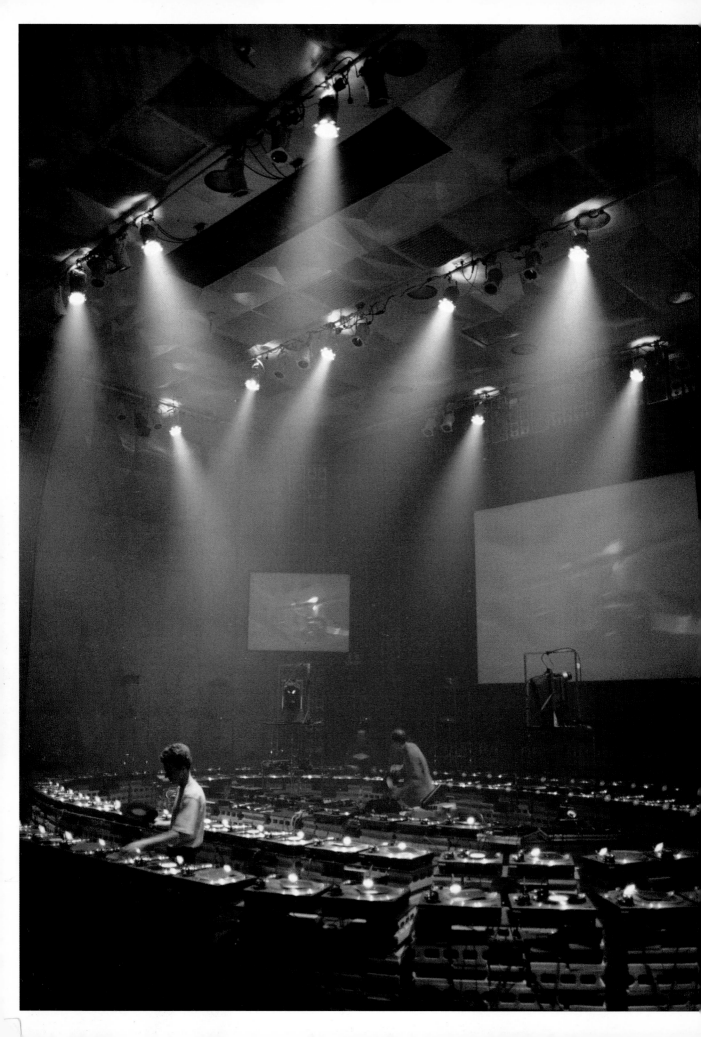

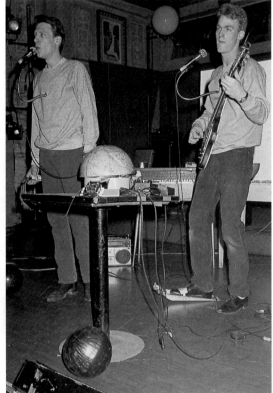

Christian Marclay at Institut Unzeit, Berlin, 1988

The Bachelors, Even by Christian Marclay and Kurt Henry, Boston, 1980

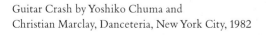

Guitar Crash by Yoshiko Chuma and
Christian Marclay, Danceteria, New York City, 1982

New York Objects and Noise,
Christian Marclay at the Willisau Jazz Festival, 1984

CHRISTIAN MARCLAY

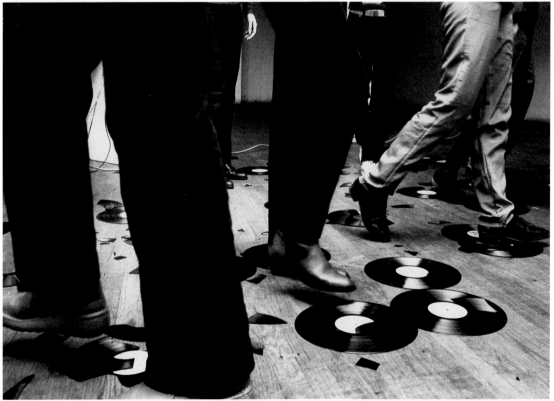

Dead Stories, The Performing Garage, New York City, 1986

Record Players, The Kitchen, New York City, 1982

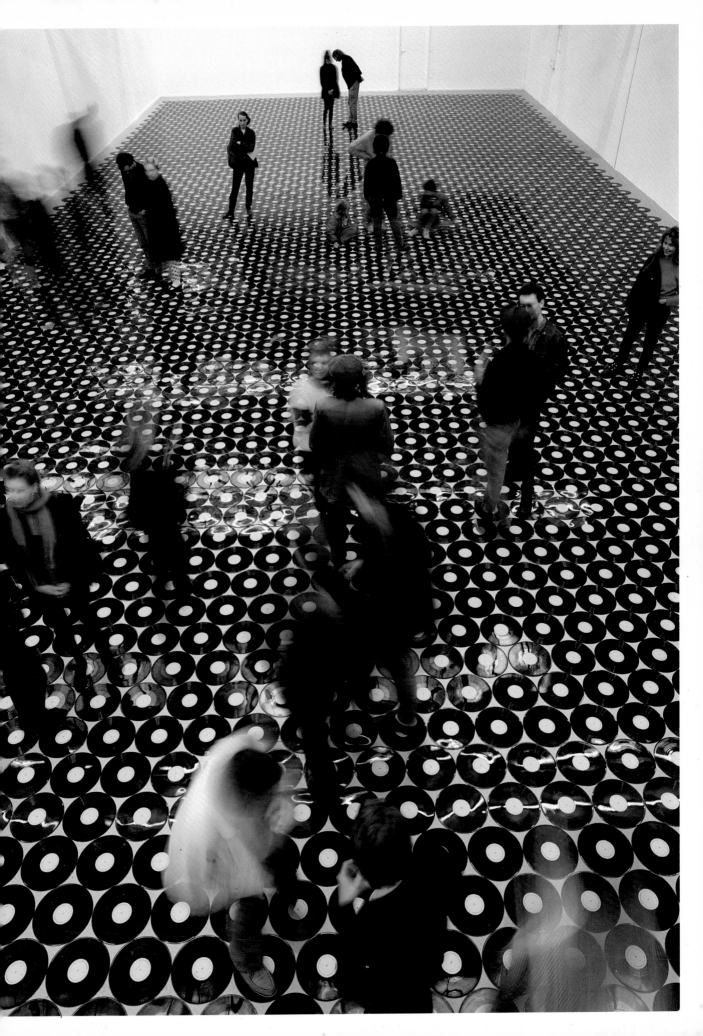

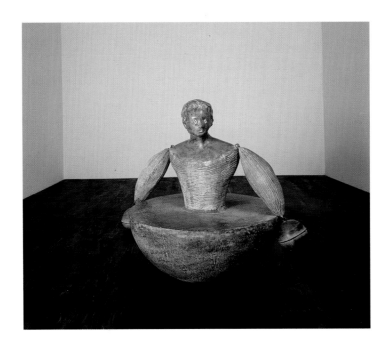

Bailarina, 1990

Un Mes Antes, 1988

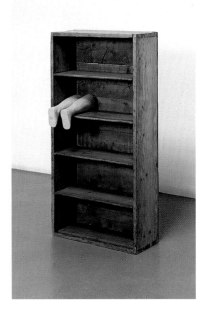

Estudio para el apuntador, 1991

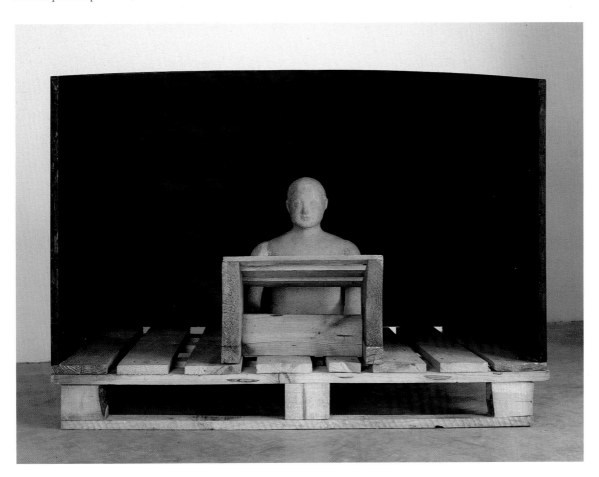

SIMON PATTERSON

rine the Great *William the Conqueror* *William Shatner* *George Takei* *Leonard Nimoy* *Fra Bartolommeo*

Untitled, Milch Gallery, London, 1990

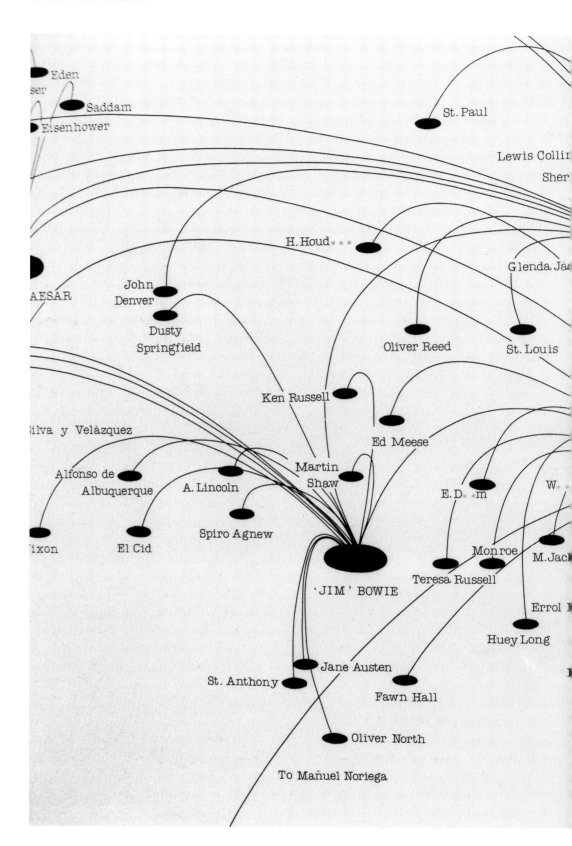

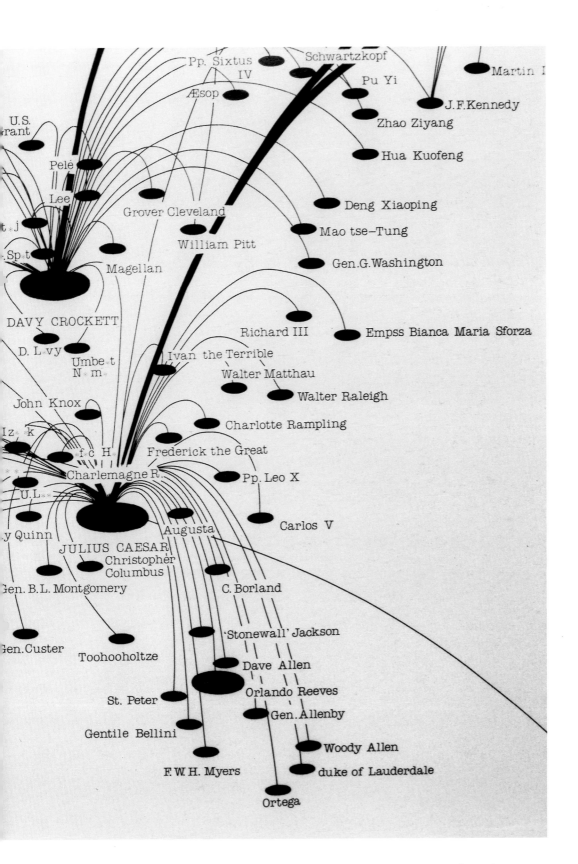

Detail of wall drawing, Transmission Gallery, Glasgow, 1991

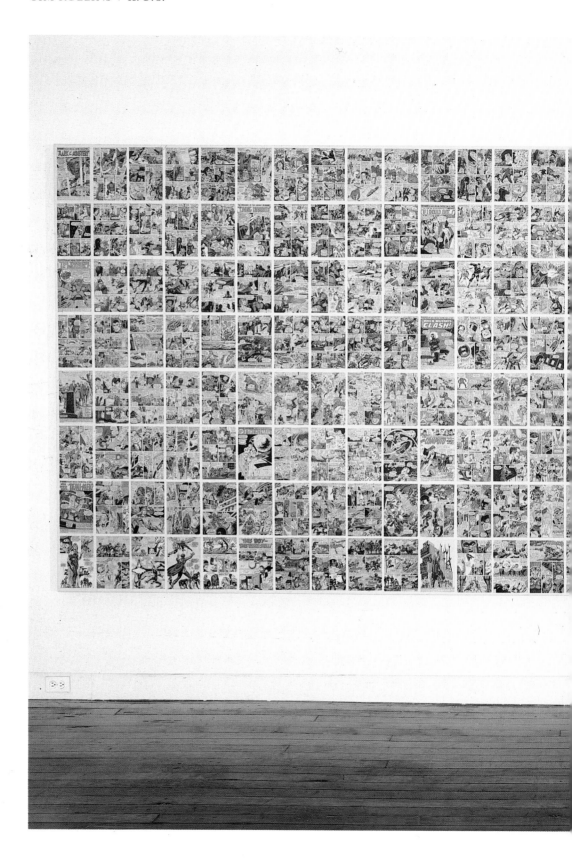

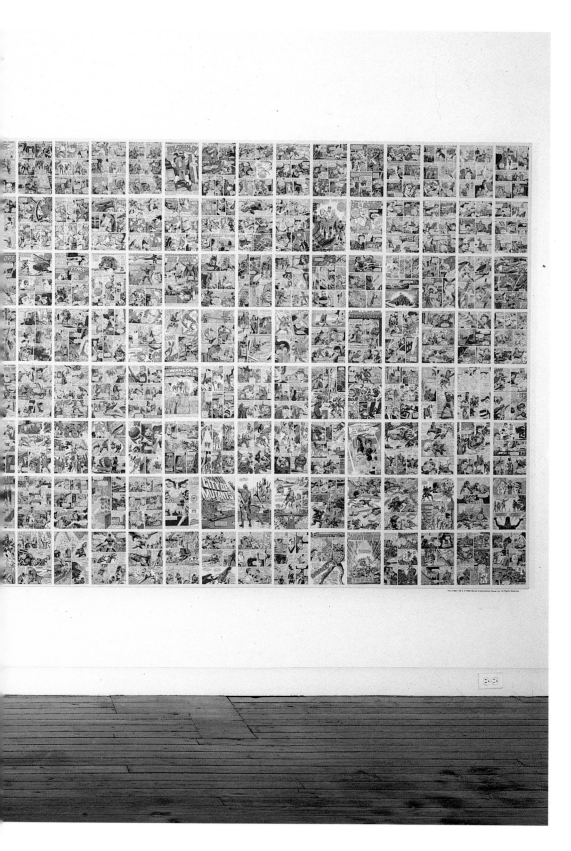

X-Men, 1968, 1990

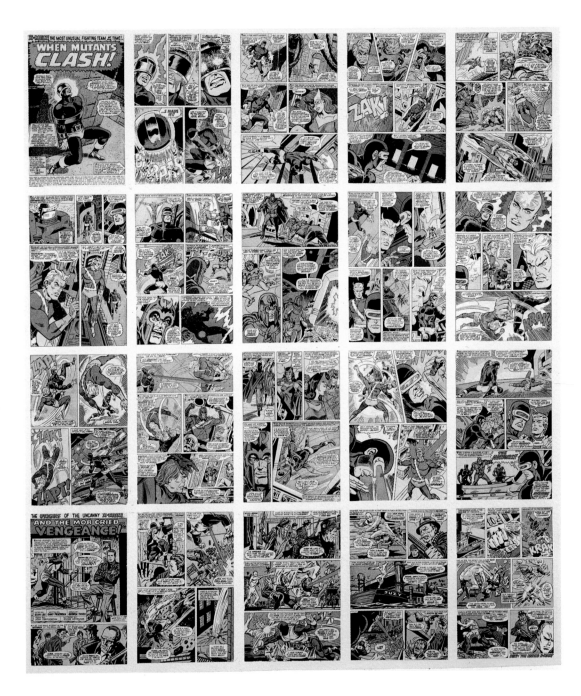

X-Men No 45 – When Mutants Clash, 1990

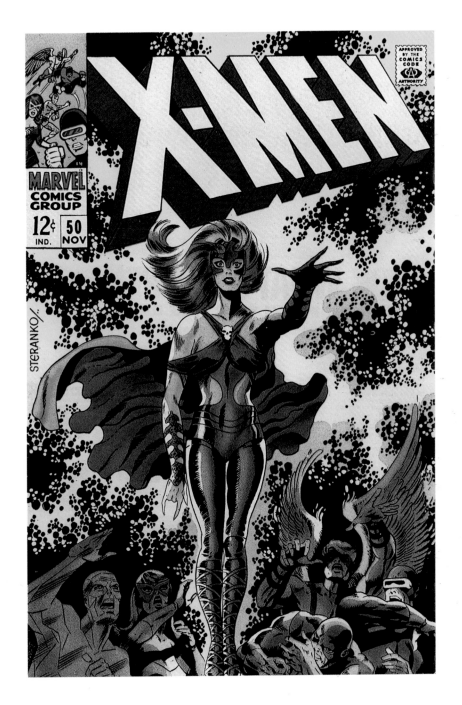

X-Men No 50 Cover, 1991

Le Quattro Stagioni : Primavera, 1990–1991

Le Quattro Stagioni : Estate, 1990–91

Le Quattro Stagioni : Autunno, 1990–91

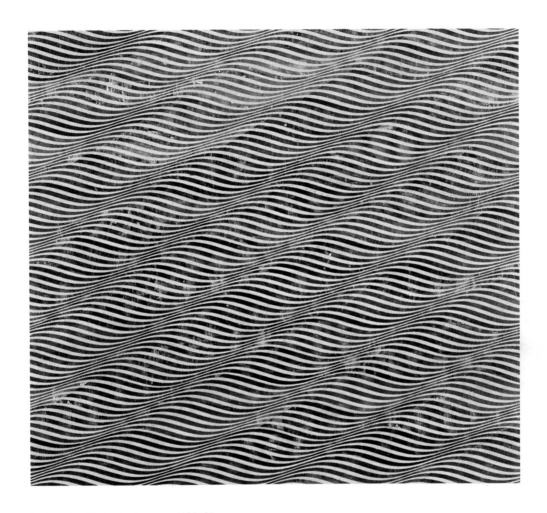

Le Quattro Stagioni : Inverno, 1990–91

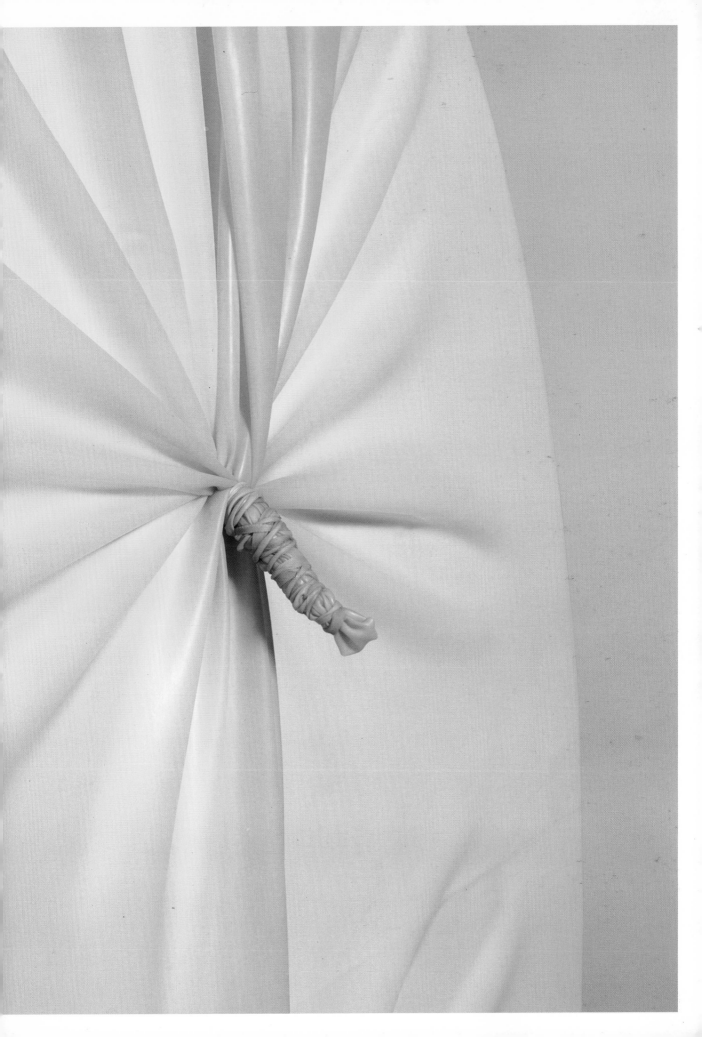

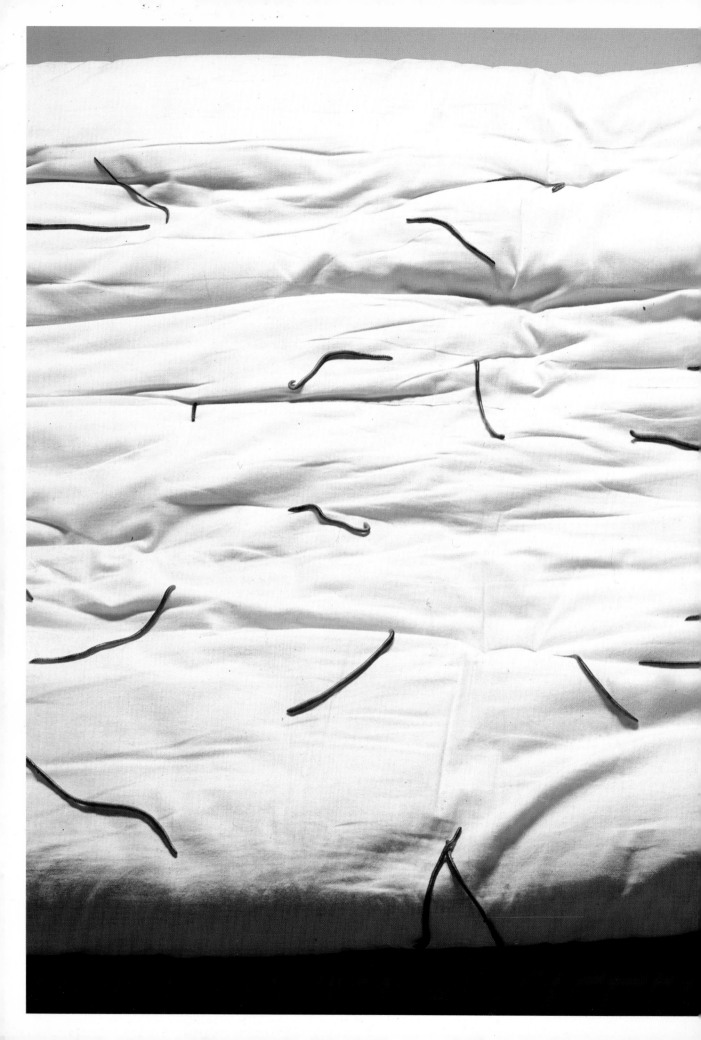

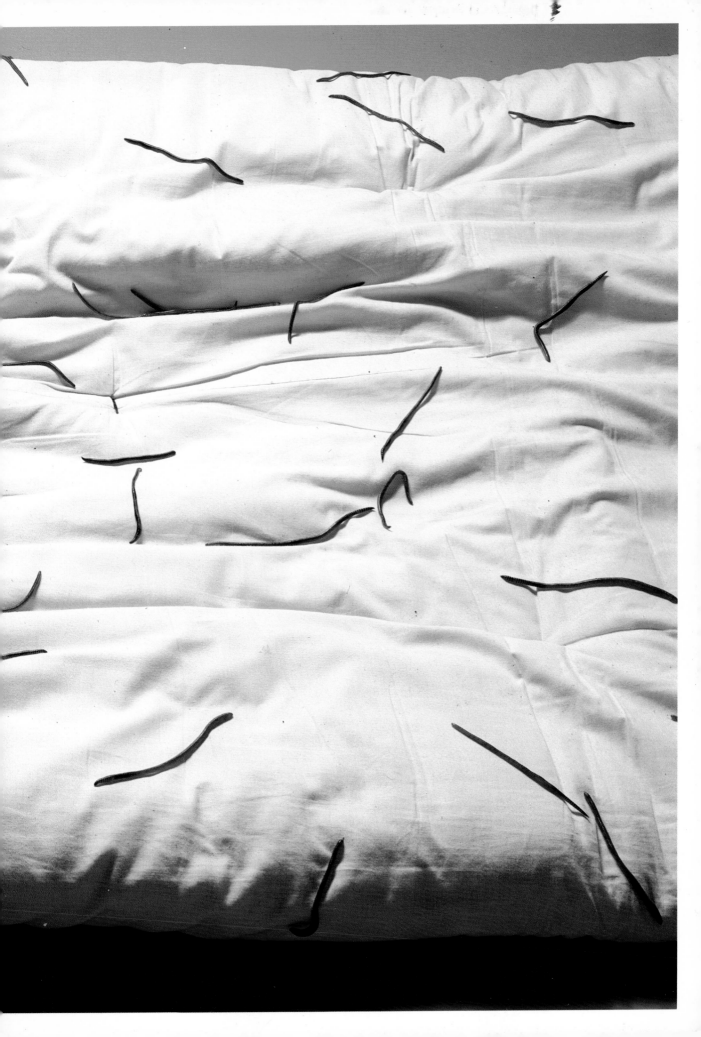

Untitled, 1991

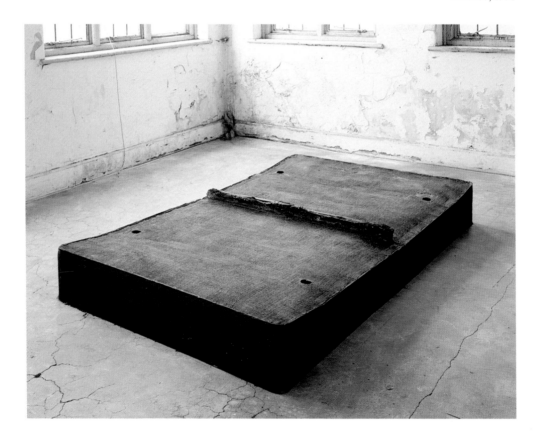

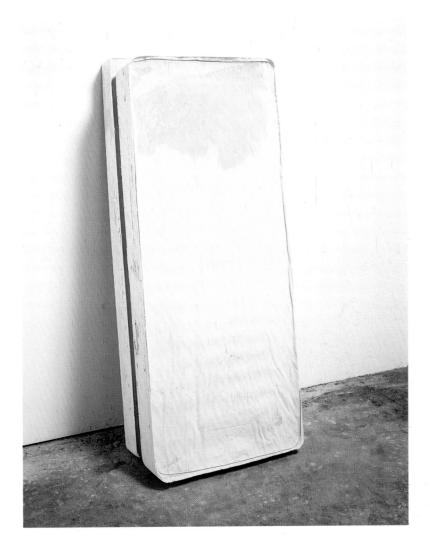

Untitled (Yellow Bed, Two Parts), 1991

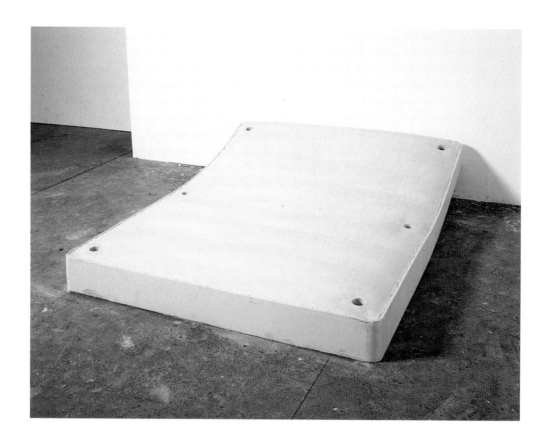

Untitled (White Sloping Bed), 1991

Untitled (Amber Slab), 1991

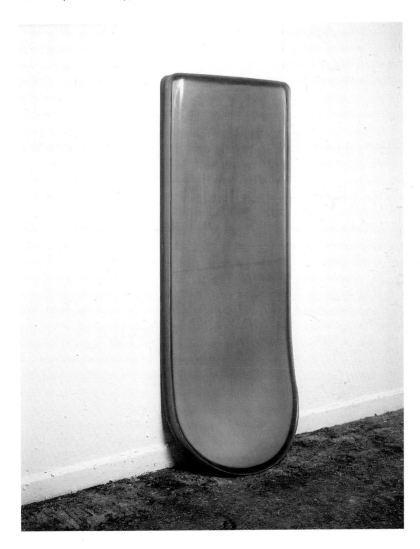

Index and Captains to Artists' Plates

STEPHAN BALKENHOL

p 120
Münster Projekt, 1987
Photo: S. Balkenhol

p 121
Städelgarten Projekt (Nischenfigur), 1991
Photo: S. Balkenhol

p 122
Grosses Kopfrelief (Mann), 1991
Dyed seasoned poplar; 144 x 126 x 14 cm
Galerie Löhrl, Mönchengladbach

p 123
Grosser Kopf (Mann), 1991
Painted wawa-wood; 100 x 75 cm
Lembach Haus, Münster

SOPHIE CALLE

pp 124–127
Cash Machine, 1991
4 black and white photographs; each 95 x 73 cm
Courtesy Galerie Crousel-Robelin/BAMA

SAINT CLAIR CEMIN

p 128
Soap Elephant, 1987
Bronze, pink patina; 19 x 17.7 x 22.8 cm
Courtesy Robert Miller Gallery, New York

p 128
Iron Baby, 1987
Cast iron; 63.5 x 60.9 x 73.6 cm
Courtesy Robert Miller Gallery, New York

p 129
Washdog, 1990
Bronze; 128 x 120 x 56 cm
Galerie Thaddaeus Ropac

p 130
Aquarella, 1990
Bronze and watercolour pigment
20.3 x 61 (diam.) cm
Galerie Thaddaeus Ropac

p 131
Guardian Angel, 1990
Steel construction and painted plaster
335 x 152 x 152 cm
Galerie Thaddaeus Ropac

PETER FISCHLI / DAVID WEISS

pp 132–135
Untitled installation, Cham, Switzerland, 1991
Painted polyurethane objects in a garage

KATHARINA FRITSCH

pp 136/137
Stefan George, Der kindliche Kalender

p 138
Hellgrünes Bild, 1991

Wood, cotton, paint and polystyrol foil,
140 x 100 x 8 cm

p 139
Oranges Bild, 1991
Wood, cotton, paint and polystyrol foil,
140 x 100 x 8 cm

both: Photo: Richard A. Stoner
Courtesy Jablonka Gallery, Cologne

JULIO GALÁN

p 140
Boy Crying Magnolias (940), 1988
Oil on canvas; 175 x 195 cm
Collection Family H. de Groot, Groningen

p 141
Hice Bien Quererte, 1990
Diptych, oil on canvas; 199.4 x 430.5 cm
Collection Janet de Botton, London

p 142
Ya No, 1988
Oil and collage on canvas with hole
160 x 190 cm
Private collection

p 143
El Hermano (Niño Berengena y Niña Santa Claus),
1985
Oil on canvas with antique ornaments
Two panels, 177.5 x 244 cm;
total 355 x 244 cm
Collection Thomas Ammann, Zürich

ROBERT GOBER

p 144
Untitled, 1991
Wood, wax, leather, cotton, human hair, steel
25.4 x 90.2 x 69.8 cm
Photo: Andrew Moore
Courtesy Paula Cooper Gallery, New York

p 145
Untitled, 1991
Wood, wax, human hair, fabric, fabric paint, shoes
22.8 x 42 x 114.3 cm
Collection of the artist
Photo: Andrew Moore
Courtesy Paula Cooper Gallery, New York

pp 146/147
Snapshots of works in progress
New York City, November 1991

ANDREAS GURSKY

p 148
Karlsruhe, 1990; 170 x 200 cm

p 149
Börse New York, 1991; 167 x 200 cm

p 150
Hechingen, 1990; 160 x 205 cm
p 151
Bremen, Autobahn, 1991; 165 x 196 cm

ANN HAMILTON

p 152
indigo blue, May 1991–August 1991, Places with a
Past, Charleston, South Carolina
Elements: steel, wood, work clothing, books:
erased, cloth, soybeans
Courtesy Louver Gallery, New York

plus detail

p 153
view, March 1991–June 1991, *Works* Project
Hirshhorn Museum and Sculpture Garden,
Washington, D.C.
Collaboration with Kathryn Clark
Elements: blind stamped wax
Courtesy Louver Gallery, New York
Photo: Lee Stalzberg

plus detail
Photo: Kathryn Clark

p 154
offerings, October 1991–February 1992
The Carnegie International, Pittsburgh
Elements: steel, glass, wax: melting, canaries
Courtesy Louver Gallery, New York
Photo: Michael Olijnyk

plus detail

p 155
parallel lines, September 1991–December 1991,
São Paulo Bienal, São Paulo, Brazil
Elements: copper tokens, steel, candles, glass,
turkey carcasses, dermisted beetles, soot
Courtesy Louver Gallery, New York
Photo: Richard Ross

GARY HILL

pp 156/157
Beacon (two Versions of the Imaginary), 1990
2 videotapes, 2 black and white monitors with
projection lenses, aluminium tubing, motor
Collection Stedelijk Museum, Amsterdam

p 158
Between Cinema and a Hard Place, 1991
3 videotapes, 23 monitors, computer
controlled switcher
Courtesy Donald Young Gallery, Seattle

p 158
Disturbance (among the jars), 1988
7 videotapes, 7 monitors, stereo sound
Collection Musée National d'Art Moderne,
Paris

p 159
Glasses from Core Series, 1991
1 videotape, 2 monitors, electronic switch
Courtesy Galerie des Archives, Paris

JENNY HOLZER

p 160
Inflammatory Essays, 1978–79
Installation View
A Forest of Signs
Museum of Contemporary Art, 7 May –
13 August, 1989
Los Angeles, California
Courtesy Barbara Gladstone Gallery, New York

p 161
The Living Series, 1981–82
Cast bronze plaque, 12.7 x 25.4 cm
Courtesy Barbara Gladstone Gallery, New York
p 162
The Survival Series, 1983–85
(Men Don't Protect You Anymore)
Untitled video stills
Courtesy Barbara Gladstone Gallery, New York

p 163
Truisms, 1986
Hexodecimal electronic display signboard,
243.8 x 396.2 cm
Installation, baggage carousels, McCarran
International Airport, Las Vegas
Organised by Nevada Institute of
Contemporary Art, University of Nevada, Las Vegas
Courtesy Barbara Gladstone Gallery, New York

NARELLE JUBELIN

p 164/165
Domain Road & Environs: A Distanced View, 1987
Found English oak frame, cotton petit-point
21.3 x 100.7 cm
Collection Vivienne Sharpe

pp 164/165
North Terrace & Environs: A Distanced View, 1987
Found English oak frame, cotton petit-point
22.0 x 59.7 cm
Collection Vivienne Sharpe

p 166
Sydney Heads & Environs: A Distanced Viw, 1987
Found English oak frame, cotton petit-point
18.0 x 39.5 cm
Collection Joan Kerr, Sydney

p 166
Port Adelaide Light: A Distanced View, 1987
Found English oak frame, cotton petit-point
21.8 x 36.8 cm
Collection Joe Wissert, Woollahra

p 167
Sydney Heads & Environs: A Distanced View
(detail), 1987

MIKE KELLEY

p 168

'No man, however highly civilized, can listen for long to African drumming, or Indian chanting, or Welsh hymn-singing, and retain intact his critical and self-conscious personality. It would be interesting to take a group of the most eminent philosophers from the best universities, shut them up in a hot room with Moroccan dervishes or Haitian voodooists and measure, with a stop watch, the strength of their psychological resistance to the effects of rhythmic sound. Would the Logical Positivists be able to hold out longer than the Subjective Idealists? Would the Marxists prove tougher than the Thomists or the Vedantists? What a fruitful field for experiment! Meanwhile, all we can safely predict is that, if exposed long enough to the tom-toms and the singing, every one of our philosophers would end up by capering and howling with the savages.' Aldous Huxley

p 169

Imagination lies in wait as the most powerful enemy. Naturally raw, and enamored of absurdity, it breaks out against all civilizing restraints like a savage who takes delight in grimacing idols.' Goethe.

p 170

Rightward Slant No. 1

p 171

Rightward Slant No. 2

JON KESSLER

p 172

The Decline of the West, 1991
Wagon, glass, steel, tyre, lights, motor
396.2 x 122 x 228.6 cm
Collection of the artist

p 173

Arts et Metiers, 1989
Steel, glass, antiques, motor, rubber hose, amplifyer; 226 x 289.5 x 150 cm
Collection of the artist

pp 174/175

City, 1989
Glass, steel, steel mesh, meters, lights
233.7 x 228.6 x 152.4 cm
Collecton of Emily Fisher Landau

JEFF KOONS

p 176

White Terrier, 1991
Wood, edition of 3
52 x 35.6 x 50.8 cm

p 177

Large Vase of Flowers, 1991
Wood, edition of 3
132 x 109.2 x 109.2 cm

p 178

Yorkshire Terriers, 1991
Wood, edition of 3
44.4 x 52.1 x 43.2 cm

p 179

Bourgeois Bust – Jeff and Ilona, 1991
Marble, edition of 3
113 x 71.1 x 53.3 cm

GLENN LIGON

p 180

A Loner, Shy and Sad, 1990–91
Oil on canvas; 81.3 x 55.8 cm
Collection of Emily Fisher Landau, New York
Courtesy Max Protetch Gallery, New York

p 181

Son of a Role Model, 1990–91
Oil on canvas; 95.9 x 55.8 cm
Collection of Emily Fisher Landau, New York
Courtesy Max Protetch Gallery, New York

p 182

No. 348 (from *Dreambook* series), 1990
Oil on paper; 76.2 x 57.2 cm
Collection of Emily Fisher Landau, New York
Courtesy Max Protetch Gallery, New York

p 183

No. 333 (from *Dreambook* series), 1990
Oil on paper; 76.2 x 57.2 cm
Collection of Emily Fisher Landau, New York
Courtesy Max Protetch Gallery, New York

CHRISTIAN MARCLAY

p 184

One Hundred Turntables by Christian Marclay with Jazzy Joyce, Yoshide Otomo, Nicolas Collins. Lights and video by Perry Hoberman. P/N Hall, Tokyo, 1991

p 185

Christian Marclay at Institut Unzeit, Berlin, 1988
Photo: Ulf Erdman-Ziegler

p 185

The Bachelors, Even by Christian Marclay and Kurt Henry, Eventworks, Boston, 1980
Photo: P. Noel

p 185

Guitar Crash by Yoshiko Chuma and Christian Marclay, Danceteria, New York City, 1982
Photo: Jacob Burckhardt

p 185

New York Objects and Noise, Christian Marclay at the Willisau Jazz Festival, Switzerland, 1984
Photo: Leonard Mühlheim

p 186

Dead Stories, The Performing Garage, New York City, 1986

Top row: David Garland, David Moss, René Cendre.
Bottom row: Shelley Hirsh, Sheila Schonbrun, Susie
Timmons; Photo: Kery Pickett

p 186
Record Players, The Kitchen, New York City,
1982; Photo: Paula Court

p 187
Footsteps, The Shedhalle, Zürich
1989; Photo: Werner Graf

JUAN MUÑOZ

pp 188/189
N.Y. Floor Piece, 1991
Bronze, steel, rubber
Left figure 76.2 x 35.6 x 38.1 cm
Right figure 76.2 x 43.2 x 38.1 cm
Shelf 92.7 x 2.54 cm
Courtesy Galería Marga Paz

p 190
Un Mes Antes, 1988
Resin, sand, wood
106 x 53 x 30 cm
Courtesy Galería Marga Paz

p 190
Bailarina, 1990; Bronze; 55 x 66 x 65 cm
Courtesy Galería Marga Paz

p 191
Estudio para el apuntador, 1991
Wood, terracotta
58 x 117 x 67 cm
Courtesy Galería Marga Paz

SIMON PATTERSON

pp 192/193
Untitled
First exhibited Milch Gallery, London,
October 1990
Collection of Nell & Jack Wendler

pp 194/195
JP 233
Detail of wall drawing
Exhibited Transmission gallery, Glasgow, August 1991
Photo: Dave Allen
Collection of the artist

TIM ROLLINS + K.O.S.

pp 196/197
X-Men 1968, 1990
193 x 492.8 cm
Acrylic/paper, linen
Collection of Fredrik Roos

p 198
X-Men No. 45 – When Mutants Clash, 1990
96.5 x 83.8 cm
Acrylic/paper, linen

p 199
X-Men No. 50 Cover, 1991
45.7 x 35.6 cm
paper/linen

all: Courtesy Mary Boone Gallery, New York
TM copyright 1991 Marvel Entertainment Group,
Inc. All rights reserved

PHILIP TAAFFE

p 200
Le Quattro Stagioni: Primavera, 1990–91
Mixed media on linen
200 x 213 cm

p 201
Le Quattro Stagioni: Estate, 1990–91
Mixed media on linen
200 x 217 cm

p 202
Le Quattro Stagioni: Autunno, 1990–91
Mixed media on linen
200 x 217 cm

p 203
Le Quattro Stagioni: Inverno, 1990–91
Mixed media on linen
200 x 222 cm

BOYD WEBB
pp 204/207
Palliasse, 1991

RACHEL WHITEREAD

p 208
Untitled, 1991
Fibreglass and rubber
30.5 x 188 x 137.2 cm
Photo: Sue Ormerod
Private collection, courtesy Karsten Schubert Ltd

p 209
Untitled (Yellow Bed, Two parts) (detail), 1991
Dental plaster; 167.7 x 68.1 x 35.6 cm
Photo: Ed Woodman
Courtesy Karsten Schubert Ltd

p 210
Untitled (White Sloping Bed), 1991
Rubber and high-density foam
38.1 x 152.4 x 193.1 cm
Photo: Ed Woodman
Courtesy Karsten Schubert Ltd

p 211
Untitled (Amber Slab), 1991
Rubber and high-density foam
205.7 x 78.7 x 11.4 cm
Photo: Ed Woodman
Courtesy Karsten Schubert Ltd

STEPHAN BALKENHOL Stephan Balkenhol's materials — carved wood, which may be painted, and concrete — are among the simplest available that allow readings not simply as material, but also as social and cultural components. He is not tied to any source exclusively, but draws various ones together in an attempt to shape a positive common alphabet of representation. Balkenhol treads a delicate path between conservative adherence to tradition and its dynamic reinvigoration, begging the question of what 'tradition' means to a figurative artist trained by concept, minimal and land artists. His figures are not likenesses of specific people, but nor are they without character. They are generic, each containing an urge to individuality. Sometime this is betrayed in their features, sometimes in their clothes (the colour of a shirt is often the single distinguishing characteristic). The artist's decisions explicitly echo those of countless other artists and craftsmen who have come before, giving rise to sculptures that bear witness to their precedents, just as living beings are conditioned by their evolution as individual members of a species. They bear a disconcerting relationship to monumental public sculpture, since they are both of the crowd and yet somehow stand apart from it, signalled in such simple terms as being always just smaller or larger than expected.

BORN 1957 IN FRITZLAR/HESSEN, WEST GERMANY. STUDIED 1976–82 AT THE HOCHSCHULE FÜR BILDENDE KÜNSTE, HAMBURG, UNDER ULRICH RÜCKRIEM. LIVES IN HAMBURG AND EDELBACH.

INDIVIDUAL EXHIBITIONS 1984 Galerie Löhrl, Mönchengladbach / 1985 A. O. Kunstraum, Hamburg; Kunstverein Bochum / 1987 Kunstverein Braunschweig; Deweer Art Gallery, Zwevegem-Otegem / 1988 Galerie Löhrl, Mönchengladbach; Kunsthalle Basel; Portikus, Frankfurt / 1989 Kunsthalle Nürnberg; Galerie Rüdiger Schöttle, Munich; Galerie Mai 36, Lucerne; Galerie Johnen & Schöttle, Cologne / 1990 Deweer Art Gallery, Zwevegem-Otegem / 1991 Galerie Rüdiger Schöttle, Paris; Skulpturen im Städelgarten, Städtische Galerie im Städel, Frankfurt/Main; Galerie Johnen & Schöttle, Cologne; Kunstverein Ulm; Galerie Löhrl, Mönchengladbach; Irish Museum of Modern Art, Dublin / 1992 Galerie Mai 36, Lucerne

RECENT GROUP EXHIBITIONS 1987 Skulptur Projekte, Münster / 1988 *The Binational: American Art of the Late '80s,* Museum of Fine Arts, Boston; Kunsthalle Düsseldorf, Düsseldorf / 1989 *Prospekt '89,* Frankfurt Kunstverein, Frankfurt / 1990 *First Tyne International Exhibition of Contemporary Art,* Newcastle upon Tyne; *Possible Worlds,* Institute of Contemporary Art and Serpentine Gallery, London

SELECTED FURTHER READING *Stephan Balkenhol,* essay by Jeff Wall, Kunsthalle Bern, exhibition catalogue, 1988 / Koepplin, Dieter, 'Stephan Balkenhol', *Parkett* 22, 1989, pp. 6–11 / *Possible Worlds,* Institute of Contemporary Art and Serpentine Gallery, London, exhibition catalogue, 1990.

SOPHIE CALLE It is unusual, except in Sophie Calle's work, to find a woman in the role of an active voyeur. Many of the dramas conveyed through her photographs and installations from the past decade are foreshadowed in the twists and turns of an early piece, *La Filature,* in

which Calle — through a third party — engaged a private eye to follow her for a day. We feel a strong sensation of the self being watched, in the knowledge that she has in fact manipulated the watcher's every move, and is in the privileged position of being able to compare two narratives — her own and her pursuer's — of the same events. A powerful desire to measure the friction between the private and public realms has on occasion led Calle to covert intrusions into people's lives, intrusions which would, by normal social standards, seem unacceptable. As a whole, her work suggests that a general availability to scrutiny is part of our current condition; also that for her, as an artist, to get beneath the skin she is obliged to transgress. The *Cash Machine* series developed out of her looking at the video-surveillance records of a bank. From these she isolated a number of self-contained readable narratives which very concisely run the gamut of human emotions and behaviour, through hope, fear, deceit, loss, violence, joy. The mechanical confessional they represent parallels a real confessional used as the focus of an installation work by Calle from 1983.

BORN 1953 IN PARIS. LIVES IN MALAKOFF.

INDIVIDUAL EXHIBITIONS 1981 Galerie Canon, Geneva / 1983 Galerie Chantal Crousel, Paris / 1984 Galerie Formi, Nîmes / 1985 A. P. A. C., Nevers / 1986 Ecole des Beaux-Arts, Dunkerque; Centre d'Art Contemporain, Orleans; Galerie Crousel-Hussenot, Paris; Stichting De Appel, Amsterdam; Tasmania School of Fine Arts, Hobart / 1987 Centre d'Art de Flaine; Museotrain du F. R. A. C. Limousin, Limoges / 1988 Galería Montenegro, Madrid / 1989 Fred Hoffman Gallery, Los Angeles / 1990 Institute of Contemporary Art, Boston; Berkeley University Gallery/Matrix Gallery, Berkeley; Galería La Maquina Espanola, Seville; Galerie Crousel-Robelin BAMA, Paris / 1991 Luhring Augustine Gallery, New York; Pat Hearn Gallery, New York; Musée d'Art Moderne de la Ville de Paris (A. R. C.), Paris; Kultur huset, Stockholm

RECENT GROUP EXHIBITIONS 1989 *At Face Value,* Kettles' Yard, Cambridge and Third Eye Centre, Glasgow; *Histoires de Musée,* Musée d'Art Moderne de la Ville de Paris, Paris / 1990 *Seven Obsessions,* Whitechapel Art Gallery, London / 1991 *Dislocations,* Museum of Modern Art, New York; *Carnegie International,* Carnegie Museum of Art, Pittsburgh

SELECTED FURTHER READING Scarpetta, Guy, 'Sophie Calle: Le jeu et la distance', *Art Press,* February 1987, pp. 16–19 / Pincus, Robert L., 'Sophie Calle, The Prying Eye', *Art in America,* October 1989, pp. 192–7 / Wagstaff, Sheena, 'Sophie Calle. C'est mon plaisir', *Parkett* 24, 1990, pp.6–17 / Bennett, Oliver, 'Veiled Stories. Sophie Calle & Melanie Counsell', *Performance,* No. 62, November 1990, pp. 26–35 / *Sophie Calle,* essays by Hervé Guibert and Yve-Alain Bois, Musée d'art Moderne de la Ville de Paris (A. R. C.), Paris exhibition catalogue, 1991

SELECTED ARTIST'S PUBLICATIONS 'Suite Vénitienne', *Collection Ecrits sur l'Image,* l'Etoile, Paris (Postface de J. Baudrillard, Please Follow Me...'), 1983. English translation, Bay Press, Seattle, 1988 / 'L'Homme au Carnet', series published in *Libération,* 2 August, 4 September 1983 / 'L'Hôtel', *Collection Ecrits sur l'Image,* l'Etoile, Paris, 1984 / 'La Fille du Docteur', ed. Thea Westreich, New York, 1991.

SAINT CLAIR CEMIN Born in Brazil, Saint Clair Cemin moved to Paris at the age of twenty-two; he has spent much of the past ten years in New York, though he is increasingly drawn to Egypt. In his work, too, there are few boundaries. Influences from various cultures permeate it, as do different styles, genres and attitudes to materials (although Cemin offers evidence of a sense of 'truth to materials', by laying emphasis on their physical qualities as much as on strictly cultural associations). What declares itself a sculpture in his work often has all the characteristics of a piece of furniture, while images of furniture are often to be found elaborately embedded in his 'sculptures'. This eclecticism is far from being a value-free embracing of contradictory sources: it implies instead a resolute sense of dialectic, a willingness and ability to reconcile opposites. In the same way that notions of time, form and origin are for him variables, scale offers Cemin much room for manoeuvre. Typically tiny objects are reproduced as massive, and large things reduced to toys. By turns elegant and crude, whimsical and straight-to-the-point, Cemin's sculptures betray a profound and evolving awareness of the way objects in the world impinge upon each other, and upon us.

> BORN 1951 IN CRUZ ALTA, BRAZIL. STUDIED AT THE ECOLE NATIO-
> NALE SUPERIEURE DES BEAUX-ARTS, PARIS. LIVES IN PARIS AND
> NEW YORK.

INDIVIDUAL EXHIBITIONS 1979 Galería Projecta, São Paulo; Galería Guinard, Porto Alegre / 1980 The White Room, Hasselt / 1981 Galería Guinard, Porto Alegre; Galería Projecta, São Paulo / 1982 Galería Projecta, São Paulo; The Red Bar, New York / 1984 Beulah Land, New York / 1985 Daniel Newburg Gallery, New York / 1986 Daniel Newburg Gallery, New York / 1987 Massimo Audiello Gallery, New York / 1988 Daniel Weinberg Gallery, Los Angeles; Sperone Gallery, Rome; Rhona Hoffman Gallery, Chicago / 1989 Massimo Audiello Gallery, New York; Daniel Weinberg Gallery, Los Angeles / 1990 Anders Tornberg Gallery, Lund, Sweden; Massimo Audiello Gallery, New York; Sperone Westwater Gallery, New York; Galerie Thaddaeus Ropac, Paris / 1991 Witte de With center for contemporary art, Rotterdam; Baumgartner Galleries, Inc.; Daniel Weinberg Gallery, Santa Monica / 1991–92 Hirshhorn Museum and Sculpture Garden, Washington, D.C. / 1992 Robert Miller Gallery, New York

RECENT GROUP EXHIBITIONS 1987 *Similia/Dissimilia: Modes of Abstraction in Painting, Sculpture and Photography Today,* Kunsthalle Düsseldorf, Wallach Art Gallery, Columbia University, New York; Leo Castelli Gallery and Sonnabend Gallery, New York; *Art at the End of the Social,* Rooseum, Malmö; *The Binational: American Art of the Late '80s,* Museum of Fine Arts, Boston; Kunsthalle Düsseldorf / 1989 *Horn of Plenty,* Stedelijk Museum, Amsterdam / 1991 *Desplazamientos: Aspectos de la identidad y las culturas,* Centro Atlantico de Arte Moderno, Las Palmas / 1991–92 *Altrove/fra immagine e identità, fra identità e tradizione,* Museo d'Arte Contemporanea Luigi Pecci, Prato

SELECTED FURTHER READING Cooke, Lynne, 'Saint Clair Cemin', *Artscribe,* March/April 1988, p.88 / *Saint Clair Cemin,* Nishizawa, Midori, ed; poetry by David Shapiro, Art Random, Kyoto, Japan, 1990 / Hayt-Atkins, Elizabeth, 'Quaesto Facti: The Sculpture of Saint Clair Cemin', *Arts,* December 1990, pp. 42–4 / Kuspit, Donald, 'Saint Clair Cemin', *Artforum,* December 1990, p.132 / *Saint Clair Cemin,* artist's text, Witte de With center for contemporary art, Rotterdam exhibition catalogue, 1991.

PETER FISCHLI / DAVID WEISS In the summer of 1991 in the small Swiss village of Cham, outside Zürich, Peter Fischli and David Weiss converted a garage into an art installation posing as a workshop. It was unclear, however, exactly what was being made: every cluttered object had in fact been hand-carved by the artists out of polyurethane, and then painted in faintly hallucinatory colours. From their earliest collaborations in the late 1970s Fischli and Weiss have re-presented ordinary, humble objects in different guises, aiming to rescue from oblivion these neglected elements of our surroundings and to reveal their emotional charge. The early colour photographs comprising *Die Wurstserie* showed snack foods such as sausages and bits of cheese assembled into anthropomorphic combines, in equal measure poignant and absurd. A later group of 300 clay figurines sought to explain the world through simplified vignettes of events both famous and mundane. The films of Fischli and Weiss have, similarly, shown a highly sophisticated sense of play, whether in the artists' naïve impersonations of a rat and a bear offering instruction, or in the home-science-kit dramas of *Der Lauf der Dinge*. Humour is for them a conscious —if unavoidable —device, employed to disarm the viewer and allow consideration of subjects that might otherwise be spurned. Recently they have also made works concerned with their own and their culture's fascination with tourism and the exotic.

PETER FISCHLI: BORN 1952 IN ZÜRICH, SWITZERLAND. STUDIED 1975–76 AT THE ACCADEMIA DI BELLE ARTI, URBINO AND 1976–77 AT THE ACCADEMIA DI BELLE ARTI, BOLOGNA.

DAVID WEISS: BORN 1946 IN ZÜRICH, SWITZERLAND. STUDIED 1963–64 AT THE KUNSTGEWERBESCHULE, ZÜRICH AND 1964–65 IN THE SCULPTURE CLASS OF THE KUNSTGEWERBESCHULE, BASEL.

BOTH ARTISTS LIVE IN ZÜRICH, WHERE THEY BEGAN COLLABORATIVE WORK IN 1979.

INDIVIDUAL EXHIBITIONS 1981 *Plötzlich diese Übersicht*, Galerie Stäbli, Zürich / 1983 *Fieber*, Galerie Monika Sprüth, Cologne / 1985 *Stiller Nachmittag*, Galerie Monika Sprüth, Cologne; Kunsthalle Basel/ Groninger Museum; Centre cultural suisse, Paris; Produzentengalerie, Hamburg / 1986 Sonnabend Gallery, New York / 1987 Galerie Monika Sprüth, Cologne; List Visual Arts Center, Massachusetts Institute of Technology, Boston; Renaissance Society, Chicago; Le Casa d'Arte, Milan / 1988 P. S. 1, New York; Institute of Contemporary Art, London; Museum of Contemporary Art, Los Angeles; Third Eye Centre, Glasgow; Dallas Museum of Art, Dallas; University Art Museum, Berkeley; Musée de Grenoble; Interim Art, London; Musée de l'art contemporain, Geneva; Galerie Portikus, Frankfurt/Main / 1989 Sonnabend Gallery, New York; Galerie Monika Sprüth, Cologne; La Casa d'Arte, Milano / 1990 Galerie Hussenot, Paris; Ivam, Valencia; Kunstverein München, Munich; Galería Marga Paz, Madrid / 1991 Kunstverein Düsseldorf; Secession, Vienna; Galerie Achenbach, Frankfurt/Main; Galleria Bonomo, Rome

RECENT GROUP EXHIBITIONS 1988 *Carnegie International*, Carnegie Museum of Art, Pittsburgh / 1989 *XX São Paulo Bienal*, São Paulo / 1990 *The Readymade Boomerang, Certain Relations in*

20th Century Art, Sydney Biennale, Art Gallery of New South Wales, Sydney / 1991 *Chamer Raüme,* Cham; *Metropolis,* Martin-Gropius-Bau, Berlin
SELECTED FURTHER READING 'Collaboration: Peter Fischli / David Weiss', artists' project and essays by Bernhard Johannes Blume, Germano Celant, Patrick Frey, Karen Marta, Jeanne Silverthorne, Sidra Stitch, *Parkett* 17, 1988, pp. 20–87 / *Das Geheimnis der Arbeit. Texte zum Werke von Peter Fischli und David Weiss,* Kunstverein, Munich and Kunstverein für die Rheinlande und Westfalen, Edition Patrick Frey, Düsseldorf, 1990. *Le desenchantement du monde,* Villa Arson, Centre National d'Art Contemporain, Nice, 1990

SELECTED ARTISTS' PUBLICATIONS 1982 *Plötzlich diese Übersicht,* Edition Stähli, Zürich / 1988 *Portikus Katalog,* Frankfurt/Main / 1990 *Airports,* Edition Patrick Frey, Zürich/Ivam, Valencia / 1991 *Bilder, Ansichten,* Edition Patrick Frey, Zürich/Secession, Vienna

SELECTED ARTIST'S FILMS 1981 *Der geringste Widerstand* /1983 *Der rechte Weg* / 1987 *Der Lauf der Dinge.*

KATHARINA FRITSCH Typically, Katharina Fritsch makes objects in three-dimensional, 'sculptural' forms; but sometimes also in the guise of drawings, records, or installations such as her recent application of red pigment directly on to the walls of a room in the Martin-Gropius-Bau, in Berlin, a room simultaneously filled with sound. What makes these objects unnerving is the sensation they produce of always having been there, as if they were readymades with specific histories. Their original impulses are in fact always highly personal, stemming from a private dream world that overlaps at points with images drawn from popular European culture. The process by which they become manifested as actual objects is one of intensive refining of the image at a research stage, followed by various phases of industrial manufacture. Fritsch's works are in effect prototypes of mass-produced goods, often looking as if they could be found in shops. The fact that they cannot, combined with our inability to link them directly to a tradition of art-making, gives them a highly ambiguous presence. The dissonance between their origins and their appearance releases an almost quantifiable energy. It also leaves a gap, a void in understanding which the audience is compelled to try to fill by projecting its own meanings and experience on to the work. A common ground is proposed, but not provided. BORN 1956 IN ESSEN, WEST GERMANY. STUDIED FROM 1977 AT THE KUNSTAKADEMIE, DÜSSELDORF; 1981, MASTER STUDENT UNDER FRITZ SCHWEGLER. LIVES IN DÜSSELDORF.

INDIVIDUAL EXHIBITIONS 1984 Galerie Rüdiger Schöttle, Munich (with Thomas Ruff) / 1985 Galerie Johnen & Schöttle, Cologne / 1987 Kaiser Wilhelm Museum, Krefeld / 1988 Kunsthalle Basel; Institute of Contemporary Art, London / 1989 Kunstverein Münster; Portikus, Frankfurt/Main / 1990 Galerie Rüdiger Schöttle, Munich

RECENT GROUP EXHIBITIONS 1988 *Sydney Biennale,* Art Gallery of New South Wales, Sydney; *Carne-gie International,* Carnegie Museum of Art, Pittsburgh / 1989 *What is Contemporary Art?* Rooseum, Malmö / 1990 *New York: A New Generation,* San Francisco Museum of Modern Art, San Francisco; *Wei-tersehen 1980–1990,* Museum Haus Lange and Museum Haus Esters, Krefeld; *Objectives: The New Sculpture,* Newport Harbor Art Museum, Newport Beach, California / 1991 *Metropolis,* Martin-Gropius-Bau, Berlin; *Carnegie International,* Carnegie Museum of Art, Pittsburgh

SELECTED FURTHER READING *Elefant,* essay by Julian Heynen, Kaiser Wilhelm Museum, Krefeld, exhi-bition catalogue, 1987 / Koether, Jutta, 'Elephant', *Parkett* 13, 1987, pp. 90-2 / *Katharina Fritsch,* essay by Jean-Christophe Ammann, Kunsthalle Basel / Institute of Contemporary Art, London, exhibition catalo-gue, 1988 / Reust, Hans-Rudolf, 'Rosemarie Trockel – Katharina Fritsch', *Artscribe,* No. 73, January / Feb-ruary 1989 / 'Collaboration Katharina Fritsch', artist's project and essays by Gary Garrels, Julian Heynen and Dan Cameron, *Parkett* 25, 1990, pp. 36–75.

JULIO GALÁN Julio Galán's paintings have the hallucinatory precision of involuntary acts of memory. Their many components and influences, each in itself skewed and incomplete, nevertheless add up to disturbingly intact atmospheric evocations. The disjunction they embody derives primarily from the use of a many-layered public format, filled with imagery that is at once extremely private and yet redolent of multiple identities. The artist's own image appears frequently, often more than once within the same painting. In the ambiguity of his bio-logical origins and sexuality lie the seeds of Galán's ambition to carry the mantle of his legendary compatriot Frida Kahlo. His debt to Catholic art, whether in the form of frescoes or small ex-votos, is evident, although distorted by the very large format he normally employs. A vibrant and emotive sense of colour has similar precedents, but derives in part from cheap advertisements and decorative patterns, which often lend a structure to his paintings. Within such an over-conditioned framework he assembles complex rebuses with no solution, their elements drawn from sources as diverse as his personal past (and even future), children's illustrations, Catholic icons, and pre-Columbian creation myths. These are fused into melan-choly highly self-conscious images of loss and decay.

BORN 1959 IN MUZQUIZ, COAHUILA, MEXICO. STUDIED ARCHITEC-TURE 1978–82. LIVES IN MONTERREY.

INDIVIDUAL EXHIBITIONS 1980 Galería Arte Actual Mexicano, Monterrey / 1982 Galería Arte Actual Mexicano, Monterrey; Galería Arvil, Mexico City / 1983 Galería Arte Actual Mexicano, Monterrey / 1984 Galería Uno, Puerto Vallarta; Galería Clave, Guadalajara / 1985 Consulada Mexicano, New York; Art Mart Gallery, New York / 1986 Barbara Farber Gallery, Amsterdam; Paige Powell & Edit De Ak, New York / 1987 Museo de Monterrey / 1989 Annina Nosei Gallery, New York / 1990 Sperone Gallery, Rome; Annina Nosei Gallery, New York; Witte de With center for contemporary art, Rotterdam

RECENT GROUP EXHIBITIONS 1991 *Art in Intercultural Limbo, Transmission,* Rooseum, Malmö; *Myth and Magic in America: The Eighties,* New Museum of Contemporary Art, Monterrey; *Magiciens de la Terre,* Musée Nationale d'Art Moderne, Centre Georges Pompidou and Grand Halle la Villette, Paris

SELECTED FURTHER READING *Julio Galán,* essay by Francesco Pellizzi, Annina Nosei Gallery, New York, exhibition catalogue, 1990 / Kozloff, Max, 'Memories of the Future', *Artforum,* Vol. XXX, No. 2, October 1991, pp. 106–111.

ROBERT GOBER There is a tangible tension in all of Robert Gober's work between the mundane, deadpan appearance of the objects he creates and the load of meanings that they carry. This is in part because he does not simply present readymade objects but re-makes them, hand-crafting something intensely personal out of artefacts dredged from the shallows of functional and cultural significance. Gober's sinks, doors, playpens, plug-holes, bags of cat litter, wallpaper and body parts derive their force not only from their method of fabrication, but from their suggestion that our personalities, both individual and collective, actually reside within these simple objects that surround us. Like our personalities, and therefore subject to change and to distortion, Gober's sculptures undergo frequent transmutation. His frame of reference also shifts periodically, giving rise to whole new groups of work which reappear in novel combinations. He seems to be pointing to divergent cultural codes, tempting us to decipher them or to discern the continuous line of enquiry running through them. Gober consistently gives voice to hidden histories and gives substance to repressed thoughts, not in a melodramatic way but quietly, as if they have just risen to the surface.

BORN 1954 IN WALLINGFORD, CONNECTICUT, U.S.A. STUDIED 1973–74 AT THE TYLER SCHOOL OF ART, ROME, AND 1976 AT MIDDLE-BURY COLLEGE, VERMONT, NEW ENGLAND. LIVES IN NEW YORK.

INDIVIDUAL EXHIBITIONS 1984 *Slides of a Changing Painting,* Paula Cooper Gallery, New York / 1985 Daniel Weinberg Gallery, Los Angeles; Paula Cooper Gallery, New York / 1986 Daniel Weinberg Gallery, Los Angeles / 1987 Galerie Jean Bernier, Athens; Paula Cooper Gallery, New York / 1988 Tyler Gallery, Tyler School of Art, Temple University, Elkins Park, Pennsylvania; The Art Institute of Chicago; Galerie Max Hetzler, Cologne; Galerie Gisela Capitain, Cologne / 1989 Paula Cooper Gallery, New York / 1990 Museum Boymans-van Beuningen, Rotterdam; travelled to Kunsthalle Bern; Galería Marga Paz, Madrid / 1991 Galerie Nationale du Jeu de Paume, Paris / 1992 Dia Center for the Arts, New York

RECENT GROUP EXHIBITIONS 1989 *Gober, Halley, Kessler, Wool: Four Artists from New York,* Kunstverein München, Munich; Einleuchten: Will, Vorstel und Simul in HH, Deichtorhallen, Hamburg / 1990 *Culture and Commentary, An Eighties Perspective,* Hirshhorn Museum and Sculpture Garden, Washington, D.C.; *Objectives: The New Sculpture,* Newport Harbor Art Museum, Newport Beach, California; *The Readymade Boomerang, Certain Relations in 20th Century Art,* Sydney Biennale, Art Gallery of New South Wales, Sydney / 1991 *Metropolis,* Martin-Gropius-Bau, Berlin

SELECTED FURTHER READING 'Collaboration Robert Gober', *Parkett* 27, 1991 pp. 28–111 / Sherlock, Maureen P., 'Arcadian Elegy: The Art of Robert Gober', *Arts*, September 1988, pp. 44–49 / Liebman, Lisa, 'The Case of Robert Gober', *Parkett* 21, 1989, pp. 6–9 / Koether, Jutta, 'Robert Gober', *Artforum*, February 1989, p. 145 / *Robert Gober,* Museum Boymans-van Beuningen, Rotterdam / Kunsthalle, Bern, exhibition catalogue, 1990.

ANDREAS GURSKY The format of Andreas Gursky's large-scale colour photographs evokes all the grandeur and controlled intensity of History Painting. Their massive scale, formalised structure, precise composition (even when the subject is in itself chaotic or off-centre) and typically sharp overall focus create a truly frozen, pregnant moment in time. Such concentration lends authority to the most unassuming of events. As captured in Gursky's work, these are so restrained and generalised they feel almost like non-events, scenes that might be glimpsed through the window of a moving car, or registered while passing though a building. But these photographs question precisely what does constitute an event for the mass of humanity today, when Work is followed by Leisure Time and history happens on television. Gursky's camera observes with equal dispassion the factory and the stock exchange, swimming pool and ski lodge. He neither idealises nor condemns the social relations evinced by such settings, but rather portrays their inherent psychological charge. Within these scenes, social meaning is constructed without recourse to either anecdote or explanation.

BORN 1955 IN LEIPZIG, EAST GERMANY. STUDIED 1978–81 AT THE FOLKWANGSCHULE (G.H.S.) IN ESSEN, AND 1981–87 AT THE KUNSTA-KADEMIE DÜSSELDORF; 1985, MASTER STUDENT OF PROF. BERN-HARD BECHER. LIVES IN DÜSSELDORF.

INDIVIDUAL EXHIBITIONS 1987 Düsseldorf Airport, Düsseldorf / 1988 Galerie Johnen & Schöttle, Cologne / 1989 Centre Genevois de Gravure Contemporaine, Geneva; P.S.1, Clocktower Gallery, New York (with Thomas Struth); 303 Gallery, New York; Museum Haus Lange, Krefeld / 1991 Galerie Rüdiger Schöttle, Munich; Galerie Johnen & Schöttle, Cologne; 303 Gallery, New York; Galerie Rüdiger Schöttle, Paris; Künstlerhaus Stuttgart

RECENT GROUP EXHIBITIONS 1990 *Aperto*, Venice Biennale; *The past and the present of photography – when photographs enter the museum*, The National Museum of Modern Art, Tokyo; The National Museum of Modern Art, Kyoto / 1991 *Aus der Distanz*, Kunstsammlung Nordrhein-Westfalen, Düsseldorf; *Sguardo di Medusa*, Castello de Rivoli, Rivoli

SELECTED FURTHER READING Messler, Norbert, Review, *Artscribe*, September/October 1988 / Troncy, Eric, 'Andreas Gursky: L'ordinaire comme qualité', *Halle Sud, Magazine d'art contemporain*, No. 21, 1989 / Graw, Isabelle, 'Düsseldorfer Künstler IV: Ausflug. Ein Interview von Isabelle Graw mit Andreas Gursky', *Artis*, January 1990, pp. 52 ff.

ANN HAMILTON 'Making site-related work — work that is ephemeral and constituted of organic materials — is part of retracing the path back towards art that is among the living, and therefore among the dying.' This statement, made jointly with Kathryn Clark in the brochure of their recent collaborative installation in Washington, D.C., highlights a number of crucial characteristics of Ann Hamilton's work, as well as its broad intentions. Instead of making art as a product, she makes considered interventions in particular places at specific times. Usually she incorporates a living element — human, sheep, moths, snails, canaries — which leads to an organic development in the work. It also introduces a social aspect, since the animals are seldom alone and interact with each other and with the viewer. In the installation *between taxonomy and communion,* hundreds of human and animal teeth were arrayed on a central table, directly echoed by letters of phrases from folk tales, pressed into the surrounding white plaster walls. Hamilton evokes a genetic, collective understanding of things known prior to speech, an understanding which today must be expressed through myth. When language does appear in her work it is in a fragile, undemonstrative way like a background hum, part of an effort to articulate that is always countered by the visceral directness of the installation's other elements.

BORN 1956 IN LIMA, OHIO, U.S.A. STUDIED FOR B.F.A. IN TEXTILE DESIGN AT THE UNIVERSITY OF KANSAS, AND FOR M.F.A. IN SCULPTURE AT YALE SCHOOL OF ART. LIVES IN COLUMBUS, OHIO.

INSTALLATIONS 1985 'reciprocal fascinations', Santa Barbara Contemporary Arts Forum, Santa Barbara, California; 'left-footed measure', M.F.A. Thesis Exhibition, Yale Art and Architecture Gallery, New Haven, Connecticut / 1986 'circumventing the tale', *Set in Motion,* Gallery 1, San Jose State University, San Jose, California / 1987 'the middle place', *Tangents,* Maryland Institute, Baltimore, Maryland; travelled to Oakland Museum of Art and Cleveland Institute of Art; 'the map is not the territory', *The Level of Volume,* Carl Solway Gallery, Cincinnati, Ohio; 'rites', Arts Festival Exhibition, Santa Barbara Contemporary Arts Forum, Santa Barbara; 'the earth never gets flat', *Elements: 5 Installations,* Whitney Museum of American Art at Philip Morris, New York / 1988 'dissections ... they said it was an experiment', *Social Spaces,* Artists' Space, New York; 'dissections ... they said it was an experiment', *5 Artists,* Santa Barbara Museum of Art, Santa Barbara, California; 'still life', *Home Show,* 11 artists working in private homes open to public tour, sponsored by Santa Barbara Contemporary Arts Forum; 'the capacity of absorption', *The Temporary Contemporary,* The Museum of Contemporary Art, Los Angeles / 1989 'privations and excesses', Capp Street Project, San Francisco; 'palimpsest', collaboration with Kathryn Clark, *Strange Attractors, Signs of Chaos,* New York Museum, New York / 1990 'between taxonomy and communion', La Jolla Museum of Art, La Jolla; San Diego Museum of Contemporary Art; 'linings', *Awards in the Visual Arts 9,* Travelling exhibition, New Orleans Museum of Art; 'palimpsests', collaboration with Kathryn Clark, Artemisia Gallery, Chicago; 'palimpsests', collaboration with Kathryn Clark, Arton A Galleri, Stockholm; 'dominion', *New Works for New Spaces: Into the Nineties,* Wexner Center for the Visual Arts / 1991 *The Savage Garden,* Fundación Caja de Pensiones, Madrid; 'view', collaboration with Kathryn Clark, Hirshhorn Museum and Sculpture Garden, Washington, D.C.; 'malediction', Louver Gallery, New York

PERMANENT PROJECTS 1990 Headlands Center for the Arts, Mess Hall commission, San Francisco; San Francisco Public Library Arts Commission; in collaboration with architects James Fried and Kathy Simon

RECENT GROUP EXHIBITIONS 1991 'indigo blue', *Places with a Past: New Site-specific Art in Charleston*, The Spoleto Festival, Charleston, South Carolina; 'parallel lines', *XXI São Paulo Bienal*, São Paulo; 'offerings', *Carnegie International*, Carnegie Museum of Art, Pittsburgh

SELECTED FURTHER READING Apple, Jacki, 'Ann Hamilton', *High Performance*, Summer 1989, pp. 48–49 / Spector, Buzz, 'A Profusion of Substance', *Artforum*, October 1989, p. 128 / Pagel, David, 'Still Life', *Arts*, May 1990, pp. 56–61 / Baker, Kenneth, 'Palimpsest', *Artforum*, October 1990 / *Ann Hamilton*, essay by Susan Stewart, La Jolla, California; San Diego Museum of Contemporary Art, exhibition catalogue, 1991 / *The Savage Garden*, essay by Dan Cameron, Fundaçión Caja de Pensiones, Madrid, exhibition catalogue, 1991.

GARY HILL In Gary Hill's work the medium of video is used in a highly sophisticated but unpretentious way: hardware is often stripped down to what it simply is, a medium for transforming electronic messages into images. Sometimes, however, the subject of the work seems to call for a more sculptural, even figurative formation. This attention to the nature of his framework is matched in Hill's work —both videotape and installation —by a profound sense of the physicality of the message transmitted through it. His concern is with the articulation of language, both as it appears on a page (where it can be touched and torn apart), or as it is employed to construct the way we read a body or a situation. On the screen, words are sometimes playfully deconstructed by being read forwards and backwards; in a similar way, he manipulates the wider codes of fiction. Text is both a conduit and a barrier to understanding for Hill, who offers other more rhythmic routes to comprehension, routes that fall somewhere between the organic and the technological. In this search he utilises texts which themselves permit a multiplicity of interpretations, and which effectively offer the basis for their own questioning: the writings of Maurice Blanchot, or the Gnostic texts, for instance. Collapse is always imminent, being in fact implied in the constant to-and-fro motion between meaning and nonsense.

> BORN 1951 IN SANTA MONICA, CALIFORNIA, U.S.A. STUDIED AT ARTS
> STUDENTS LEAGUE, WOODSTOCK, NEW YORK. LIVES IN SEATTLE.

INDIVIDUAL EXHIBITIONS *Video Viewpoints*, Museum of Modern Art, New York; Media Study, Buffalo, New York / 1981 And/Or Gallery, Seattle, Washington, D.C.; The Kitchen, New York / 1982 Long Beach Museum of Art, Long Beach, California; Galerie H at O.R.F., Steirischer Herbst, Graz / 1983 Monte Video, Amsterdam; Whitney Museum of American Art, New York; American Center, Paris; International Culture Center, Antwerp / 1985 Scan Gallery, Tokyo / 1986 Nexus Gallery, Philadelphia, Pennsylvania; Whitney Museum of American Art, New York / 1987 2nd Seminar on International Video, St. Gervais, Geneva; Los

Angeles Contemporary Exhibitions, Los Angeles; Museum of Contemporary Art, Los Angeles / 1988 E. L. A. C. Art Contemporain, Lyon; Video Wochen, Basel; Western Front, Vancouver / 1989 Pacific Film Archives, San Francisco; Musée d'Art Moderne, Villeneuve d'Ascq; Kijkuis, The Hague, The Netherlands; Beursschouwburg, Brussels / 1990 Museum of Modern Art, New York; Y.Y.Z. Artist's Outlet, Toronto; Galerie Huset/Glyptotek Museum, Copenhagen; Galerie des Archives, Paris / 1991 *Between Cinema and a Hard Place,* Espace d'art contemporain, O.C.O., Paris Galerie des Archives, Paris; *Impakt,* Culturecentrum E. K. K. O., Utrecht; Galerie des Archives, Paris

RECENT GROUP EXHIBITIONS 1990 *Passages de l'Image,* Centre Georges Pompidou, Paris; travelled to Fundacio Caixa de Pensiones, Barcelona, Wexner Center for the Arts, Ohio State University and San Francisco Museum of Art; *Energien,* Stedelijk Museum, Amsterdam / 1991 Installation in metro, Wiener Fest Wochen, Vienna; *Metropolis,* Martin-Gropius-Bau, Berlin / 1992 Tokyo Video Festival, Tokyo (retrospective)

SELECTED FURTHER READING Furlong, Lucinda, 'A Manner of Speaking. An interview with Gary Hill', *Afterimage,* Vol. 10, No. 8, March 1983 / *Gary Hill, Disturbance (among the jars),* essays by George Quasha and Jean-Paul Fargier, Musée d'Art Moderne, Villeneuve d'Ascq, exhibition catalogue, 1989 / Mittenhall, Robert, 'Between Seeing and Being Seen. Video's Event: Gary Hill's Catastrophe', *Reflex,* November/ December 1989 / Lageira, Jacinto, *Parachute,* June 1991.

JENNY HOLZER Jenny Holzer has worked with words, conveyed in a very broad range of visual forms of public address, since the late 1970s. Her chosen vehicles have included posters, books, T-shirts, signs on trucks, stone benches, and electronic display boards of varying size and complexity. Inspired by and constantly relating back to their public sources, Holzer's language pieces have also been tailored into temple-like gallery and museum installations around the world. As her format changes, so do the tone, register and linguistic codes of her writings. The voices of cliché, propaganda, icy rage and visionary hysteria have built up, through distinct series, into a repertoire of volatile prescriptions on which Holzer continues to draw in her changing presentations. Whatever their origin, these are words that echo in our heads. They both subvert and fulfil the potential of their media, producing a compelling political message to be found not just in what they say but in the shifting of control they represent, insinuating subjectivity into channels of information and persuasion. In recent years Holzer has produced short, sharp works for television broadcast. That these are often presented on music stations is appropriate, given her interest in rap music, with which she shares a narrative structure by turns fluent and abrasive, whimsical and impassioned.

BORN 1950 IN GALLIPOLIS, OHIO, U. S. A. STUDIED 1971–72 AT OHIO UNIVERSITY, 1975–76 AT RHODE ISLAND SCHOOL OF DESIGN AND 1977 IN WHITNEY MUSEUM INDEPENDENT STUDY PROGRAM. LIVES IN HOOSICK, NEW YORK.

INDIVIDUAL EXHIBITIONS 1978 *Painted Room: Special Project P. S. 1.* Institute for Art and Urban Resources at P. S. 1, Long Island City, New York; Franklin Furnace, New York / 1979 Fashion Moda, Bronx; *Printed Matter,* New York / 1980 Textes Positions (with Peter Nadin), Onze Rue Clavel Gallery, Paris / 1981 *Living* (with Peter Nadin), Galerie Rüdiger Schöttle, Munich. Artist's book; *Eating Friends* (with Peter Nadin) Artists' Space, New York. Artist's book; *Living* (with Peter Nadin) Le Nouveau Musée, Villeurbanne, France; *Living* (with Peter Nadin), Museum für (Sub)Kultur, Berlin / 1982 *Jenny Holzer-Peter Nadin: Living,* Galerie Chantal Crousel, Paris; Art Lobby, Marine Midland Bank, 140 Broadway, New York; *Messages to the Public,* 1 Times Square, New York, sponsored by Public Art Fund, Inc., New York; *Plaques for Buildings: 30 texts from the Living* Series, cast in bronze by Jenny Holzer and Peter Nadin, Barbara Gladstone Gallery, New York / 1983 *Essays, Survival Series,* Institute of Contemporary Art, London; *Jenny Holzer With A-One, Mike Glier, and Lady Pink: Survival Series,* Lisson Gallery, London; Institute of Contemporary Art, University of Pennsylvania, Philadelphia, with outdoor installation; Barbara Gladstone Gallery, New York / 1984 Galerie 't Venster-Jenny Holzer-Lady Pink, Rotterdam Kunststichting; *Truisms and Inflammatory Essays,* Amelie A. Wallace Gallery, State University of New York College at Old Westbury; *Graphics change 2,* Bus Shelter (designed by Dennis Adams), 66th Street and Broadway, New York, sponsored by Public Art Fund, Inc., New York; Kunsthalle, Basel; travelled to Le Nouveau Musée, Villeurbanne, France; *Sign on a Truck: A Program by Artists and Many Others on the Occasion of the Presidential Election,* outdoor installations, New York, sponsored by Public Art Fund Inc., New York / 1984–85 Dallas Museum of Art, Dallas / 1986 Selection from *The Survival Series,* 1 Times Square, New York; Galerie Monika Sprüth, Cologne; Keith Haring-Jenny Holzer, Am Hof, Vienna; Electronic Sign Project, Palladium, New York; Galerie Crousel-Hussenot, Paris; *Protect Me from What I Want,* outdoor installations, Las Vegas, organised by Nevada Institute for Contemporary Art, University of Nevada, Las Vegas; *Signs,* Des Moines Art Center, Des Moines; Aspen Art Museum, Aspen; Artspace, San Francisco; Museum of Contemporary Art, Chicago; List Visual Arts Center, Massachusetts Institute of Technology, Cambridge, Massachusetts; *Under a Rock,* Barbara Gladstone Gallery, New York / 1987 Outdoor Installations, Hamburg; *Under a Rock,* Rhona Hoffman Gallery, Chicago / 1988 *Signs/Under a Rock,* Institute of Contemporary Art, London (with outdoor installations in London and Belfast); *Plaques, The Living Series 1980–82, The Survival Series 1983–85,* Interim Art, London; *Art Break* series initiated, M.T.V., New York; *Signs and Benches,* The Brooklyn Museum, Brooklyn, New York; Winnepeg Art Gallery, Winnipeg; Hoffman-Borman Gallery, Santa Monica / 1989 Solomon R. Guggenheim Museum, New York; Benches, Doris C. Freedman Plaza, New York. Sponsored by the Public Art Fund, Inc.; *Laments 1988–89,* Dia Art Foundation, New York; Ydessa Hendeles Art Foundation, Toronto / 1990–91 *The Venice Installation,* American Pavilion, Venice Biennale, Venice; travelled to Städtische Kunsthalle, Düsseldorf; Walker Art Center, Minneapolis; Albright-Knox Art Gallery, Buffalo, New York; Louisiana Museum, Humleback

RECENT GROUP EXHIBITIONS 1989 *A Forest of Signs: Art in the Crisis of Representation,* Museum of Contemporary Art, Los Angeles / 1990 *High and Low: Modern Art and Popular Culture,* Museum of Modern Art, New York; travelling to Art Institute of Chicago; Museum of Contemporary Art, Los Angeles; *Energien,* Stedelijk Museum, Amsterdam; *The Decade Show,* Museum of Contemporary Hispanic Art/ New Museum of Contemporary Art/Studio Museum in Harlem, New York; *Culture and Commentary, An Eighties Perspective,* Hirshhorn Museum and Sculpture Garden, Washington, D. C.

SELECTED FURTHER READING Evans, Steven, 'Not all about death' (interview), *Artscribe International,* Summer 1989, pp. 57–59 / Ferguson, Bruce, 'Wordsmith' (interview), *Art in America,* December 1986, pp. 108–115 / Kuspit, Donald, 'The Only Immortal', *Artforum,* Vol. 28, No. 6, February 1990, pp. 110–118 / *Jenny Holzer,* essay by Diane Waldman and interview with the artist, Solomon R. Guggenheim Foundation, New York, exhibition catalogue, 1989 / *Jenny Holzer: The Venice Installation,* essay by Michael Auping and text by the artist, Albright-Knox Art Gallery, Buffalo, exhibition catalogue, 1990

SELECTED ARTIST'S PUBLICATIONS *A Little Knowledge,* New York, self-published, 1979 / *Truisms and Essays,* Nova Scotia, Nova Scotia College of Art and Design Press, 1983.

NARELLE JUBELIN In a series of related groups of work, beginning with *His Story* in 1986, Narelle Jubelin has presented selected Australian monuments and scenic views as petit-point embroideries. The monuments stand in awkward self-importance, representing trans-ported values, hierarchies and the imposition of an authority inextricably bound up in the codes of colonisation. Jubelin undermines that authority — and by definition other self-legiti-mising systems — by restating it in her own terms. Petit-point is a classically under-acknow-ledged female art form, labour-intensive, small in scale, and most often performed as a craft without the pretensions of art. Her use of this medium shifts our understanding of the colonial town plan in many other ways: the dignity of historical commemoration or of majestic views at sunset is given a very sharp, if satirical, personal focus; the landmark is given body as the equivalent of a souvenir; real collective imaginings are lent the texture of aspiration in a genu-ine labour of love. Found frames, often bigger than the images they surround, serve to unbal-ance and evoke, through irony, the dense enclosed interiors where Europeans first dreamed of mastering the world. The frame and the panoramic format of Jubelin's installation acknow-ledges the limits of Eurocentric vision.

BORN 1960 IN SYDNEY, AUSTRALIA. STUDIED 1979–82 FOR BACHE-LOR OF EDUCATION IN ART AT ALEXANDER MACKIE C.A.E., SYDNEY, AND 1983 FOR GRADUATE DIPLOMA IN PROFESSIONAL ART STUDIES AT CITY ART INSTITUTE, SYDNEY. 1988, ARTIST-IN-RESIDENCE, SOUTH AUSTRALIAN C.A.E. 1991, ARTIST-IN-RESIDENCE, UNIVERSITY OF WOLLONGONG. ARTIST-IN-RESIDENCE, AUSTRALIA COUNCIL, TOKYO STUDIO. LIVES IN SYDNEY.

INDIVIDUAL EXHIBITIONS 1985 Plan Z Gallery, Sydney (with Paul Saint) / 1986 *His Story,* Mori Gallery, Sydney; *Remembrance of things past lays bare the plans for destiny,* Avago-Paddington, Sydney / 1987 *Representing His Story,* Institute of Technology Architecture Faculty Gallery, Sydney; *The Crossing* (colla-boration with Adrienne Gaha), First Draft, Sydney / 1988 *Second Glance (at the Coming Man),* College Gallery, Adelaide, and Mori Gallery, Sydney / 1989 *Second Glance (at the Coming Man),* George Paton Gallery, University of Melbourne / 1991 *Old Love,* Wollongong City Gallery, Wollongong

RECENT GROUP EXHIBITIONS 1990 *Trade Delivers People,* Aperto, Venice Biennale; *Adelaide Biennial,* Art Gallery of South Australia / 1991 *Places with a Past: New Site Specific Art in Charleston,* Spoleto Fes-tival, Charleston, South Carolina; *The Subversive Stitch,* Monash University Gallery, Melbourne, and Mori Annexe, Sydney

SELECTED FURTHER READING *Second Glance at the Coming Man,* essay by Elizabeth Gerstakis, Mori Gallery, Sydney, exhibition catalogue, 1988 / Fox, Paul, 'Second Glance (at the Coming Man)', *Transition,* Winter 1989 / Kerr, Joan, 'Remaking Hi(s)tory', *Artlink,* Vol. 8, No. 3, 1988 / *Trade Delivers People,* essay by Vivien Johnson, published by Mori Gallery, Sydney; Venice Biennale, exhibition catalogue, 1990 / Hannah Bronwyn, 'The Subversive Stitch', *Transition,* R. M. I.T., Melbourne, July, 1987.

MIKE KELLEY In the late 1970s Mike Kelley staged a number of trance-like performances, in which the aura of heavy-metal rock music was re-connected to its implicit tribal origins. Since then he has continued to explore these and many other manifestations of group psychology not normally dignified with the name of culture. He does this by dissecting the emblems of common belief systems, from sentimental religious banners to college sports memorabilia. His work has also dealt with garbage and excrement, with what is left of human behaviour once the goodness has been extracted. Installations or 'arenas' incorporating stuffed animals suggest a sub-world of meaning, where relics of cultural detritus re-enact the very relations that brought them into being. Bleak as this vision is it remains less cynical than sad, without illusions; Kelley perceives and lays bare the devotion and investment that lie behind his found materials. Little instrinsic worth is to be discerned in the objects he collects and displays, it is the 'love hours' put into them that establish their meaning and their precise location within contemporary myth-making patterns. Informed by an acute psychoanalytic observation, his work's full impact depends upon a gut reaction to its simple logic.

BORN 1954 IN DETROIT, MICHIGAN, U.S.A. STUDIED 1976 FOR B. F. A., UNIVERSITY OF MICHIGAN, ANN ARBOR, AND 1978 FOR M. F. A., CALIFORNIA INSTITUTE OF THE ARTS, VALENCIA, CALIFORNIA. LIVES IN LOS ANGELES.

INDIVIDUAL EXHIBITIONS Mizuno Gallery, Los Angeles / 1982 Metro Pictures, New York / 1983 Rosamund Felsen Gallery, Los Angeles; Halls Walls, Buffalo, New York / 1984 Metro Pictures, New York; Rosamund Felsen Gallery, Los Angeles / 1985 Rosamund Felsen Gallery, Los Angeles / 1986 Metro Pictures, New York / 1987 *Vintage Works: 1979–1986,* Rosamund Felsen Gallery, Los Angeles; Rosamund Felsen Gallery, Los Angeles / 1988 Renaissance Society, Chicago; Metro Pictures, New York / 1989 Rosamund Felsen Gallery, Los Angeles; Jablonka Galerie, Cologne; Galerie Peter Pakesch, Vienna; Jablonka Galerie, Cologne; *Pansy Metal/Clovered Hoof,* Metro Pictures, New York; Pacific Film Archive, University Art Museum, University of California, Berkeley; *Pensy Metal/Clovered Hoof,* Robbin Lockett Gallery, Chicago / 1990 Metro Pictures, New York; Rosamund Felsen Gallery, Los Angeles; Galerie Ghislaine Hussenot, Pairs / 1991 Hirshhorn Museum and Sculpture Garden, Washington, D. C.; Juana de'Aizpuru, Madrid; Jablonka Galerie, Cologne / 1992 Galerie Peter Pakesch, Vienna

RECENT GROUP EXHIBITIONS 1990 *Lotte or the Transformation of the Object,* Grazer Kunstverein, Graz; travelling to Akademie der Bildenden Kunst, Vienna / 1991 *The Savage Garden,* Fundación Caja de Pensiones, Madrid; *Metropolis,* Martin-Gropius-Bau, Berlin; *Carnegie International,* Carnegie Museum of Art, Pittsburgh / 1992 *Helter Skelter,* Museum of Contemporary Art, Los Angeles

SELECTED FURTHER READING Cameron, Dan, 'Mike Kelley's Art of Violation', *Arts Magazine,* June 1986, pp. 14–17 / Howell, John, 'Mike Kelley, Plato's Cave, Rothko's Chapel, Lincoln's Profile', *Artforum,* May 1987, pp. 151–52 / Gholson, Craig, Interview, *Bomb,* Winter 1988 / Koether, Jutta, 'C-Culture and B-Culture, *Parkett* 24, 1990, pp. 97–106 (from an interview with Elisabeth Sussman and David Joselit) / Nesbitt, Lois E., 'Not a Pretty Sight', *Artscribe,* September–October 1990, pp. 64–67 / Lewis, James, 'Beyond Redemption', *Artforum,* Summer 1991, pp. 71–75

SELECTED ARTIST'S PUBLICATIONS 'Foul Perfection: Thoughts on Caricature', *Artforum,* January 1989, pp. 92–99 / 'Mekanik Destruktïw Kommandoh: Survival Research Laboratories and Popular Spectacle'; *Parkett* 22, 1989 / 'Theory, Garbage, Stuffed Animals, Christ (Dinner Conversation Overhead at Romantic French Restaurant)', *Forehead,* Vol. 2, 1989, pp. 12–21

SELECTED ARTIST'S PERFORMANCES 1984 'The Sublime', Museum of Contemporary Art, Los Angeles / 1986 'Plato's Cave, Rothko's Chapel, Lincoln's Profile', Artists' Space, New York / 1991 '3 Blowhards and A Little Lady', Beyond Baroque, Venice, California.

JON KESSLER Jon Kessler's mechanised sculptures refer directly to Western culture's representations of itself: via dioramas, tableaux vivants and automata, images of what we think we and the world around us are like, or ought to be. Very evidently worlds within worlds, these sculptures achieve fantasy through simple transformations of scale, light and sound effects, and a kind of tinkering that appeals to a tradition of home invention. Kessler's are not kinetic works in any classic sense, and it is not enough for them to function well mechanically in order to achieve a formal or narrative effect. Rather, they depend for their success on instilling an element of wonder, whether on a large scale and through quite complex means (as in rambling assemblages such as *Taiwan* of 1987) or in smaller and more precise ways (as in recent, tiny works which employ light-sensitive music machines). Kessler's kinesis parallels our collective memory processes: through a relatively simple mechanism he re-plays, before our rapt attention, events or images that throw off an acquired glow of significance.

> BORN 1957 IN YONKERS, NEW YORK, U.S.A. STUDIED 1980 FOR B. F. A. AT S. U. N.Y. AT PURCHASE, NEW YORK, AND 1980 IN WHITNEY MUSEUM INDEPENDENT STUDY PROGRAM, NEW YORK. LIVES IN NEW YORK AND PARIS.

INDIVIDUAL EXHIBITIONS 1983 Artists' Space, New York; White Columns, New York / 1984 Galleri Bellman, New York / 1985 Luhring, Augustine & Hodes Gallery, New York / 1986 Museum of Contemporary Art, Chicago; Cincinnatti Art Center, Cincinnatti; Contemporary Arts Museum, Houston / 1987 Luhring,

Augustine & Hodes Gallery, New York / 1988 Galerie Max Hetzler, Cologne / 1989 *Multiples,* Galerie Gisela Capitain, Cologne; Galerie Crousel-Robelin, Paris; Galerie Ursula Schurr, Stuttgart; Luhring Augustine Hetzler Gallery, Santa Monica, California / 1990 Luhring Augustine Gallery, New York / 1991 Carnegie Museum of Art, Pittsburgh; Galerie Metropol, Vienna

RECENT GROUP EXHIBITIONS 1989 *Strange Attractors: Signs of Chaos,* New Museum of Contemporary Art, New York; *Gober, Halley, Kessler, Wool; Four Artists From New York,* Kunstverein Munich / 1990 *Reorienting: Looking East,* Third Eye Centre, Glasgow; Nicola Jacobs Gallery, London / 1991 *Metropolis,* Martin-Gropius-Bau, Berlin

SELECTED FURTHER READING Cooke, Lynne, 'Anamnesis: The Work of Jon Kessler', *Artscribe,* May 1988, pp. 50–54 / Rian, Jeffrey, 'Jon Kessler', *Galleries Magazine,* April/May 1989, pp. 82–85 / Myers, Terry, 'Up to Code: Jon Kessler's Recent Sculptures', *Arts,* March 1991, pp. 71–73.

JEFF KOONS From his distinctive mid-80s sculptures which considered the ontological status of consumer items such as vacuum cleaners and ornamental whiskey flasks, Jeff Koons moved further into the realm of banality, and on to desire. In the *Banality* series of sculptures, great care and expertise were lavished by traditional craftsmen —operating to Koons' instructions — to give new, heightened, and permanent form to ephemeral cultural icons by means of disconcerting juxtapositions, shifts in scale and alterations to detail. *The Pink Panther* and *Popples* shared the stage with a white-faced Michael Jackson. These reworkings of current collective fantasies made explicit contact with older vernacular traditions. Over the past two years, Koons has worked with Ilona Staller (La Cicciolina) to produce a series of sculptures, 'paintings', posters, and photopieces for magazines, all related to their continuing project, *Made in Heaven.* The popular tradition referenced here is that of pornography, paradoxically the most private and yet one of the most pervasive of cultural forms. The sexually explicit behaviour of Koons and Cicciolina in these works is underscored by the flat self-consciousness of their characters. They are an Adam and Eve for whom any distinction between the primal and the corrupt can no longer have real meaning.

BORN 1955 IN PENNSYLVANIA, U.S.A. STUDIED 1972–75 AT MARYLAND INSTITUTE COLLEGE OF ART, BALTIMORE, MARYLAND, 1976–76 AT SCHOOL OF THE ART INSTITUTE OF CHICAGO, AND 1976 FOR S. F. A. AT MARYLAND INSTITUTE COLLEGE OF ART, BALTIMORE, MARYLAND, LIVES IN NEW YORK AND MUNICH.

INDIVIDUAL EXHIBITIONS 1980 'The New' (installation), New Museum of Contemporary Art, New York / 1985 Feature Gallery, Chicago; International With Monument Gallery, New York / 1986 Daniel Weinberg Gallery, Los Angeles; International With Monument Gallery, New York / 1987 Daniel Weinberg Gallery, Los Angeles / 1988 *Banality,* Donald Young Gallery, Chicago; *Banality,* Galerie Max Hetzler,

Cologne; *Banality,* Sonnabend Gallery, New York; Museum of Contemporary Art, Chicago / 1989 *Jeff Koons — Nieuw Werk,* Galerie 't Venster, Rotterdamse Kunststichting, Rotterdam / 1991 *Made in Heaven,* Galerie Max Hetzler, Cologne; *Made in Heaven,* Sonnabend Gallery, New York

RECENT GROUP EXHIBITIONS 1988 *Schlaf der Vernunft,* Museum Fridericianum, Kassel; *Carnegie International,* Carnegie Museum of Art, Pittsburgh / 1989 *A Forest of Signs: Art in the Crisis of Representation,* Museum of Contemporary Art, Los Angeles; *Image World,* Whitney Museum of American Art, New York / 1990 *Culture and Commentary, An Eighties Perspective,* Hirshhorn Museum and Sculpture Garden, Washington, D. C.; *Objectives: The New Sculpture,* Newport Harbor Art Museum, Newport Beach, California; *Aperto,* Venice Biennale, Venice; *High and Low: Modern Art and Popular Culture,* Museum of Modern Art, New York; Art Institute of Chicago, Chicago; Museum of Contemporary Art, Los Angeles; *Metropolis,* Martin-Gropius-Bau, Berlin

SELECTED FURTHER READING 'Collaboration Jeff Koons', artist's project and essays by Jean-Christophe Ammann, Burke & Hare, Diedrich Diedrichsen, Klaus Kertess and Glenn O'Brien, *Parkett* 19, 1989, pp. 30–77 / Morgan, Stuart, 'Big Fun. Four reactions to the New Jeff Koons', *Artscribe,* March/April 1989, pp. 46–49.

GLENN LIGON Glenn Ligon's *Dreambook* series of paintings is based on lexicons, once common throughout Black American communities and still available, which offer concise interpretations of images from dreams, each matched to a corresponding three-digit number. The books are designed as guides to the placing of bets in the 'numbers game', an illegal but widespread lottery. The tips, couched in highly poetic, often contradictory phrases, are in turn open to subjective re-interpretation by every reader, depending on his or her circumstances and superstitions. Dreams are seen as signposts to reality, as readable clues to an underlying significance. Among the many aspects of dreambooks that intrigue Ligon is the use of language to build a structure of knowledge that gives power, in everyday life and even in games of chance; he points out that 'some people bet their dreams and win.' In other works, Ligon explores the flip side of subjective structures expressed through language. His series *Profiles,* from 1990, considers the popular, media-derived characterisations of eight young Black and Hispanic males, charged with the brutal beating and rape of a white woman jogger in Central Park, New York, in 1988. Out of confused background information, a literal 'black and white' scenario was built up, with a correspondingly clear definition of the 'other', set apart from society's norms. When dealing with such complex issues of race, Ligon views himself less as a spokesman for a particular minority group than as an artist, speaking from his particular cultural experiences to a wider context.

BORN 1960 IN THE BRONX, NEW YORK, U.S.A. STUDIED 1978–82 FOR A B.A. AT WESLEYAN UNIVERSITY, MIDDLETOWN, CONNECTICUT, 1980 AT RHODE ISLAND SCHOOL OF DESIGN, PROVIDENCE, RHODE ISLAND; AND 1985 IN THE WHITNEY MUSEUM INDEPENDENT STUDY PROGRAM. LIVES IN NEW YORK.

INDIVIDUAL EXHIBITIONS 1982 Davison Art Center, Wesleyan University, Middletown, Connecticut / 1990 *How it feels to be Colored Me,* B.A.C.A. Downtown, Brooklyn, New York; *Winter Exhibition Series,* P.S. 1 Museum, Long Island City, New York / 1991 Project room, Jack Tilton Gallery, New York; White Columns, New York / 1992 Max Protetch Gallery, New York

RECENT GROUP EXHIBITIONS 1991 *Interrogating Identity,* Grey Art Gallery, New York; travelling to Museum of Fine Arts, Boston; Walker Art Center, Minneapolis; *Whitney Biennial,* Whitney Museum of American Art, New York / 1992 *Recent Drawing: Allegories of Modernism,* Museum of Modern Art, New York

SELECTED FURTHER READING Ligon, Glenn, 'Profiles', artist pages for *Third Text,* Summer 1991 / Ligon, Glenn, 'Insert', artist pages for *Parkett,* 1991 / Nesbitt, Lois, E., 'Interrogating Identity, Grey Art Gallery', *Artforum,* Summer 1991, p.115.

CHRISTIAN MARCLAY For Christian Marclay, music possesses a universality denied to other art forms and plays more directly upon our emotions. All-pervasive and immaterial, music knows no boundaries and ultimately has no owners, as evidenced by recent trends for sampling and karaoke. Our lives today are inevitably accompanied by a sound-track. Although working within this fluid context, Marclay chooses to emphasise, even perhaps to fetishise, the physicality of the music object in his varied approaches to deconstructing found sound. In performances he manipulates phonograph records on multiple turntables, employing speed alterations, scratching, repetition and other effects. In addition to collaborating with live musicians he often includes in his performances strong visual or theatrical elements. Marclay's published records, too, rework existing pieces of music by artists as varied as Johann Strauss, Louis Armstrong and John Cage, re-investing what are almost by definition static relics with the energy of the event. One record, *Footsteps,* served both as the raw material and the final product of a large-scale sculptural installation, while found records and their covers form the basis of another series of evocative sculptures. In these and related sculptural works, concept and found image, visual message and sound (or its implication) are intextricably interwoven. BORN 1955 IN SAN RAFAEL, CALIFORNIA. STUDIED 1975–77 AT ECOLE SUPÉRIEURE D'ART VISUEL, GENEVA, 1978 COOPER UNION, NEW YORK, AND 1980 MASSACHUSETTS COLLEGE OF ART, BOSTON. LIVES IN NEW YORK.

INDIVIDUAL EXHIBITIONS 1987 *850 Records,* Clocktower Gallery, New York / 1988 Tom Cugliani Gallery, New York; *One Thousand Records,* Gelbe Musik, Berlin / 1989 Tom Cugliani Gallery, New York; Shedhalle, Zürich; Galerie Rivolta, Lausanne / 1990 Tom Cugliani Gallery, New York; Hirshhorn Museum, Washington, D.C. / 1991 Galerie Isabella Kacprzak, Cologne; Interim Art, London; *Abstract Music,* Trans Avant-Garde Gallery, San Francisco; Tom Cugliani Gallery, New York / 1992 Galleria Valentina Moncada, Rome

RECENT GROUP EXHIBITIONS 1989 *Broken Music: Artist's Recordworks,* Daad Galerie, Berlin; *Strange Attractors: Signs of Chaos,* New Museum of Contemporary Art, New York / 1990 *Status of Sculpture,* Espace Lyonnais d'Art Contemporain, Lyon; Institute of Contemporary Art, London; Museum of Art, Hasselt; Stiftung Starke, Berlin; *New Work For New Spaces: Into the '90s,* Wexner Center, Columbus, Ohio / 1991 *The Savage Garden,* Fundación Caja de Pensiones, Madrid; *Whitney Biennial,* Whitney Museum of American Art, New York

SELECTED FURTHER READING *Directions: Christian Marclay,* essay by Amada Cruz, Hirshhorn Museum, Washington, D.C., exhibition catalogue, 1990 / *Sound by Artists,* ed. Dan Lander and Micah Lexier, Art Metropole, Toronto, 1990 / Archer, Michael, 'Christian Marclay', *Art Monthly,* April 1991 / *The Savage Garden,* essay by Dan Cameron, Fundación Caja de Pensiones, Madrid, exhibition catalogue, 1991 / Vogel, Sabine, 'In Record Time', *Artforum,* May 1991, cover and pp. 103–107

SELECTED PERFORMANCES 1981 Franklin Furnace, New York / 1985 *Ghosts,* The Kitchen, New York / 1986 *Dead Stories,* The Performing Garage, New York / 1989 *No Salesman Will Call,* Christian Marclay and Perry Hoberman, The Kitchen, New York; Steirisches Herbstfestival, Graz / 1991 *100 Turntables,* Tokyo P/N, Tokyo

SOLO RECORDS 1985 *Record Without A Cover,* Recycled Records / 1988 *More Encores,* Recommended Records / 1989 *Footsteps,* Recrec.

JUAN MUÑOZ In his finely tuned sculptural installations, Juan Muñoz seems to be searching for a site on which meaning might be constructed. He sets the stage for significance and readies its vehicles, without presuming to give anything away. Typically he draws on a cast of characters derived from popular culture before it became mass culture: these include dwarves, ballerinas, prompters and ventriloquists' dummies, marginal figures who can tell us things not vouchsafed to others. Perhaps because their words are not their own, what they unassumingly reveal are the workings, the mechanics, the tricks of revelation. Muñoz' sculptures are, after all, silent, deliberately begging such questions as where does speech originate and who is responsible for it? or is it simply out there on the airwaves? True knowledge, he suggests, can be displayed over and over, in clear view, and still be incomprehensible. The often elaborate, spatially intricate settings in which Muñoz' characters sometimes find themselves —tiled floors, or, by contrast, small, raised balconies — are spaces of distancing and inaccessibility.

BORN 1953 IN MADRID, SPAIN. STUDIED 1979 AT CENTRAL SCHOOL
OF ART AND DESIGN AND CROYDON SCHOOL OF ART AND TECHNOL-
OGY, LONDON, AND 1982 AT PRATT INSTITUTE, NEW YORK.

INDIVIDUAL EXHIBITIONS 1984 Galería Fernando Vijande, Madrid / 1985 Galería Cómicos, Lis-
bon / 1986 Galerie Joost Declercq, Ghent; Galería Marga Paz, Madrid / 1987 Galerie Roger Pailhas, Mar-
seilles; Lisson Gallery, London; Galería Cómicos, Lisbon; Musée d'Art Contemporain de Bordeaux / 1988
Galeria Jean Bernier, Athens; Galerie Konrad Fischer, Düsseldorf; Galerie Ghislaine Hussenot,
Paris / 1989 Galería Marga Paz, Madrid (a project with Paul Robbrecht); Galerie Joost Declercq, Ghent;
Galería Marga Paz, Madrid; Lisson Gallery, London / 1990 Galeria Jean Bernier, Athens; Arnolfini Gallery,
Bristol; Renaissance Society, Chicago; Centre d'Art Contemporain, Geneva / 1991 Museum Haus Lange,
Krefeld; Galerie Konrad Fischer, Düsseldorf; Marian Goodman Gallery, New York; Stedelijk Van Abbe
Museum, Eindhoven.

GROUP EXHIBITIONS 1990 *The Readymade Boomerang, Certain Relations in 20th century Art,* Syd-
ney Biennale, Art Gallery of New South Wales, Sydney; *Objectives, The New Sculpture,* Newport Harbor
Art Museum, Newport Beach, California; Weitersehen 1980–1990, Museum Haus Lange and Museum
Haus Esters, Krefeld; *Possible Worlds,* Sculpture from Europe, Serpentine Gallery/Institute of Contem-
porary Arts, London / 1991 *Art in Intercultural Limbo, Transmission,* Rooseum, Malmö; Carnegie Inter-
national, Carnegie Museum of Art, Pittsburgh

SELECTED FURTHER READING Tazzi, Pier Luigi, 'Albrecht Dürer Would Have Come Too', *Artforum Interna-
tional,* September 1986, pp. 124–128 / Power, Kevin, 'Juan Muñoz', *Artscribe,* Summer 1987,
p. 93 / Melo, Alexandre, 'Some Things That Cannot be said Any Other Way', *Artforum,* May 1989,
pp. 119–21 / *Possible Worlds,* Interview by Ilona Blazwyk, James Lingwood and Andrea Schlieker, Insti-
tute of Contemporary Art and Serpentine Gallery, London, exhibition catalogue, 1990 / Roberts, James,
Artefactum, February–March 1990

SELECTED ARTIST'S WRITINGS *Segment,* Renaissance Society, Chicago; Centre d'Art Contemporain,
Geneva, 1990.

SIMON PATTERSON Simon Patterson's first exhibited works were pairs or trios of paintings of
names that are linked together in popular consciousness, such as *Elizabeth Taylor* and
Richard Burton. Questions were raised: were the names employed for conceptual or formal
reasons? Why were these groupings made, and why not others? The paintings suggested the
redundancy of public portraiture today, when it seems enough simply to state a name in order
for a flood of associative images to be released. Patterson subsequently moved more
towards installation work, using much larger sets of names ranging in derivation across
history and embracing kings, presidents, philosophers, film stars and lesser celebrities. Clear
classifications sometimes underlie the selection, but often they follow a more rhythmic,
intuitive order of the kind that places *William the Conqueror* and *William Shatner* side by side.
Recent works have adapted names from Patterson's archive to such readymade schemata as

the plan of the London Underground or a Delta Airlines route map. Underlying his whimsical deftness is a compulsion to discover a coherence for the iconic figures who float freely within the common domain.

BORN 1967 IN LEATHERHEAD, SURREY, UNITED KINGDOM. STUDIED 1986–9 AT GOLDSMITHS' COLLEGE, LONDON. LIVES IN LONDON.

INDIVIDUAL EXHIBITIONS 1989 Third Eye Centre, Glasgow / 1990 Milch Gallery, London / 1991 Riverside Studios, London

RECENT GROUP EXHIBITIONS 1988 *Freeze* (Parts I and II), London Docklands, London / 1989 *Ideas and Images of Revolution,* Kettles' Yard, Cambridge / 1990 Milch Gallery, London (Part IV)

SELECTED FURTHER READING Dannat, Adrian, *Flash Art,* January/February 1990, p. 96 / Morgan, Stuart, *Artscribe,* January/February 1991, pp. 13–14 / *Republicans,* artist's book published by Simon Patterson, Arefin Inc., Third Eye Centre, Glasgow, 1989 / *Technique Anglaise: Current Trends in British Art,* artist's pages, ed A. Renton and L. Gillick, Thames and Hudson / One Off Press, 1991.

TIM ROLLINS + K. O. S. In 1985, artist Tim Rollins moved from part-time teaching to full-time collaboration with Kids of Survival, a group of learning-disadvantaged teenagers from the South Bronx. Consisting originally of 7 core members, of whom 4 have remained to be joined recently by younger participants, K.O.S. work with Rollins in the Art & Knowledge Workshop which doubles as collective studio and after-school programme. Plans are well advanced for its development into an Academy, in a building currently being designed by Aldo Rossi. The idealism of the project is reflected in the work it has given birth to, from the earliest, triumphant golden paintings in the *Amerika* series to the more restrained beauty of the recent paintings based on Flaubert's *The Temptation of Saint Antony.* Usually taking a literary classic as a starting point, Rollins and K. O. S. struggle to find an image, or suite of images, to translate its central message into an emblem of contemporary personal relevance to the group. The idea of a canon of great works is adhered to (although augmented by titles such as *The Autobiography of Malcom X* and *The X-Men* series of comics) partly in the belief that access to mainstream culture is a prerequisite for social power, but also in recognition of the communal nature of the world of the imagination and for the personal enrichment that it offers. Interpretation and ownership are believed to be the heritage of not just the privileged few, but of anyone; it is a heritage to be gained through a collaborative process.

TIM ROLLINS BORN 1955 IN PITTSFIELD, MAINE, U.S.A. STUDIED 1976–78 AT UNIVERSITY OF MAINE, AUGUST, MAINE, 1978–80 FOR

B. F. A. AT SCHOOL OF VISUAL ARTS, NEW YORK, AND 1980 AT DEPART-
MENT OF EDUCATION, NEW YORK UNIVERSITY, NEW YORK. TAUGHT AT
NEW YORK SCHOOLS 1980–87. CO-FOUNDED GROUP MATERIAL, NEW
YORK, 1979. FOUNDED K. O. S. (KIDS OF SURVIVAL) AND THE ART AND
KNOWLEDGE WORKSHOP INC., SOUTH BRONX, 1982. LIVES IN NEW
YORK. CURRENT MEMBERS K.O.S.: ANGEL ABREU, BORN 1974;
GEORGE ABREU, BORN 1979; CHRISTOPHER HERNANDEZ, BORN
1978; VICTOR LLANOS, BORN 1975; NELSON MONTES, BORN 1972;
CARLOS RIVERA, BORN 1971; NELSON SAVINON, BORN 1971; LENIN
TEJADA, BORN 1979. ALL LIVE IN THE BRONX, NEW YORK.

INDIVIDUAL EXHIBITIONS 1985 Hostos Community College, Bronx, New York / 1986 Jay Gorney
Modern Art, New York; Fashion Moda, South Bronx, New York; State University of New York, Old Westbury,
New York; Jay Gorney Modern Art, New York / 1987 Lawrence Oliver Gallery, Philadelphia; Rhona Hoff-
man Gallery, Chicago; Knight Gallery, Charlotte, North Carolina / 1988 Jay Gorney Modern Art, New York;
Walker Art Center, Minneapolis; Institute of Contemporary Art, Boston; Riverside Studios, London; Ikon
Gallery, Birmingham; Orchard Gallery, Derry; Barbara Krakow Gallery, Boston; Galería La Maquina Espa-
nola, Madrid / 1989 Jay Gorney Modern Art, New York; Galerie Johnen and Schöttle, Cologne; Dia Art
Foundation, New York; Interim Art, London / 1990 Wadsworth Atheneum, Hartford, Connecticut; Crown
Point Press, New York and San Francisco; Museum für Gegenwartskunst Basel; Museum of Contempor-
ary Art, Los Angeles; Württembergischer Kunstverein, Stuttgart; State University of New York, College at
Cortland, Cortland; Crown Point Press, New York; San Francisco; Center for Photography at Woodstock,
Woodstock, New York / 1991 Rhona Hoffman Gallery, Chicago

RECENT GROUP EXHIBITIONS 1988 *Similia/Dissimilia: Modes of Abstraction in Painting, Sculpture
and Photography Today,* Kunsthalle Düsseldorf; Leo Castelli Gallery, Sonnabend Gallery and Wallach Art
Gallery, Columbia University, New York / 1990 *The Decade Show, Frameworks of Identity in the 80's,*
Museum of Contemporary Hispanic Art/New Museum of Contemporary Art/Studio Museum in Harlem,
New York / 1991 *Whitney Biennial,* Whitney Museum of American Art, New York; *Carnegie International,*
Carnegie Museum of Art, Pittsburgh

SELECTED FURTHER READING Fisher, Jean, 'Tim Rollins + Kids of Survival', *Artforum,* January 1987,
p. 111 / Brooks, Rosetta, 'Tim Rollins + KOS (Kids of Survival)', *Artscribe,* May 1987, pp. 40–47 / Came-
ron, Dan, 'The Art of Survival: A Conversation with Tim Rollins & KOS', *Arts Magazine,* June 1988,
pp. 80–83 / 'Collaboration: Tim Rollins + KOS', artists' project and statements, and essays by M. Berman,
T. Fairbrother and T. Rollins, *Parkett* 20, 1989, pp. 34–117 / Baker, Kenneth, 'Temptation', *Artforum,*
October 1990, pp. 125–132.

PHILIP TAAFFE The city of Naples, with its astonishingly mixed cultural heritage ranging from
the Greco-Roman and Byzantine to the Saracen and Spanish, is Philip Taaffe's home and the
over-riding inspiration for his work. Taaffe's paintings are collages in fact and in spirit, fusions
of historical moments embodied in decorative styles that still live on around him. Much more
than functionless, the designs he uses carry emotion both in their original forms and in the
accretions to which they have been subjected over time. As an artist, rather than a historian or

a sentimentalist, Taaffe neither invokes nor ignores these forms' specific sources. Instead, he pays homage to the intellectual continuum from which they come, the impulse to geometric interpretation of human thoughts and aspirations. While often directly quoting ornament observed on tiles, or screens, or totems, Taaffe continues also to refer to the language of twentieth-century abstract art — particularly that of post-war figures such as Barnett Newman, Ellsworth Kelly or Bridget Riley — which he made his own early in his career. The atmospheric range of his work veers from the violently gestural to the coldly mathematical, to a geometry filled with poise and softness, in each instance persuading us of the value of complexity.

BORN 1955 IN ELIZABETH, NEW JERSEY, U.S.A. STUDIED 1977 FOR B.F.A. AT COOPER UNION, NEW YORK. LIVES IN NEW YORK AND NAPLES.

INDIVIDUAL EXHIBITIONS 1983 Roger Litz Gallery, New York / 1984 Galerie Ascan Crone, Hamburg; Pat Hearn Gallery, New York / 1986 Pat Hearn Gallery, New York; Galerie Ascan Crone, Hamburg; Galerie Paul Maenz, Hamburg / 1987 Mario Diacono Gallery, Boston; Pat Hearn Gallery, New York / 1988 Donald Young Gallery, Chicago; Mary Boone Gallery, New York; Pat Hearn Gallery, New York / 1991 Galerie Max Hetzler, Cologne; Gagosian Gallery, New York

RECENT GROUP EXHIBITIONS 1987 *Similia/Dissimilia: Modes of Abstraction in Painting, Sculpture and Photography Today,* Kunsthalle Düsseldorf; Leo Castelli Gallery; Sonnabend Gallery and Wallach Art Gallery, Columbia University, New York; *New York Art Now,* Saatchi Collection, London / 1991 *Whitney Biennial,* Whitney Museum of American Art, New York; Carnegie International, Carnegie Museum of Art, Pittsburgh

SELECTED FURTHER READING Denson, G. Roger, 'Flight into Egypt: The Islamic Reveries of Philip Taaffe', *Flash Art,* vol. XXIII, No. 154, October 1990 / 'Collaboration Philip Taaffe', artist's project, and essays by G. Roger Denson, W. Dickhoff, F. Pellizzi, J. Perrone and F. White, *Parkett* 26, 190, pp. 64–114 / *Philip Taaffe,* Essay by D. Carter, Galerie Ascan Crone, Hamburg, exhibition catalogue, 1986. P. Taaffe, 'Sublimity, Now and Forever, Amen', *Arts,* March 1989, pp. 18–19.

BOYD WEBB The photoworks made by Boyd Webb between the late 1970s and 1987 were elaborate pseudo-narratives, ridiculous enactments of human dilemmas that aspired to the status of myth. Since 1988 his world has become virtually bereft of any direct human presence. The same staged photographic format is instead now occupied by toys, inflatable animals and other chotchkas, creating an entirely self-contained, ersatz world parallel to the one we call our own. Stand-ins for a shared language, they behave according to their own codes and compulsions, oblivious of our curiosity. Such elaborate, if transparent, fictions permit many readings: as debased mythologies, environmental commentaries, anthropomorphic attempts at psychoanalysis, even wry references to the sophisticated introversion of advertis-

ing. None of these frameworks alone can explain the self-reflexive integrity of these visions, seeming by-products of an entire culture's dreaming. Whether crumpled or semi-inflated, obviously or invisibly supported, Webb's inanimate performers carry their illusionism within their very fabric, compounding the poignancy that by nature belongs to all actors. The black humour of the early work has shifted imperceptibly to the tragicomic.

BORN 1947 IN CHRISTCHURCH, NEW ZEALAND. STUDIED 1968–71 AT ILAM SCHOOL OF ART, AND 1972–75 AT THE ROYAL COLLEGE OF ART, LONDON. LIVES IN LONDON.

INDIVIDUAL EXHIBITIONS 1976 Robert Self Gallery, London / 1977 Graves Art Gallery, Sheffield; Robert Self Gallery, Newcastle; Graeme Murray Gallery, Edinburgh / 1978 Gray Art Gallery and Museum, Harlepool; Konrad Fischer Gallery, Düsseldorf; Jean and Karen Bernier Gallery, Athens; Arnolfini Gallery, Bristol; Chapter Arts Centre, Cardiff; Whitechapel Art Gallery, London / 1979 New 57 Gallery, Edinburgh; Sonnabend Gallery, New York; Galerie Sonnabend, Paris / 1980 Galerie t'Venster, Rotterdam; Museum Haus Lange, Krefeld / 1981 Galerie Loyse Oppenheim, Geneva; Anthony D'Offay Gallery, London; John Hansard Gallery, Southampton; Auckland City Art Gallery, Auckland; travelled elsewhere in New Zealand including National Gallery, Wellington; Sonnabend Gallery, New York / 1982 Badischer Kunstverein, Karlsruhe; travelled to Westfälischer Kunstverein, Münster; Jean and Karen Bernier Gallery, Athens / 1983 Centre Georges Pompidou, Paris; Galerie Crousel-Hussenot, Paris; Stedelijk van Abbemuseum, Eindhoven; travelled to Le Nouveau Musée, Villeurbane; Leeds City Art Gallery; Musée Municipale, La Roche-sur-Yon / 1984 Anthony D'Offay Gallery, London / 1985 University of Northern Illinois, Chicago; travelled to University of Massachusetts, Amherst; University of Tennessee, Knoxville; University Art Museum, California State University, Long Beach; Sonnabend Gallery New York / 1986 Adelaide Festival, Adelaide; travelled to Australian Centre for Contemporary Art, Melbourne; Centre for the Arts, University of Tasmania; Power Gallery of Contemporary Art, University of Sydney; Sue Crockford Gallery, Auckland / 1987 Jean Bernier Gallery, Athens; Galería Comicos, Lisbon / 1987/88 Whitechapel Art Gallery, London; travelled to Kestner-Gesellschaft, Hannover; The Fruitmarket Gallery, Edinburgh; Museum of Contemporary Art, Los Angeles / 1988 Meyers/Bloom Gallery, Santa Monica / 1989 Anthony D'Offay Gallery, London; Cornerhouse, Manchester; Galerie Ghislaine Hussenot, Paris; Sonnabend Gallery, New York; Galerie Bernd Kluser, Munich / 1990 Meyers/Bloom Gallery, Santa Monica; Jean Bernier Gallery, Athens; F. R. A. C. du Limousin, France; Hirshhorn Museum and Sculpture Garden, Washington, D.C.: Direction, Boyd Webb / 1991 Espace d'art contemporain, O. C. O., Paris

RECENT GROUP EXHIBITIONS 1989 *L'invention d'un Art,* Centre Georges Pompidou, Paris / 1990 *The Readymade Boomerang, Certain Relations in 20th Century Art,* Sydney Biennale, Art Gallery of New South Wales, Sydney; *Von der Natur in der Kunst,* Vienna Festival, Vienna; *British Art Now, Japan 1990–91;* travelled to Setagaya Museum, Tokyo; Fukuoka Art Museum; Nagoya City Art Museum; Tochigi Prefectural Museum of Fine Arts; Hyogo Prefectural Museum of Modern Art; Hiroshima City Museum of Contemporary Art

SELECTED FURTHER READING Decter, Joshua, 'Boyd Webb', *Arts Magazine,* December 1989, p. 98 / Hagen, Charles, 'Boyd Webb', *Artforum,* December 1989, pp. 138–139 / Heartney, Eleanor, 'Boyd Webb', *Artnews,* December 1989, p. 157 / *Global Strategy,* essay by Stuart Morgan, Whitechapel Art Gallery, London, exhibition catalogue, 1987 / *The Secondary Object,* A Desolate Object, essay by Frederick Paul, F. R. A. C. du Limousin, Limoges exhibition catalogue, 1990

FILMS 1984 *Scenes and Songs from Boyd Webb;* directed by Philip Haas; Arts Council of Great Britain.

RACHEL WHITEREAD Since the late 1980s, Rachel Whiteread has produced sculptures from casting —first in plaster, more recently in rubber —the space around or within quite ordinary objects such as tables, bathtubs, doors and beds. The earliest casts of the empty spaces under tables had a tomb-like formal inertness, interrupted by pieces of the original wooden furniture embedded in the plaster. Specific childhood recollections of claustrophobia and fear were evoked. Recently, Whiteread's language has expanded into wider-ranging cultural references, her casts from basins strongly resembling church fonts, and baths suggesting ancient sarcophagi. *Ghost,* her most ambitious work to date and the result of casting an entire room, is an imposing structure at once domestic and sacred in its associations. White-read seems to suggest that the imprint of things on our memories is more important than the things themselves. The sculptures that emerge are also of course things, inverse repositories for our sensations. The Freudian displacement of feelings on to objects is literally paralleled by the physical displacement of the original objects. Whiteread's move to use rubber, to make casts of objects including mattresses and morgue slabs, allows her a greater material flexibil-ity, along with an increased emotional range, through variations in colour and density in the medium. It also serves to emphasize the specificity of each source object, in that it more preci-sely takes on their shape and texture, albeit in reverse.

BORN 1963 IN LONDON, UNITED KINGDOM. STUDIED 1982–85 AT BRIGHTON POLYTECHNIC, AND 1985–87 AT THE SLADE SCHOOL OF ART, LONDON. LIVES IN LONDON.

INDIVIDUAL EXHIBITIONS 1988 Carlisle Gallery, London / 1990 *Ghost,* Chisenhale Gallery, Lon-don / 1991 Arnolfini Gallery, Bristol; Karsten Schubert Ltd., London / 1992 Luhring Augustine Gallery, New York

RECENT GROUP EXHIBITIONS 1989/90 *Einleuchten,* Deichtorhallen, Hamburg / 1990 *The British Art Show,* South Bank Centre, London, touring exhibition / 1991 *Metropolis,* Martin-Gropius-Bau, Berlin; *Broken English,* Serpentine Gallery, London; Turner Prize Exhibition, Tate Gallery, London; *Confronta-ciones,* Palacio de Velasquez, Madrid

SELECTED FURTHER READING Brookes, Liz, 'Rachel Whiteread Chisenhale', *Artscribe,* No. 84, November/December 1990, p. 80. / Bickers, Patricia, 'Rachel Whiteread at the Arnolfini, Bristol and Karsten Schubert Ltd, London', *Art Monthly,* No. 144, March 1991, pp. 15–17 / Archer, Michael, 'Ghost Meat: Michael Archer considers the sculpture of Rachel Whiteread', *Artscribe,* No. 87, June 1991 / Mor-gan, Stuart, 'The Turner Prize', *Frieze,* No. 1, pp. 5–6, 9–10.

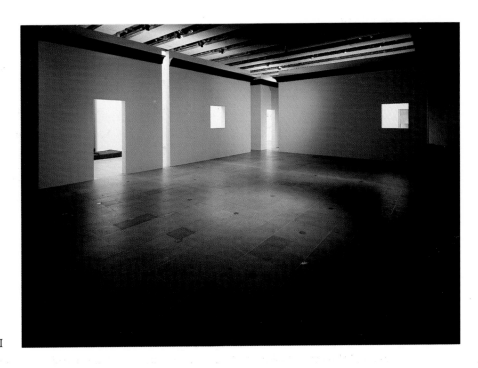

ALDO ROSSI

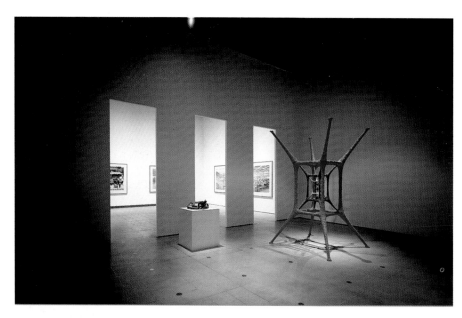

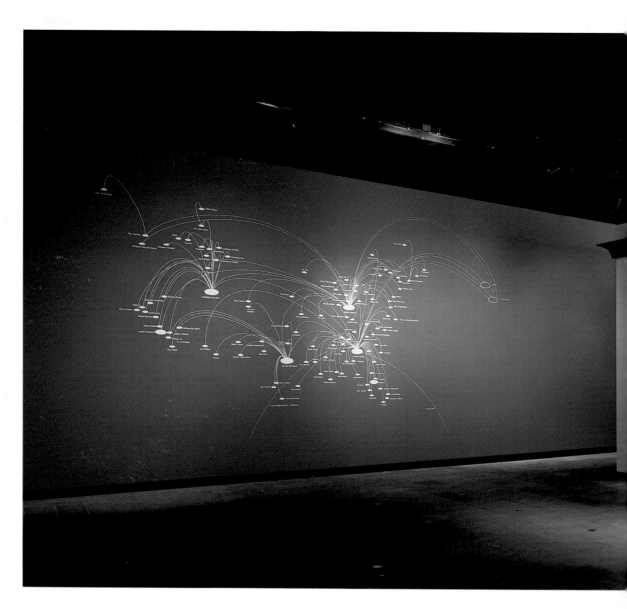

RACHEL WHITEREAD

SIMON PATTERSON

MIKE KELLEY

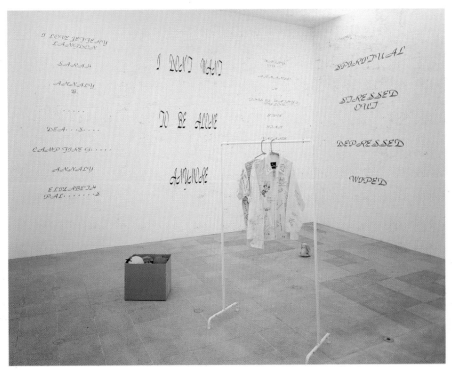

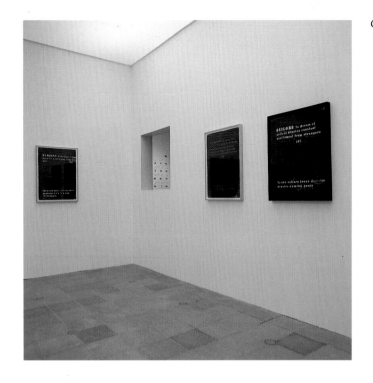

GLENN LIGON

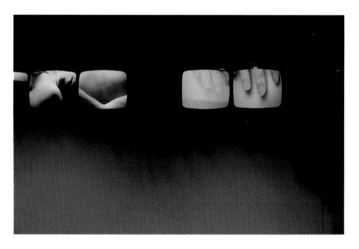

GARY HILL

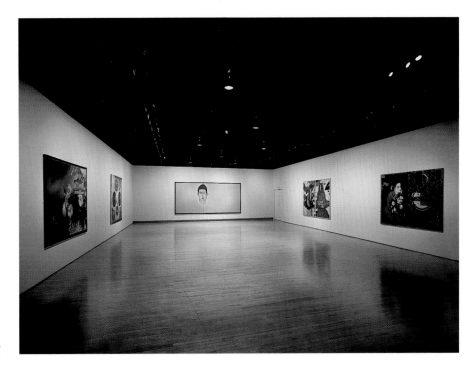

JULIO GALÁN

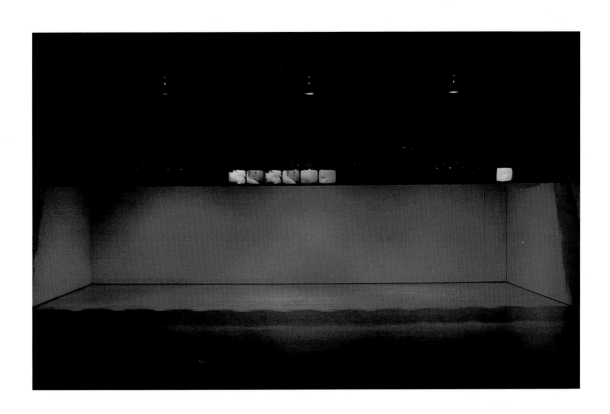

ROBERT GOBER

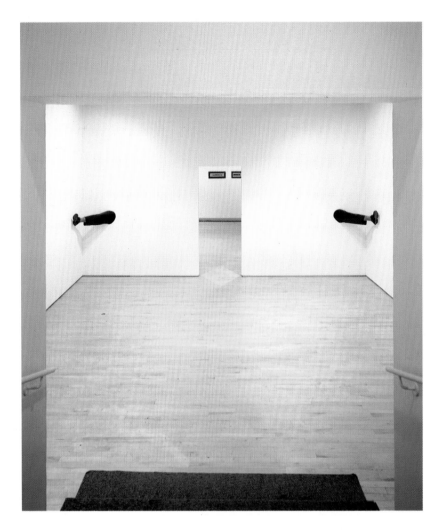

NARELLE JUBELIN

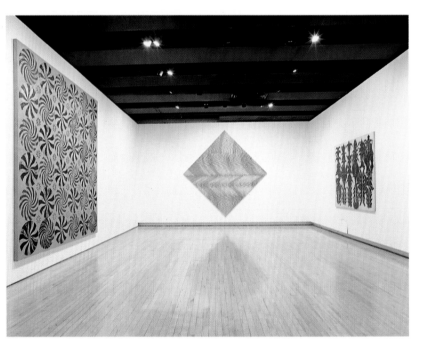

PHILIP TAAFFE

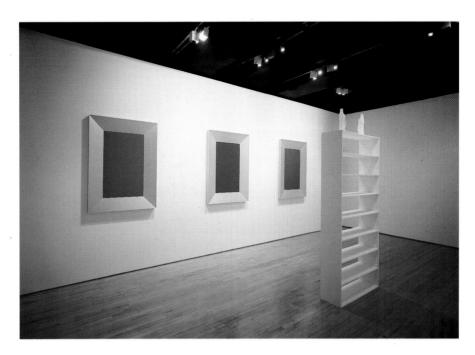

KATHARINA FRITSCH

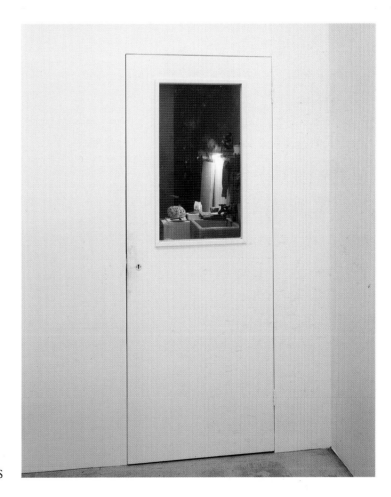

PETER FISCHLI / DAVID WEISS

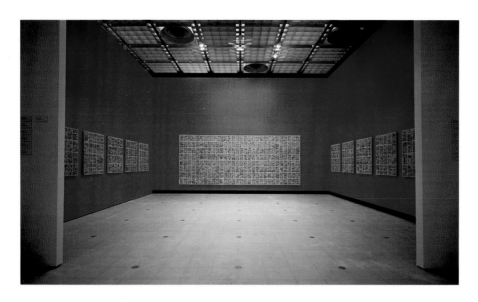

TIM ROLLINS + K.O.S.

SOPHIE CALLE

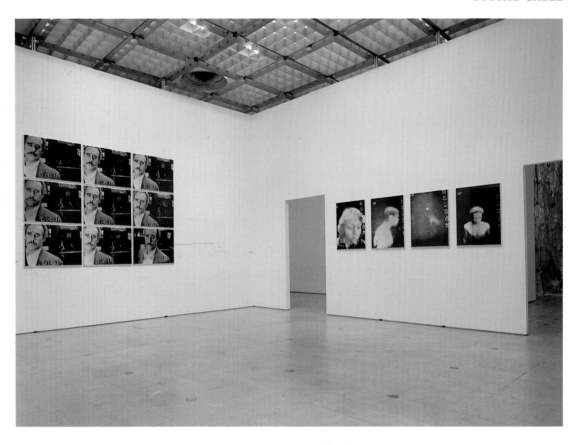

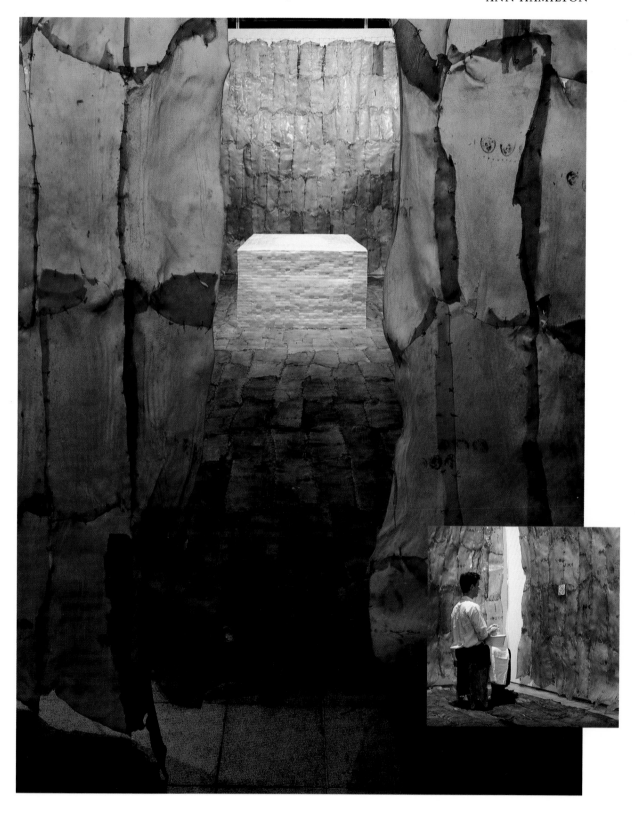

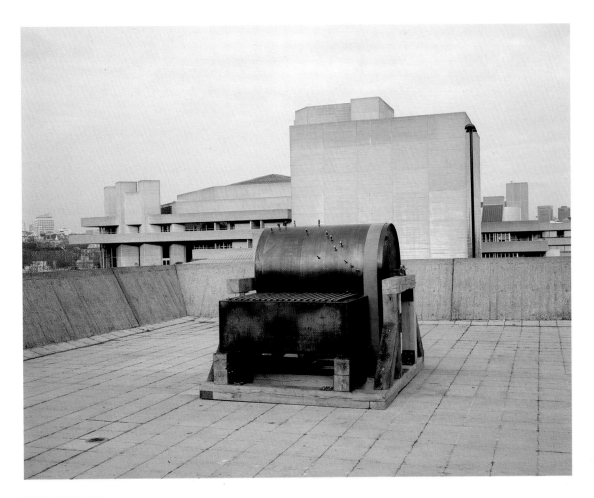

JON KESSLER

JUAN MUÑOZ

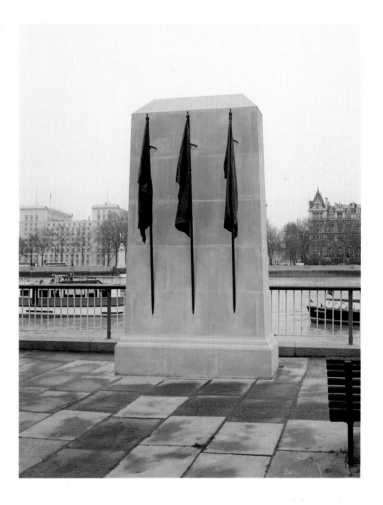

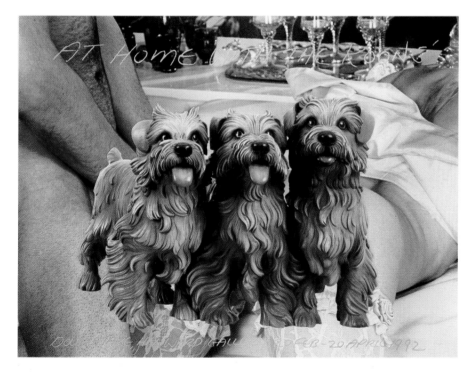

JEFF KOONS

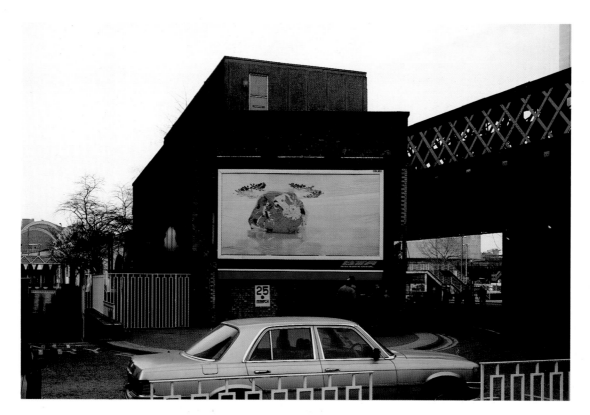

BOYD WEBB

JENNY HOLZER

List of Works
All measurements are given in the order height x width x depth

STEPHAN BALKENHOL
Head of a Man, 1992
Painted wood; 430 x 150 x 150 cm
Blackfriars Bridge
Commissioned in association with The Artangel Trust
Standing Figure on Buoy, 1992
Painted oak & metal; 250 x 50 x 40 cm
River Thames by Waterloo Bridge
Commissioned in association with The Artangel Trust

SOPHIE CALLE
Cash Machine Surveillance I, II, III, 1991
Black & white photograph, metal frame
Each work: 9 framed photographs each 73 x 95 cm;
total 219 x 285 cm
Courtesy the artist
Cash Machine Surveillance
The Assault on Pamela Magnuson, 26 August, 1983 at
21.54 and 20 seconds, 1991
Black & white photograph, metal frame
4 framed photographs each 95 x 73 cm;
total 95 x 292 cm
Courtesy Galerie Crousel Robelin/BAMA, Paris

SAINT CLAIR CEMIN
Soap Elephant, 1987
Bronze, pink patina; 19 x 17.7 x 22.8 cm
The artist, courtesy Robert Miller Gallery, New York
Iron Baby, 1987
Cast iron; 63.5 x 60.9 x 73.6 cm
The artist, courtesy Robert Miller Gallery, New York
Washdog, 1990
Bronze; 130 x 120 x 56 cm
Courtesy Galerie Thaddaeus Ropac, Paris
Acquarella, 1990
Bronze and watercolour pigment
55.8 x 55.8 x 20.3 cm
Courtesy Galerie Thaddaeus Ropac, Paris
Guardian Angel, 1990
Steel construction and hydrocal; 290 x 180 x 180 cm
Courtesy Robert Miller Gallery, New York

PETER FISCHLI / DAVID WEISS
Untitled installation, 1991/2
Painted polyurethane objects
320 x 222 x 500 cm (room dimensions)
Courtesy the artists

KATHARINA FRITSCH
Schwarzes Bild, Weisses Bild, Gelbes Bild, 1990-91
Tempera on canvas, wood, metal foil, lacquer

140 x 100 x 8.5 cm
The artist, courtesy Jablonka Galerie, Cologne
Rotes Bild, Blaues Bild, Grünes Bild, 1991
Tempera on canvas, wood, metal foil, lacquer
140 x 100 x 8.5 cm
The artist, courtesy Jablonka Galerie, Cologne
Regal mit zwei Figuren, 1991-92
Wood, colour, plaster
257 x 100 x 30 cm
The artist, courtesy Jablonka Galerie, Cologne
Unken (Toads), 1982–88
Single record
The artist, courtesy Jablonka Galerie, Cologne

JULIO GALÁN
El Que Se Viene Se Va, 2703
Oil on canvas; 229 x 173 cm
Collection Francesco Pellizzi
El Hermano (Niño Berengena y Niña Santa Claus),
1985
Oil on canvas with antique ornaments
Two panels 176.5 x 121 each part; total 180 x 245 cm
Courtesy Thomas Ammann, Zürich
Te Menti (Sofia), 1988
Oil and collage on canvas
210 x 260 cm
Private collection, courtesy Galerie Barbara Farber
Boy Crying Magnolias (940), 1988
Oil on canvas
175 x 195 cm
Family H. de Groot, Groningen,
Courtesy Galerie Barbara Farber
Urus 1989
Acrylic and oil on canvas; 162.6 x 203.2 cm
Collection Francesco Pellizzi
Hice Bien Quererte, 1990
Oil on canvas
198 x 430 cm
Collection Janet de Botton, London

ROBERT GOBER
Two Spread Legs, 1991
Wood, wax, leather, cotton, human hair, steel
28 x 89 x 70 cm each
Courtesy Paula Cooper Gallery, New York

ANDREAS GURKSY
Salerno, 1990
Colour print; 165 x 200 cm
Courtesy Galerie Johnen & Schöttle, Cologne

List of Works

Hechingen, 1990
Colour print; 160 x 205 cm
Courtesy Galerie Johnen & Schöttle, Cologne
Bremen, Autobahn, 1991
Colour print; 165 x 196 cm
Courtesy Galerie Johnen & Schöttle, Cologne
Börse, New York, 1991
Colour print; 167 x 200 cm
Courtesy Galerie Johnen & Schöttle, Cologne
Siemens, Karlsruhe, 1991
Colour print; 165 x 200 cm
Courtesy Galerie Johnen & Schöttle, Cologne

ANN HAMILTON
passion, 1992
Pigskin, soap
Courtesy Louver Gallery, New York

GARY HILL
Suspension of Disbelief (for Marine), 1991–92
4 black and white videotapes, 30 television monitors,
computer controlled switcher and aluminium beam
40 x 40 x 900 cm total length
Courtesy Donald Young Gallery, Seattle
Co-produced with the Centre d'art contemporain,
Le Creux de l'Enfer, Thiers, France

JENNY HOLZER
Selections from Truisms and The Survival Series, 1992
LED Display, Royal Festival Hall Box Office

NARELLE JUBELIN
Jamieson Valley in Cloud or Mist: The Prescribed
View, 1987
Found English oak frame, cotton petit point
220 x 365 x 20 mm
Collection of Maureen Laing, Brisbane
Courtesy Mori Gallery, Sydney
The Proclaimation Tree: Selected Vision, 1987
Found daguerreotype frame, cotton petit point
80 x 80 mm
Collection of Geoff Wilson, Adelaide
Courtesy Mori Gallery, Sydney
Marked Explorers Tree: Selected Vision, 1987
Found daguerreotype frame, cotton petit point
100 x 100 mm
Collection of Geoff Wilson, Adelaide
Courtesy Mori Gallery, Sydney
Domain Road & Environs: A Distanced View, 1987
Found English cedar frame, cotton petit point
213 x 1007 mm
Collection of Vivienne Sharpe, Sydney
Courtesy Mori Gallery, Sydney
North Terrace & Environs: A Distanced View, 1987
Found English oak frame, cotton petit point
220 x 597 mm

Collection of Vivienne Sharpe, Sydney
Courtesy Mori Gallery, Sydney
Sydney Heads & Environs: A Distanced View, 1987
Found English oak frame, cotton petit point
180 x 395 mm
Private collection, Sydney
Courtesy Mori Gallery, Sydney
Port Adelaide Light: A Distanced View, 1987
Found English oak frame, cotton petit point
218 x 368 mm
Collection of Joe Wissert, Sydney
Courtesy Mori Gallery, Sydney

MIKE KELLEY
Written in the Wind, 1991
Stuffed found animals, coat rack with jacket & shirt,
ten wall texts
Cardboard box with 10 objects
Dimensions variable
The artist, courtesy Rosamund Felsen Gallery,
Los Angeles and Metro Pictures, New York

JON KESSLER
The Millenium Machine, 1992
Steel, wood and motor; 176 x 200 x 220 cm
The artist, courtesy Luhring Augustine Gallery,
New York

JEFF KOONS
At Home with the Koons', 1992
Magazine advertisement/poster designed for the
London underground

GLENN LIGON
The Dream Book series
All works oil on paper
Nos. 000, 167, 511, 1988-89
Each 76.2 x 57.2 cm
Private collection, New York
No. 121, 1990
76.2 x 57.2 cm
The artist, courtesy Max Protetch Gallery, New York
Nos. 316, 333, 752, 1990
Each 76.2 x 57.2 cm
Collection Emily Fisher Landau, New York
Nos. 276, 291, 609, 762, 1990
Nos. 348, 417, 1990–91
Each 76.2 x 56.5 cm
Collection Emily Fisher Landau, New York

CHRISTIAN MARCLAY
Mary Had a Little Lamb, Friday 28 February 1992;
Purcell Room, South Bank Centre
Performance with found sound and live improvisation
by Christian Marclay, Han Bennink, Steve Beresford,

Phil Minton and Evan Parker
Supported by Pro Helvetia

JUAN MUÑOZ
Untitled, 1992
Jubilee Gardens walkway
3 bronze flags, artificial stone; 375 x 200 x 100 cm
Commissioned in association with The Artangel Trust

JUAN MUÑOZ with GAVIN BRYARS

A Man in a Room Gambling, 1992
10 radio pieces of 5 minutes each.
Texts by Juan Muñoz.
Composed by Gavin Bryars. Played by the Balanescu
Quartet. Sound Engineer Chris Ekers.
Commissioned in association with The Artangel Trust

SIMON PATTERSON

I quattro formaggi, 1992
178 x 381 cm
Courtesy the artist

J. P. 233 in C.S.O Blue, 1992
675 x 325 cm
Courtesy the artist

The Great Bear, 1992
Print; 102 x 127 cm
Courtesy the artist

TIM ROLLINS + K.O.S.

X-men 1968, 1990
Comic book pages, acrylic on linen; 193.1 x 492.8 cm
F. Roos Collection, Switzerland

The X-men series
All works comic book pages, acrylic on linen

X-men No. 45 – When Mutants Clash! 1990
X-men No. 50 – City of Mutants, 1990
Each 96.5 x 83.8 cm
Courtesy Thomas Ammann, Zürich

X-men No. 40 – The Mark of the Monster! 1991
X-men No. 41 – Now Strikes the Sub-Human! 1991
X-men No. 42 – If I Should Die! 1991
X-men No. 43 – The Torch is Passed…! 1991
X-men No. 44 – Red Raven, Red Raven…! 1991
X-men No. 46 – The End of the X-men! 1991
X-men No. 47 – The Warlock Wears Three Faces! 1991
X-men No. 48 – Beware Computo Commander of
The Robot Hive! 1991
X-men No. 49 – Who Dares Defy …
The Demi-Men? 1991
X-men No. 51 – The Devil had a Daughter, 1991

Each 96.5 x 83.8 cm
Courtesy Mary Boone Gallery, New York
(The X-Men, trademark and copyright 1992,
Marvel Entertainment Group, Inc. All rights reserved)

PHILIP TAAFFE

C-Wave, 1984
Linoprint, collage, acrylic and enamel on canvas
227 x 227 cm
Courtesy Thomas Ammann, Zürich

Brest, 1985
Linoprint, collage and acrylic on paper mounted
on canvas; 199 x 199 cm
Collection of Martin Sklar

Desert Flowers, 1990
Mixed media on linen; 155 x 201 cm
Courtesy Gagosian Gallery, New York

Capella, 1991
Mixed media on linen; 279 x 279 cm
Courtesy Gagosian Gallery, New York

BOYD WEBB

Untitled, 1992
Poster for billboard in Concert Hall Approach
in front of Waterloo Station

RACHEL WHITEREAD

Untitled, 1991
Fibreglass and rubber; 30.5 x 188 x 137.2 cm
Private collection, London

Untitled (Amber Slab), 1991
Rubber and high density foam; 205.7 x 78.7 x 11.4 cm
Courtesy Karsten Schubert Ltd, London

Untitled (Amber Mattress) 1992
Rubber and high density foam; 111.8 x 92.7 x 109.2 cm
Courtesy Karsten Schubert Ltd, London

Untitled (Clear Slab), 1992
Rubber; 205.7 x 78.7 x 11.4 cm
Courtesy Karsten Schubert Ltd, London

ALDO ROSSI

Reading Room

Etchings and lithographs 1987–91
Courtesy Studio San Luca, Genoa

Carteggio cabinets (1987) and Milano chairs (1987)
Courtesy *Unifor*

Consiglio table (1991) and Parigi lounge chairs (1989)
Courtesy *Molteni & C.*

Molteni & C. are represented in the United Kingdom by Orchard Associates · Mr. Roger Mallins · 2 Davenport Close, Teddington · Middlesex TW11 9EF · Tel: 081 943 3291

Unifor is represented in the United Kingdom by Ergonom Ltd, Braintree Road · South Ruislip · Middlesex HA4 OEJ · Tel: 081 842 2971 · Fax: 081 842 0960

INSTALLATION PHOTOGRAPHY BY DAVID WARD AND EDWARD WOODMAN

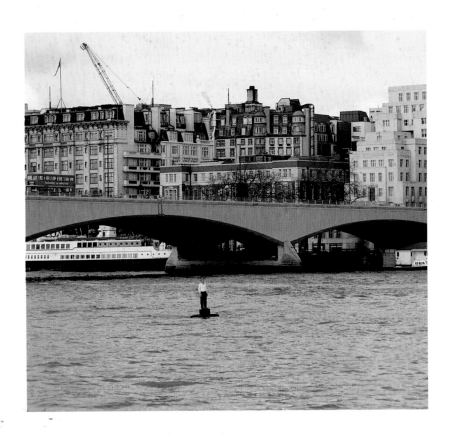

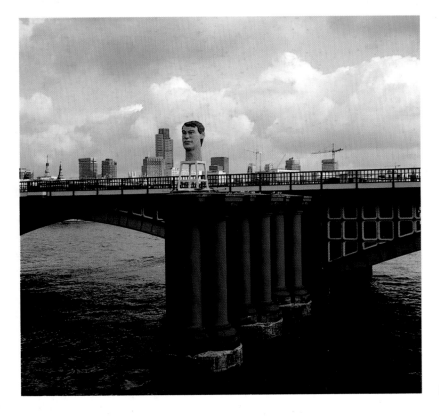

STEPHAN BALKENHOL